IMAGES
of America

BEAVER DAM
1841–1941

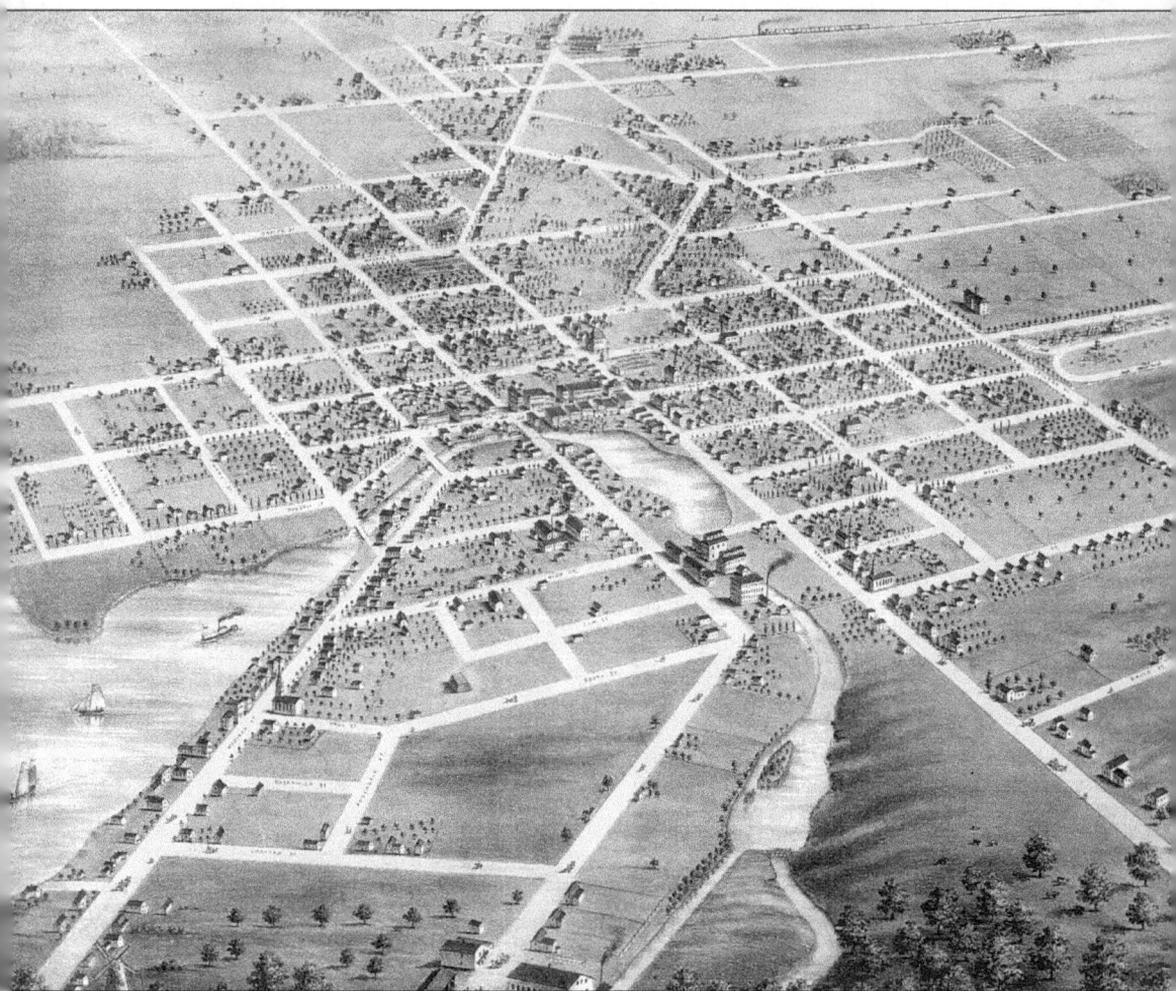

1867 MAP OF BEAVER DAM. This 1867 bird's-eye view of Beaver Dam depicts the city's then current boundaries from the railroad line to the north, to the Dodge County Fairgrounds to the east, to the Woolen Mill to the south, and finally to the man-made Beaver Dam Lake to the west.

ABOUT THE COVER: The Williams Free Library building is the current home of the Dodge County Historical Society. This Romanesque structure built in 1891 is the cornerstone of the city's downtown. To learn more about this building and its history, see pages 80 and 81.

IMAGES
of America

BEAVER DAM
1841–1941

Roger Noll

ARCADIA
PUBLISHING

Published by Arcadia Publishing,
Charleston, South Carolina

Library of Congress Catalog Card Number: 2003107808

For all general information contact Arcadia Publishing at:
Telephone 843-853-2070
Fax 843-853-0044
E-Mail sales@arcadiapublishing.com
For customer service and orders:
Toll-Free 1-888-313-2665

Visit us on the Internet at www.arcadiapublishing.com

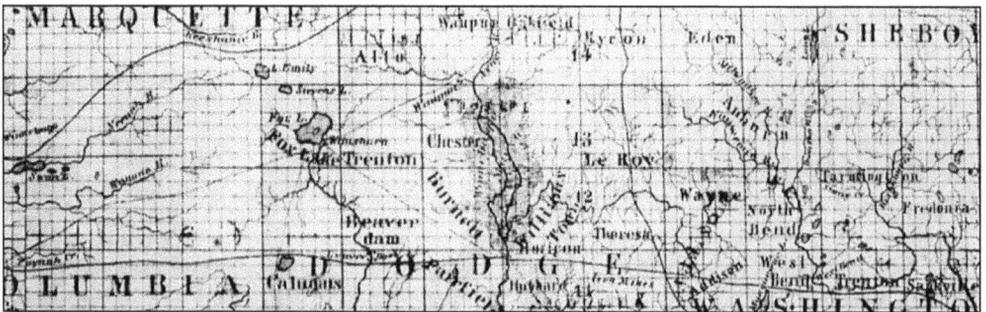

1848 ISSUE OF LAPHAM'S SECTIONAL MAP. This portion of Lapham's map depicts the Beaver Dam area at the time of its beginning prior to the creation of the man-made Beaver Dam Lake.

CONTENTS

ACKNOWLEDGMENTS

Beaver Dam is a community that has long recognized the value in preserving its local history. The Dodge County Historical Society celebrates its 65th Anniversary in 2003; it is the oldest historical society in the county. Were it not for the original board of trustees, Mrs. Peter Beule, Dr. R.R. Roberts, James Malone, Joseph Hoyt, George B. Swan, Mrs. Katrina Treichel, Miss Mary Spellman, Charles Starkweather, Albert Andorfer, and Arthur Bedker, much of Beaver Dam's history would have been lost forever and certainly this book would not have been possible.

I must also acknowledge the many directors, curators, employees, and volunteers who have lent their time and talents over the past six decades. Unfortunately, there are too many to mention here.

I, too, need to thank the many local residents who have donated their treasured keepsakes from the past so that future generations can appreciate the struggle and joy in forming this community.

I would be remiss not to acknowledge those who specifically allowed the use of their photographs for the creation of this book: Mrs. Linda Scheurer of the Delia Denning Akeley family and the Wisconsin Historical Society.

Finally, I want to extend my sincere appreciation to the current board of directors for its support of this effort and its continued dedication to the Dodge County Historical Society as a whole. They are the following: Tom Giese, Sue Scafe, Mary Cudnohfsky, Robert Frankenstein, Kris Schumacher-Rasmussen, Jerry Kamps, Tim Welch, Richard Penman, Al Kruger, Sharon Bliefernicht, Myrtle Clifton, and Dean Tillema.

INTRODUCTION

On an October day in 1937, Beaver Dam residents would discover that nearly every newspaper in the country was proclaiming that Beaver Dam was the "Most Typical Small Town In America." The incident would inspire a movie called *Magic Town* starring Jimmy Stewart. But, just as Beaver Dam was getting accustomed to the acclaim associated with such a title, the city learned that it was merely a hoax perpetrated by a British reporter. But those residents who lived here then and since know that the reporter's mistake was not that he was wrong but that he just failed to properly document it. For I truly believe that Beaver Dam is a magic town and has long been one of the finest, sweetest places on this earth to live one's life. The generations of my grandparents and parents have left a noble legacy for us to inherit. But with that legacy, my generation and those to follow must recognize our responsibility to preserve what has been so richly attained and to assure that in the process of passing it to the youth of today we hand over a better place.

In 1938, a group of ten Beaver Dam citizens recognized that duty when it organized the Dodge County Historical Society, Inc. One of its first tasks was to document the city's first century. They realized that to truly understand where we are going, we must first know where we have been.

And now on the 65th anniversary of the creation of that society, we honor the original ten and all those who have subsequently dedicated themselves to the preservation of Beaver Dam's history by once again retelling the story. But, unlike the first rendering which was heavy on words and short on images, this version will tantalize the eyes with rarely seen illustrations and photographs collected over six decades by the society.

The reader will witness first hand the early pioneer struggle, the development from village to industrial city, and citizens at work, prayer, and play. It will reveal in vivid reproductions the tales of the men and women who served their country in battle. Many returned to continue the city's march to progress while others yielded the ultimate sacrifice.

And finally, the book allows the reader to commemorate the century as if they were participants in the original Centennial Celebration of 1941.

It has been a distinct pleasure in preparing the following work. I sincerely hope you enjoy the effort.

Roger Noll
President of the Dodge County Historical Society, Inc.

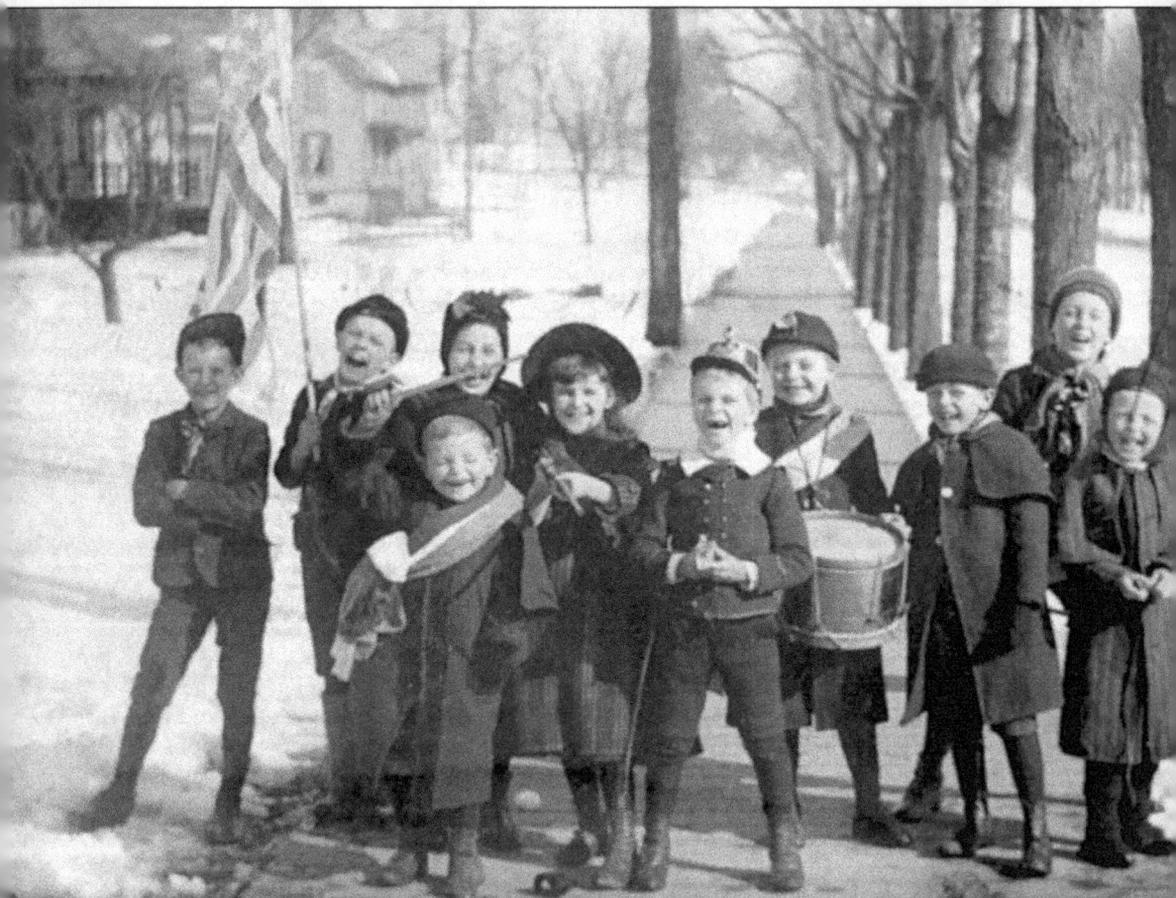

THE LEWIS GANG. Beaver Dam has long been known as a family oriented community. This 1890 picture taken on Park Avenue bears credence to this long-standing reputation. Pictured here, from left to right, are the following: (front row) George Swan, Roy Moon, Harry Lewis, Wilbur Webb, and Ira Rowell; (back row) ? Wade, Chas. McClure, Eva Harvey, Gertie Lewis, and Bert Shipman.

One

THE PIONEERS

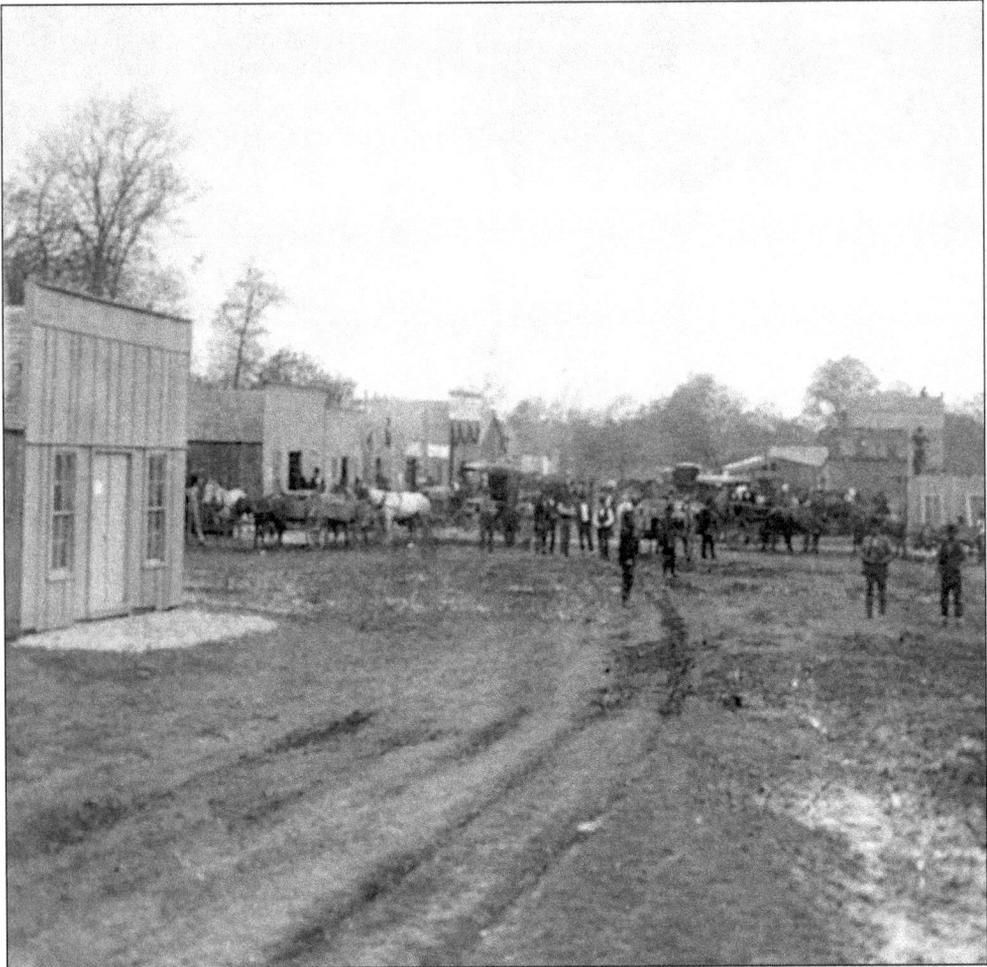

OLDEST KNOWN PICTURE OF BEAVER DAM. This picture of the city's downtown *c.* 1860 resembles an old Western town rather than a Midwestern municipality.

FIRST SETTLER THOMAS MACKIE. In the fall of 1840, Thomas Mackie and his son-in-law Joseph Goetschius followed a small stream flowing south from Fox Lake, through marsh and forest to a clearing of rich soil and abundant timber. Thomas Mackie vowed that this would be the perfect place to raise his family and both men set about felling timber to build a cabin. The two returned to Fox Lake to see out the winter and in March 1841, they traveled back the 10 miles south to the land they had found so abundant. The two constructed a log cabin on what is now identified as 128 East Mackie Street. The new city would adopt its name from the industrious animal that worked but a stone's throw away from the cabin.

EARLY SETTLER JACOB BROWER. A month later, Jacob Brower followed his brother-in law Mackie to the new settlement bringing his wife, Martha, mother and father Rachel and Paul, and his children Euphemia, George, John, Thomas, and Emily. They settled in the mid-block of what is now Front Street. Brower built a large home that also served as the first hotel and church.

NATIVE AMERICAN PRESENCE. In the early 1800s, the U.S. government entered into treaties with all of the Indian Nations of Wisconsin, relocating them to various reservations throughout the state. But the territory required one last confrontation between General Dodge and Chief Blackhawk of the United Tribes in the Blackhawk War of 1832 before the territory would be safely opened for European expansion. Native American presence would not be totally eliminated, but coexistence with the white settlers was relatively peaceful. In those early days, the Indian trade was necessary for the survival of many settlers. Pictured from left to right are the following: (front row) Wampa and Jumping Fish; (back row) Judge Leonard Mertz and Ferdinand Frings.

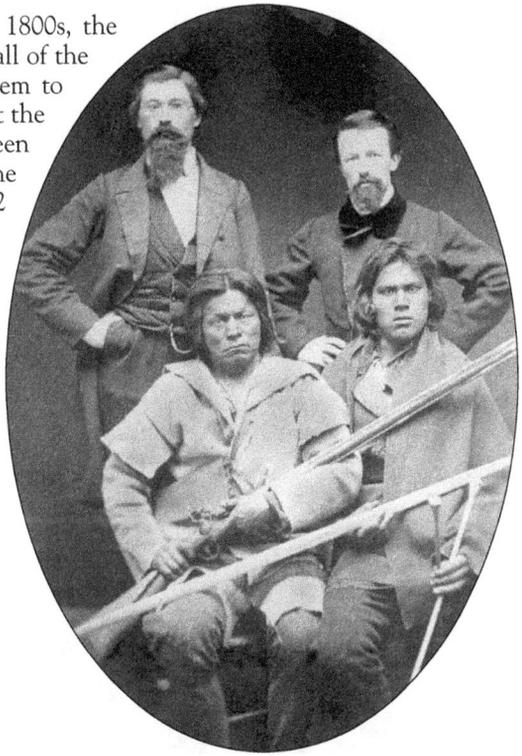

THE SACRED SPRINGS. Native Americans worshipped at the sacred springs now located at Swan City Park. One medicine man named Much Kow claimed the waters were responsible for his ripe old age of 120. And as late as the early 1900s, Native Americans returned to the city on pilgrimages to partake in the sacred springs.

THE FIRST-BORN CHILD. On May 5, 1842, the first child born in Beaver Dam—a baby boy—arrived at the Henry Stultz household. He was christened with the name George Stultz.

THE FIRST-BORN FEMALE CHILD. Two months later, on July 22, 1842, the stork blessed the city with its first baby girl, Henrietta Brower, daughter to Jacob and Martha Brower. The first-borns of Beaver Dam would be linked throughout their lives and even in death. For when Henrietta Brower passed from this earth on August 27, 1870, one of her pallbearers was George Stultz.

REVEREND MOSES ORDWAY. Rev. Moses Ordway, a man of English and Scot heritage, had traveled west from Massachusetts across the Great Lakes to Green Bay in 1836, then moved to Waukesha and ended up in Beaver Dam in 1842. A scholar and natural mechanic, Moses chose an early career in theology. He established the First Presbyterian Church in the city and held services at the Mackie home on July 1, 1843. However, Ordway's next service to the community would forever change the face of Beaver Dam and it continues to affect its character today. By 1843, the desire for log cabin housing waned and was replaced by a desire for civilized, boarded housing. This required a sawmill and a sawmill required waterpower.

Ordway and son David completed the dam adjacent to Madison Street, reinforcing the log dam with great quantities of earth and gravel. Three months later, Beaver Dam had not only waterpower but, as the water was held back, a man-made lake. A lower dam followed in mid-June 1843. The sawmill commenced producing lumber 24 hours a day. The mill started Beaver Dam's own Industrial Revolution. Ordway next added a flourmill in 1844 on the current Weyenberg site.

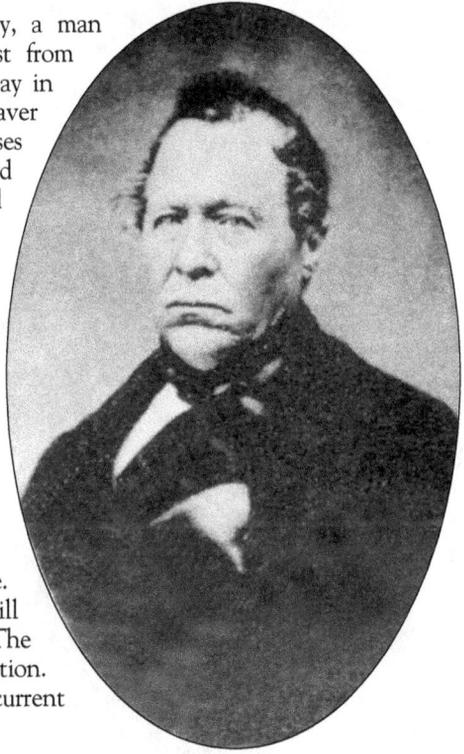

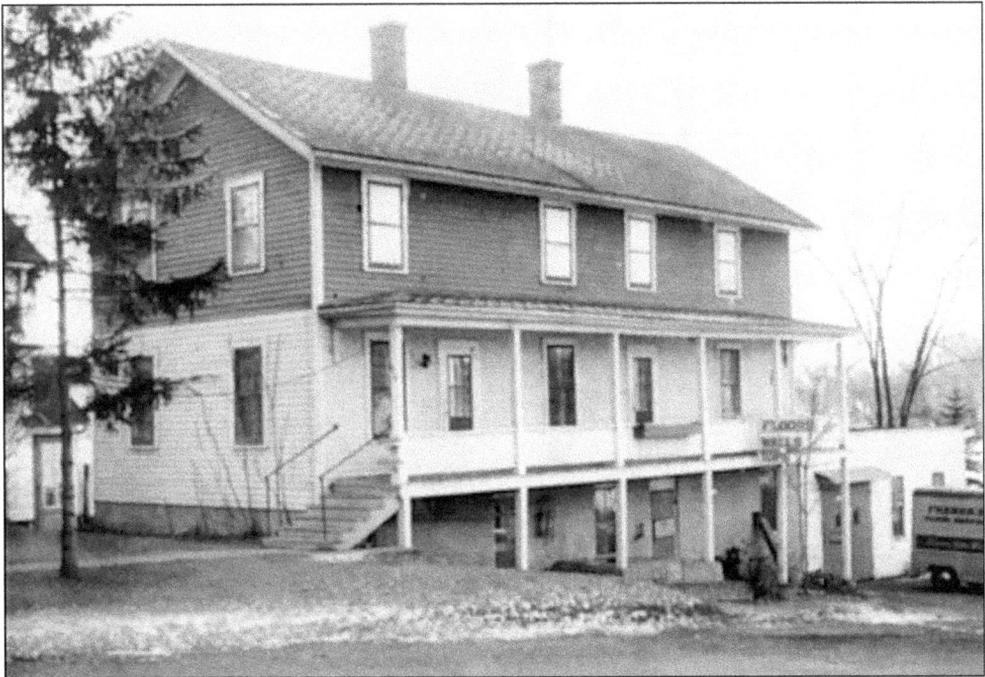

THE COOPER SHOP. A cooper shop was built by Sam and Asa Hodgman in 1845 to supply barrels for the freshly ground flour. At this location, the Hodgmans constructed the city's first tight barrel.

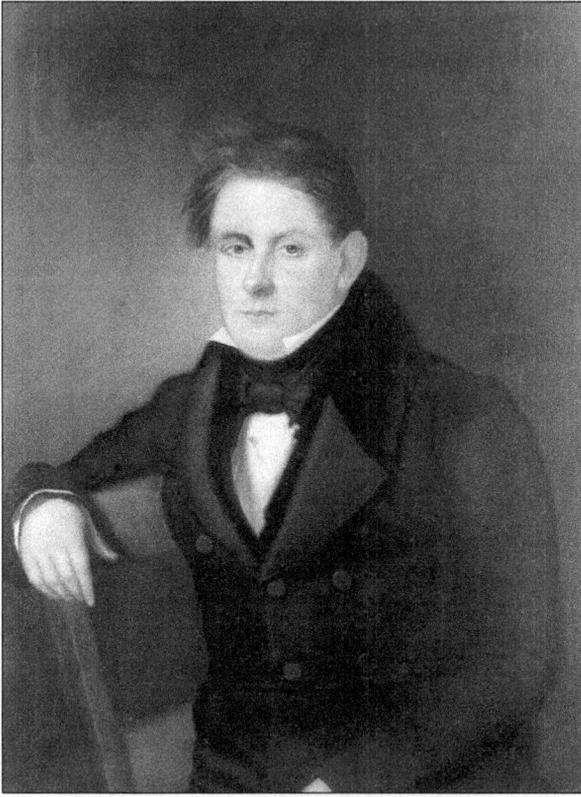

ABRAHAM ACKERMAN. In February of 1842, another Brower relative, philanthropist Abraham Ackerman, arrived and took possession of lands to the east. In 1846, Abraham Ackerman began the Woolen Mill Co. just below the sawmill at the present Kraft Site.

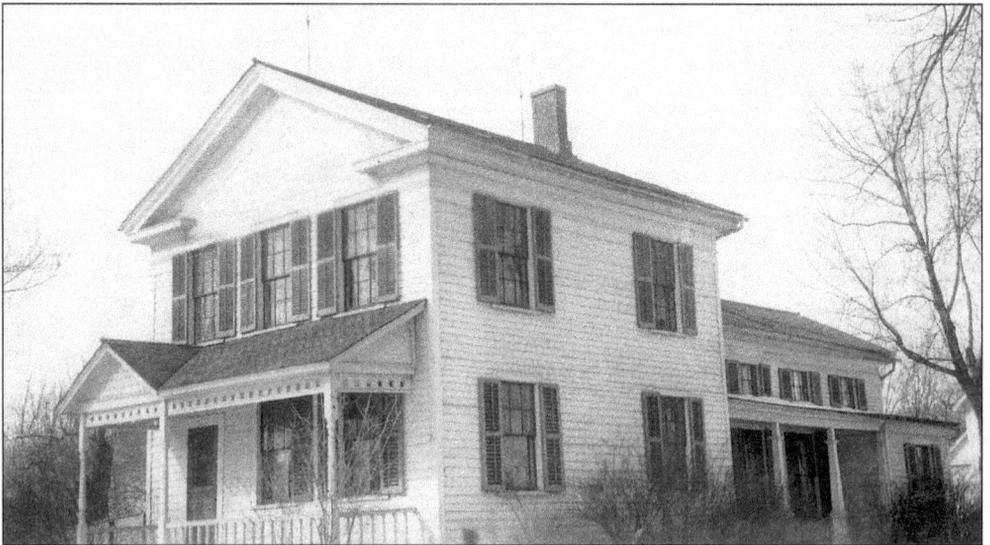

THE ACKERMAN HOME. Ackerman constructed his home at the corner of Mill and University where it still stands to this day.

S.P.K. LEWIS. S.P.K Lewis came to Wisconsin in 1847. In Beaver Dam, Lewis ran a general store for five years trading under the name S.P.K. Lewis & Co. He then turned to the milling industry, becoming part-owner in local woolen and flouring-mills. He would serve the city as mayor, alderman, school board member, justice of the peace, and town treasurer.

S.P.K. LEWIS HOME. Located on Yankee Hill (now known as Park Avenue), Lewis built one of the most lavish homes in the city. In later years, this house would serve as one of the homes lived in by movie and television star Fred MacMurray.

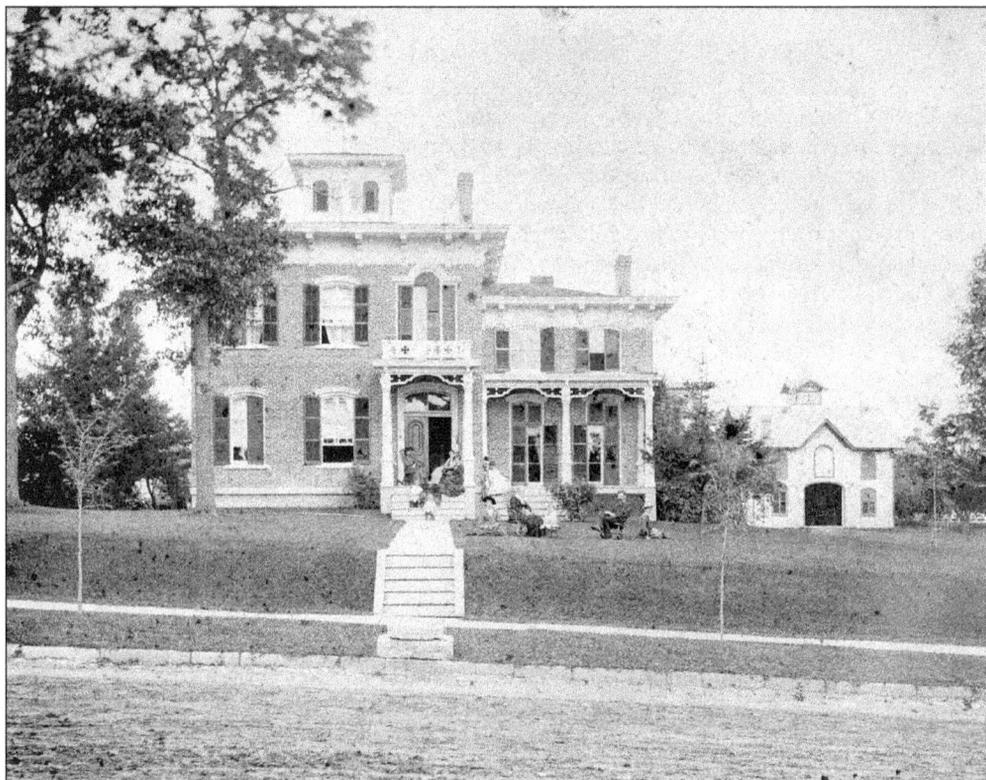

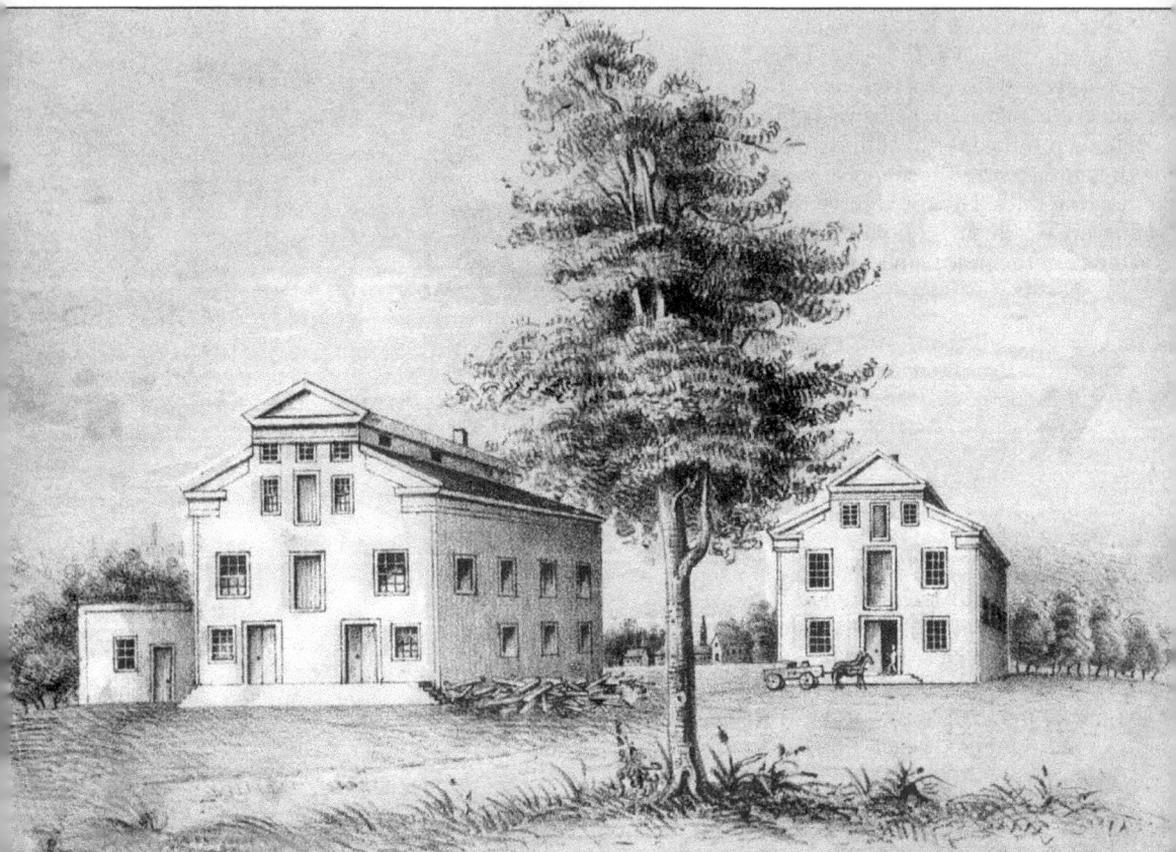

The Empire Flour Mill. In 1849, S.P.K. Lewis and Abraham Ackerman built the Empire Flour Mill on the west bank of the river near the second dam on West Mill Street. The mill was driven solely by waterpower. The flour was first shipped in Hodgman Barrels of 196 pounds net, then in 140-pound jute bags. The mill also ground grist for grain growers who in return gave one-eighth of their product back to the mill for grinding. S.P.K. Lewis would remain a constant but several partners would come and go during the mill's four-decade run. Owners included Lewis and Bogert, Lewis and Brother, Lewis and Son, and the S.P.K. Lewis Company.

Two

Business, Industry, Trade, and Agriculture

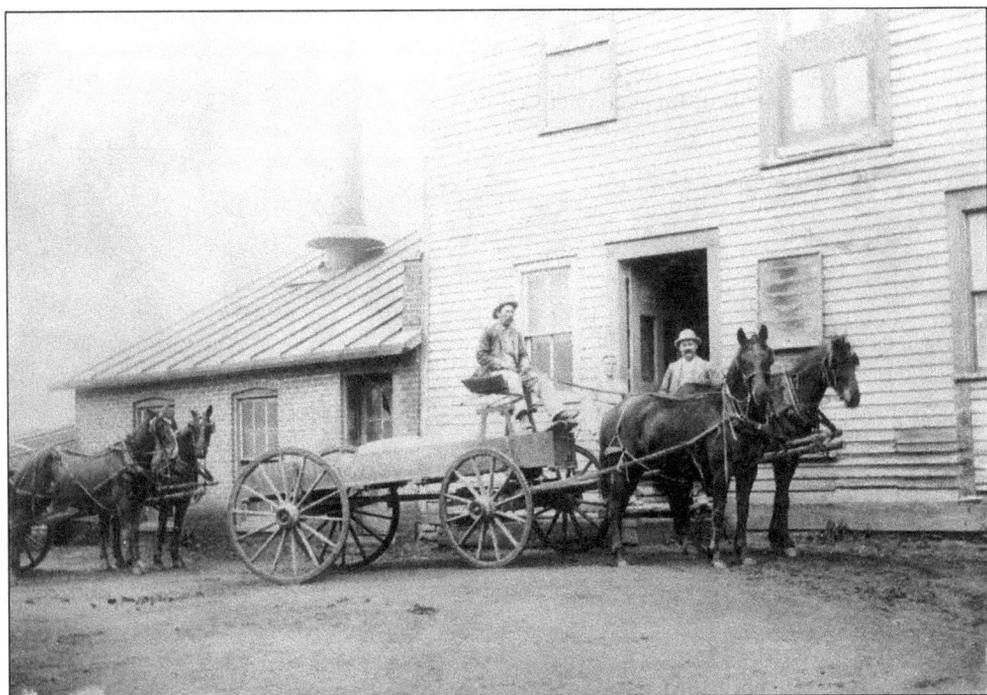

PICKUP AT THE EMPIRE MILLS. During various periods, over 100 farmers in their wagons or sleighs would wait several hours to procure the mill's ground grist.

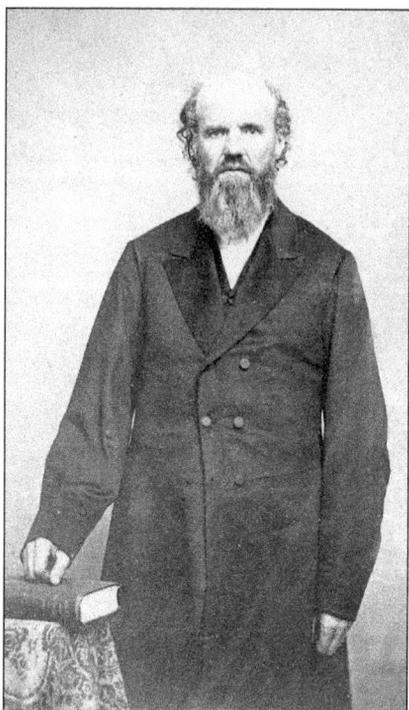

Left: GEORGE STEWART. George H. Stewart was the founder of the Woolen Manufacturing Company (a.k.a. the Dodge County Woolen Mills) and the Farmer's Woolen Mills. This woolen mill commenced business on July 1, 1853 and was locally referred to as the Upper Woolen Mill.

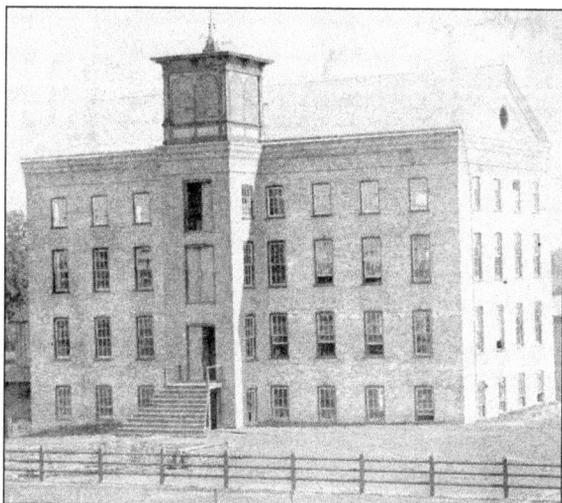

Above, right: SECOND UPPER WOOLEN MILL. In 1867, the mill was reorganized and the ownership changed to the Chandler, Congdon & Company. A massive four-story brick building replaced the original mill. This mill specialized in the manufacture of high-grade cassimeres. In 1882, the mill was renamed the Beaver Dam Worsted Company. Twenty years later, reorganization again occurred under the leadership of M.A. Jacobs. The Upper Woolen Mill continued for an additional ten years until cutthroat competition necessitated closure in 1912.

ORIGINAL UPPER WOOLEN MILL. The original Upper Woolen Mill was a stick building. It served at the Upper Mill site until 1867. Thereafter, the structure was moved to Rowell Street and used as a blacking shop for the J.S. Rowell Manufacturing Company. It was at this location that the picture was taken.

INGRAHAM GOULD. In 1854, Mr. Ingraham Gould planted his first seedlings in Beaver Dam on approximately 12 acres on the site of the current high school and surrounding area. From these humble beginnings grew the largest nursery in the United States west of New York state. The site shipped millions of trees and shrubbery to the far reaches of this country. Its reputation was unparalleled in the world of horticulture.

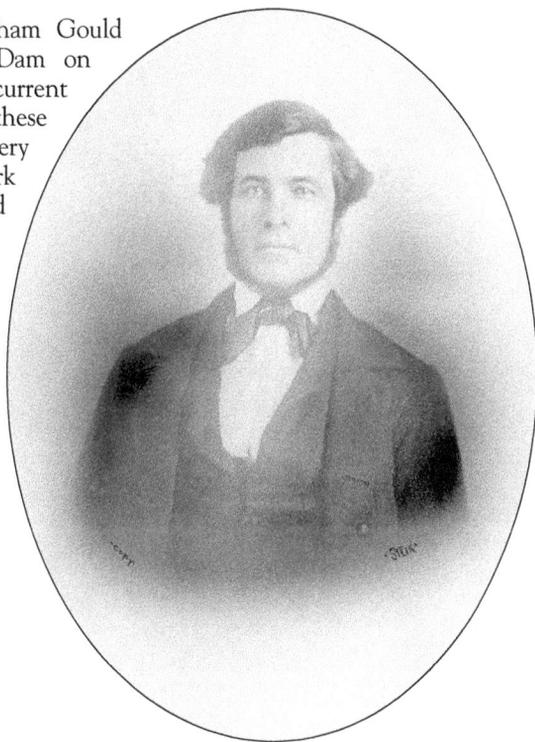

GOULD NURSERY. Farmhouse and outbuildings located on the site of the Gould Nursery.

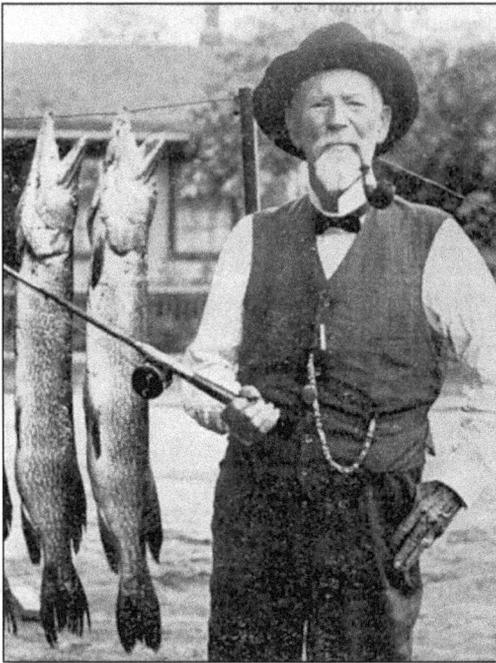

J.S. Rowell. In 1851, J.S. Rowell moved to Beaver Dam. Initially, Rowell opened a thrasher repair shop. Four years later, he established a small foundry named the J.S. Rowell Manufacturing Co. on the street named after him. The foundry concentrated on the production of quality agricultural equipment.

The Tiger Plow. J.S. Rowell was an ingenious inventor. His Tiger plows, drills, and seeders caught the favor of farmers throughout the country and Canada for nearly 60 years.

THE "TIGER" 12 HOE SPRING PRESS CHAIN DRIVE SEEDER.
Single Lever—12, 14 and 16 Hoe.

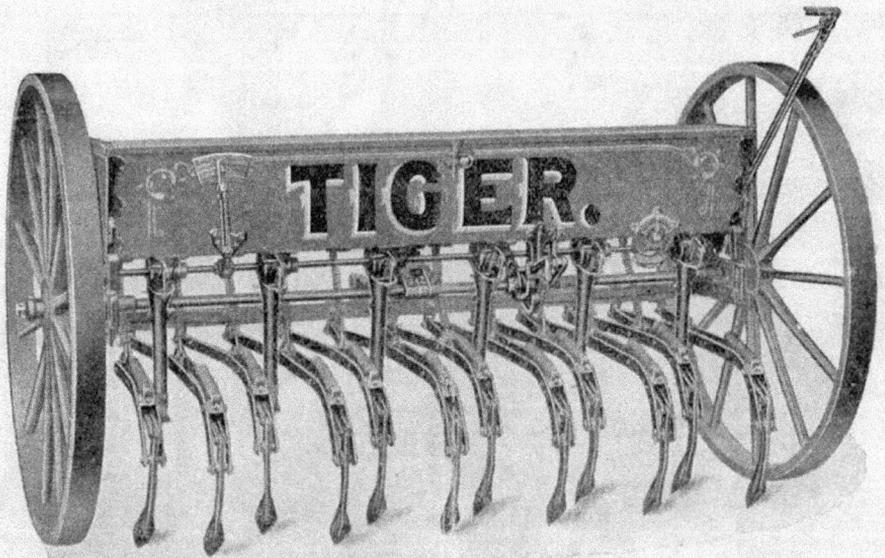

Improvements On Single Lever Seeders.

1st. **Drop Frame:** Lowers line of Draft and Machines pull MUCH EASIER and Teeth DIG better than on the old style STRAIGHT FRAME.

2d. **Hand Device to Throw Out of Gear**—This enables Operator by small hand lever to throw out of gear when cultivating, but is entirely separate and in no way interferes with the Automatic Device. Neat and simple.

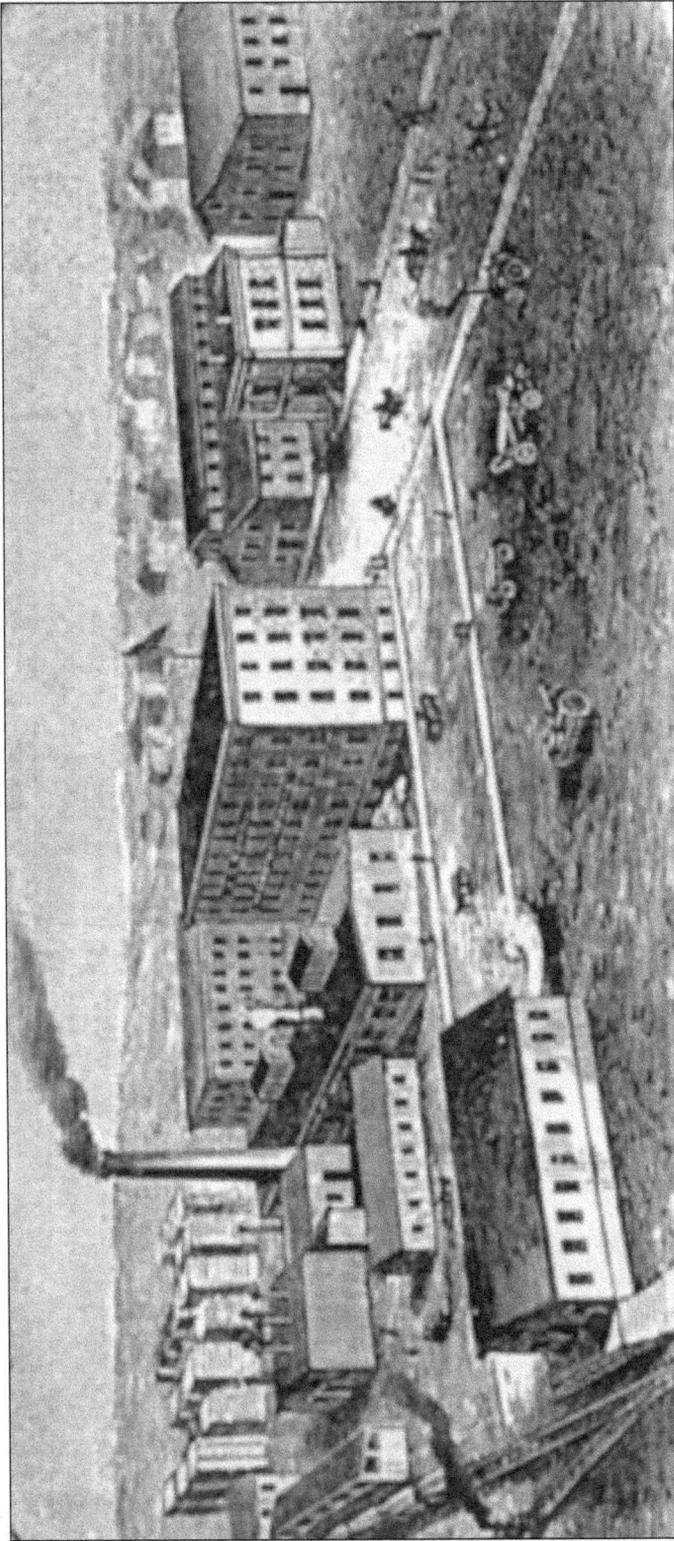

The J.S. Rowell Manufacturing Plant.

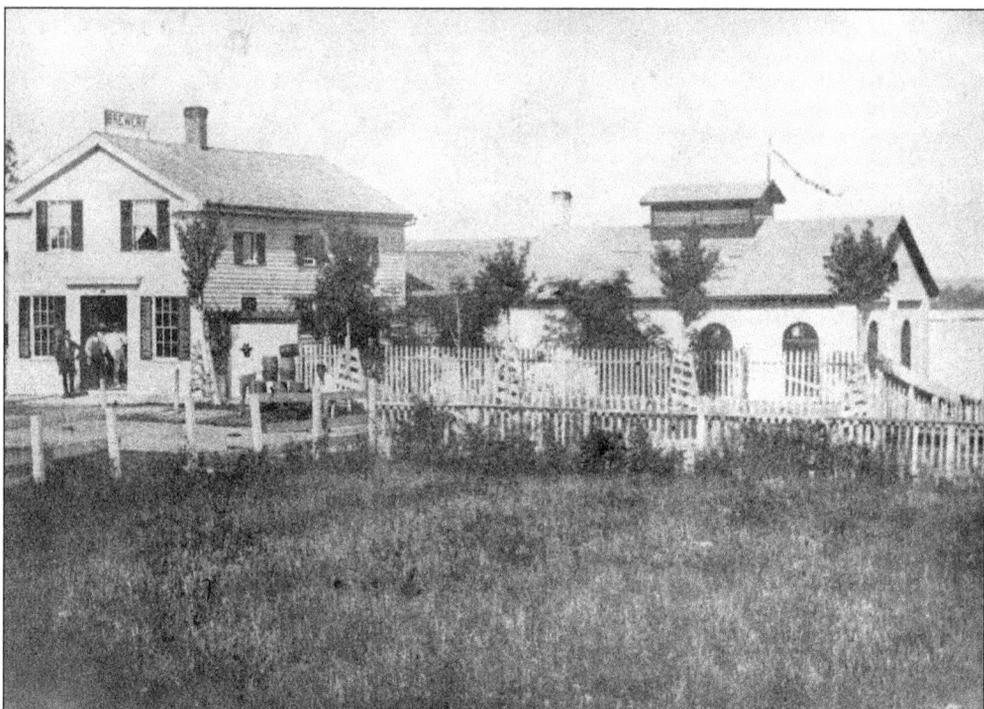

GOEGGERLE'S BREWERY. In 1856, John Goeggerle and the Patzlberger Brothers bought the site of the first Beaver Dam brewery. Goeggerle would take sole control over the production facility in 1859 and remain as head of the brewery until his death, at which time Louis Ziegler purchased the plant.

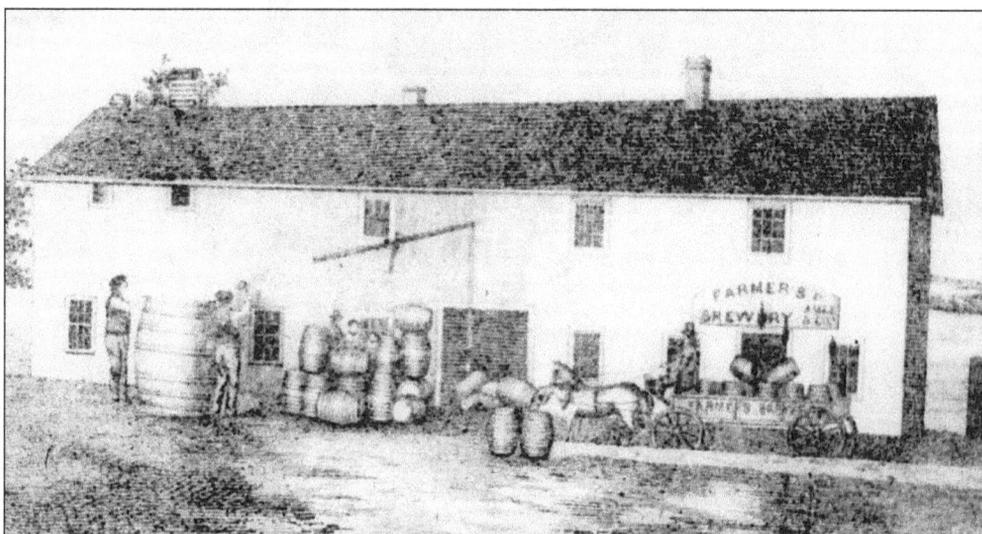

FARMERS' BREWERY. In 1857, Carl Schutte opened Beaver Dam's second brewery. Soon thereafter, records indicate that George Aman and Schutte owned the property. By 1864, the partnership dissolved as Schutte remained the sole owner until it was sold in 1866.

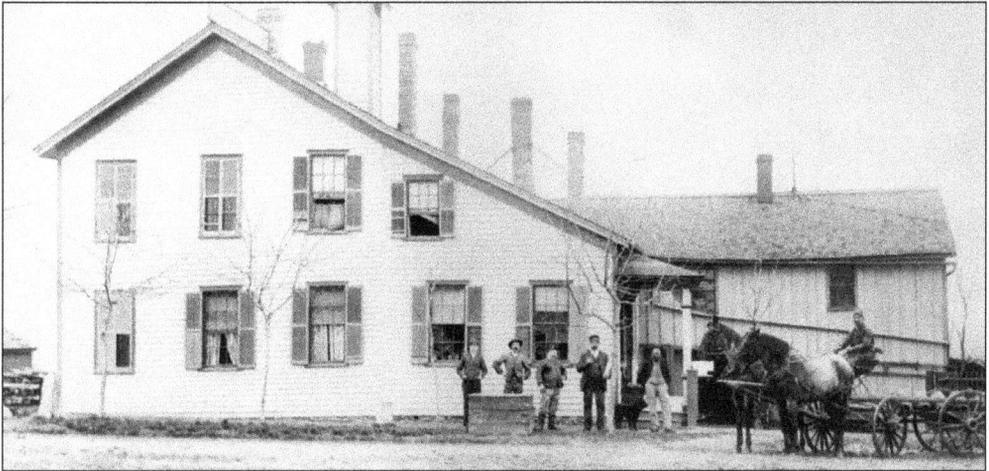

BINZEL BREWERY. John Philip Binzel purchased Farmers' Brewery in 1866. The brewery, like all the others before it, was located on Madison Street. Binzel had been taught the trade by such brewing giants as Joseph Schlitz and Valentine Blatz. The picture above was taken in 1890 just prior to an expansion, which resulted in the above buildings being torn down and a larger brick plant erected. Binzel died in 1902. The management of the Brewery first passed to his widow with help from sons Edward and Alvin. In 1906, a third son, Rudolph, would take over the reins. Over the years, the plant would again be expanded to produce a maximum output of 12,000 barrels per year in 1920. Prohibition would usher out Binzel Brewery as Rudolph Binzel turned his attention to the establishment of various canning companies throughout the state.

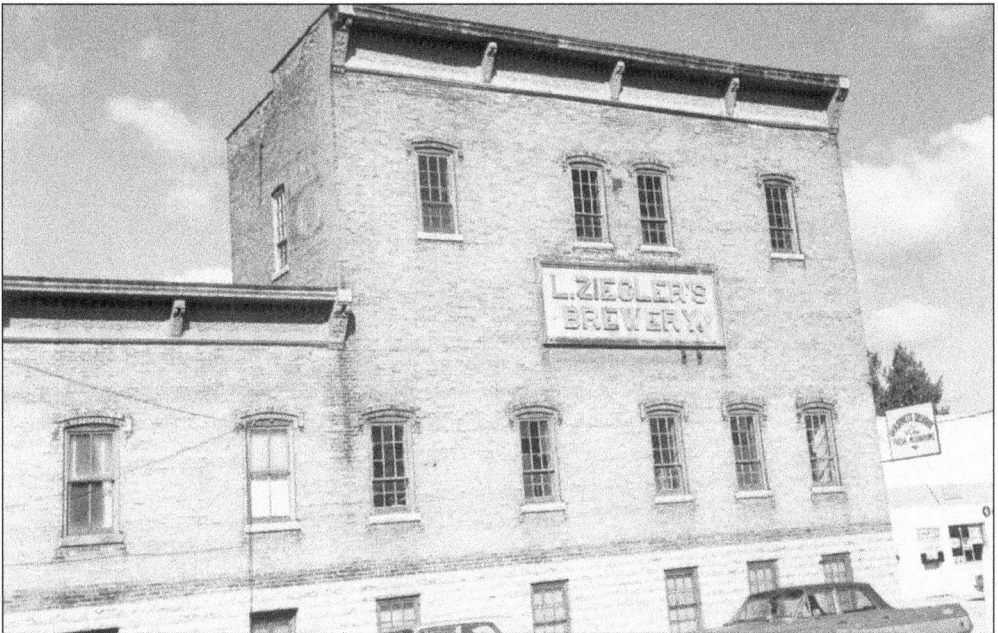

ZIEGLER BREWERY. Upon the death of John Goeggerle, Louis Ziegler assumed control of the Goeggerle Brewery property. Ziegler Brewery gained wide popularity for its 520 and Bock Beers, but the plant would suffer the same fate as all breweries being forced to close due to Prohibition. However, Ziegler would re-open the day after Prohibition's repeal and continue production through the remainder of Beaver Dam's first century and beyond.

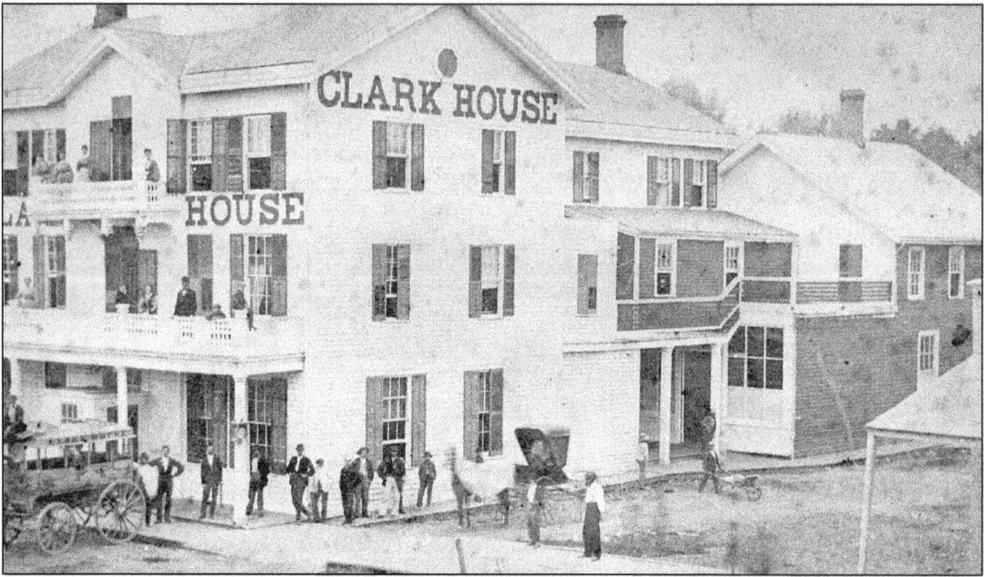

THE CLARK HOUSE. Originally named the Horn House, the Clark House was Beaver Dam's first building dedicated solely for use as a hotel. Built in 1846 by Abram Horn at the corner of Front and Center, the building was known for its then modern day luxury. In 1853, the three-story housing structure was transferred to Andrew Haight. Five years later, the building would be destroyed by fire. Rebuilt immediately, the hotel reopened within a year. Such notables as abolitionist Frederick Douglas drew the attention of hundreds of onlookers when he stayed the night after addressing a group of enthusiastic Republicans.

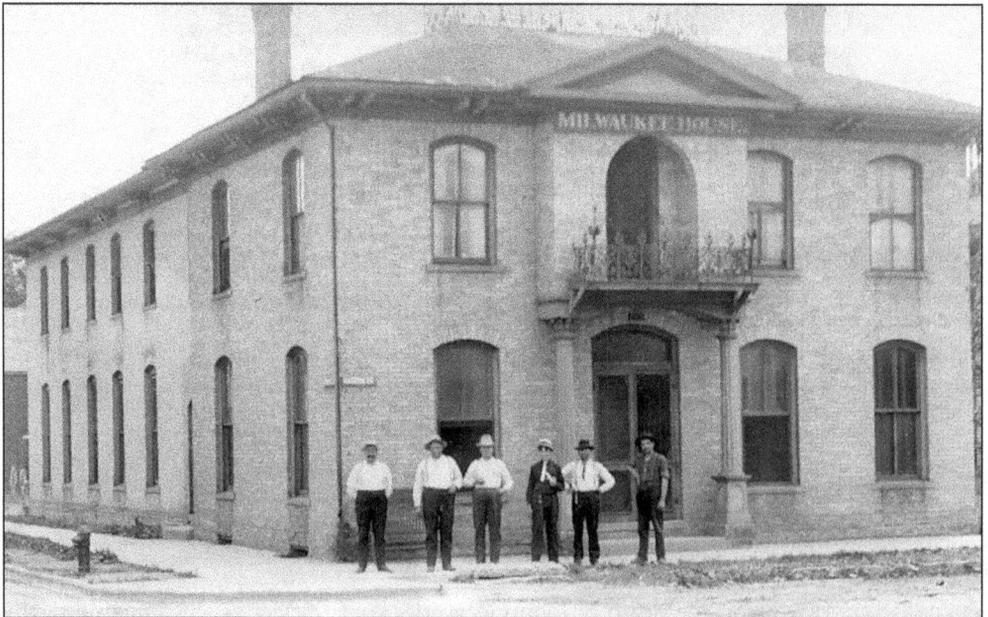

THE MILWAUKEE HOUSE. Built in 1844, this hotel originally traded under the name of the Manahan Building and the Washington House. With new ownership in 1872, the name would be changed to the Milwaukee House. In 1875, the two-story brick building seen above was added. President Grover Cleveland gave a rousing political speech from the front porch balcony.

E.C. McFetridge. E.C. McFetridge arrived in Beaver Dam in November of 1858. A lawyer by training, he practiced with A. Scott Sloan for six years before turning his attention to industry. In 1865, in concert with his brother A.J. McFetridge, E.C. opened the Beaver Dam Woolen Mills. E.C. held many positions of honor including school superintendent, mayor, county treasurer, assemblyman, and state senator.

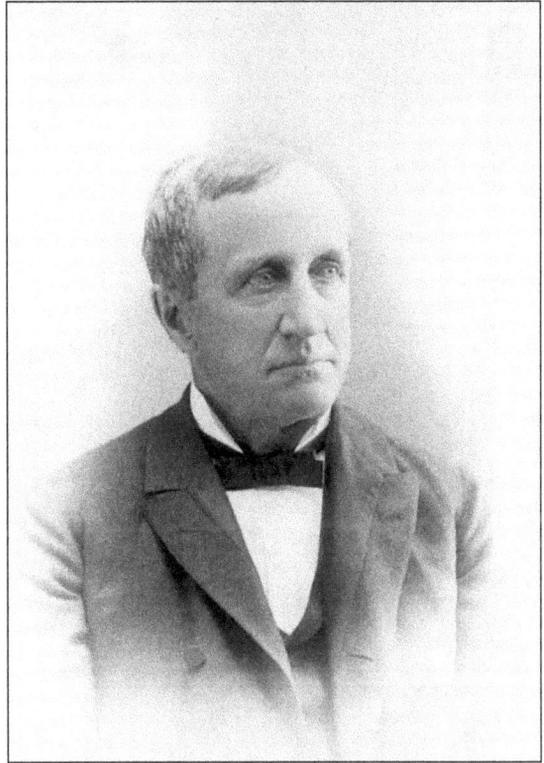

The Lower Woolen Mill. In 1865, the Beaver Dam Woolen Mill (known locally as the Lower Woolen Mill) opened in the 100 block on the eastside of South Center Street. The mill was famous for its fine doeskins, fancy cassimeres, flannel, and blankets. The small mill in later years could not compete with larger manufacturers and was forced to close in 1908.

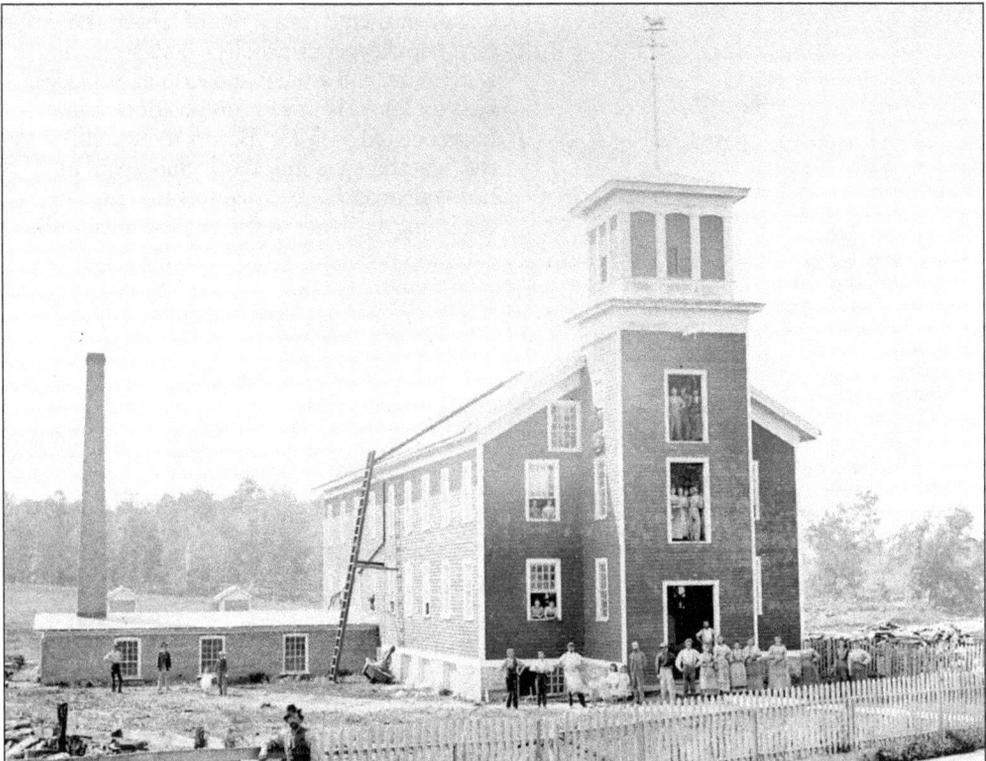

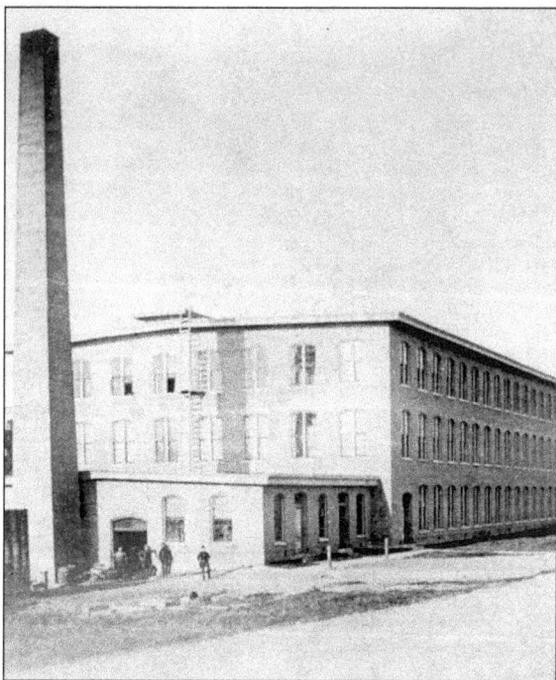

THE COTTON MILL. In 1882, with the loss of the Hoyt Cotton Mill to fire, a group of local businessman, including George B. Congdon and G.W. Chandler, pooled together $185,000 to invest in a new cotton mill, the Beaver Dam Cotton Mills, Inc. The mill's over 200 skilled laborers worked a hectic overtime schedule. But like other mills of the day, stiff competition from significantly larger plants precipitated its closure in 1906. The plant lay idle until 1911, when Paramount Knitting Company (later changed to Bear Brand Hosiery) opened its doors. Bear Brand Hosiery ceased production in 1934 due to labor strife. In 1936, the building was purchased by the city and leased to Weyenberg Shoe Manufacturing Company.

Left: **G.B. CONGDON.** George Congdon arrived in Beaver Dam in May of 1853. He started as a laborer in the woolen mill. Congdon then held a series of jobs in the city: bookkeeper at two dry-goods stores and a warehouse, and a teller and cashier at Dodge County Bank. It was in this position that he associated with Mr. Bogart to establish the Waushara County Bank. Successful in this endeavor, he returned to Beaver Dam becoming a partner in the city's woolen mill.

Right: **GEORGE W. CHANDLER.** George Chandler also arrived in Beaver Dam in 1853. Learning the woolen trade in New York, he partnered with George Stewart in 1859 to run one of the local woolen mills. Eventually he teamed with G.B. Congdon as Chandler, Congdon & Company in the same pursuit.

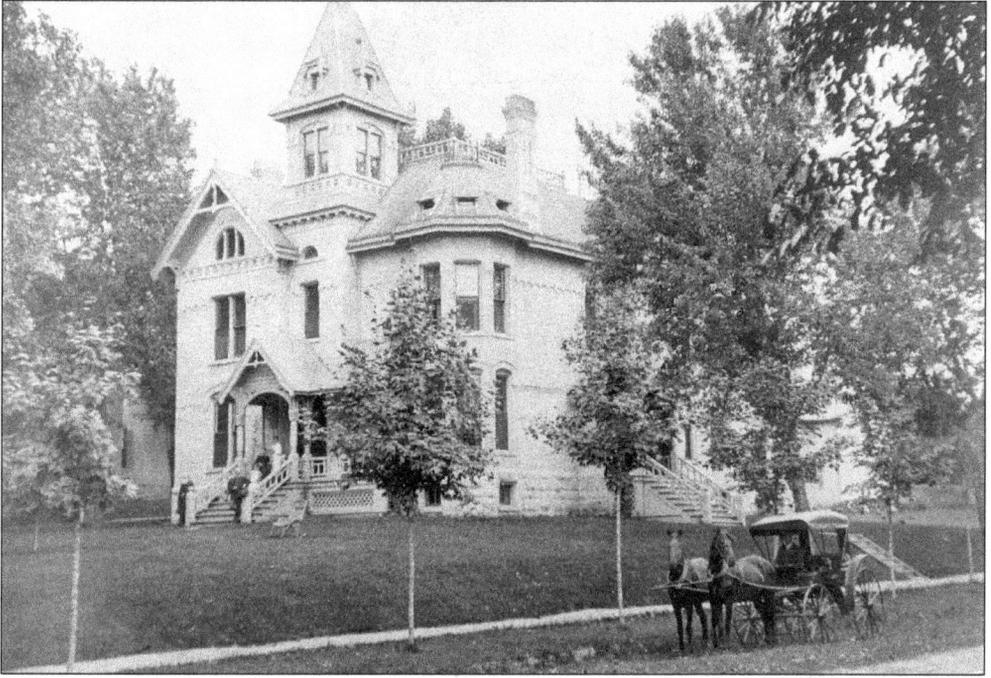

THE CHANDLER HOME. Located on the southeast corner of Park and Lincoln, the Chandler home was one of the most elegant in the city. In later years, the home was transformed into the Hillcrest School for Girls, a private elementary school.

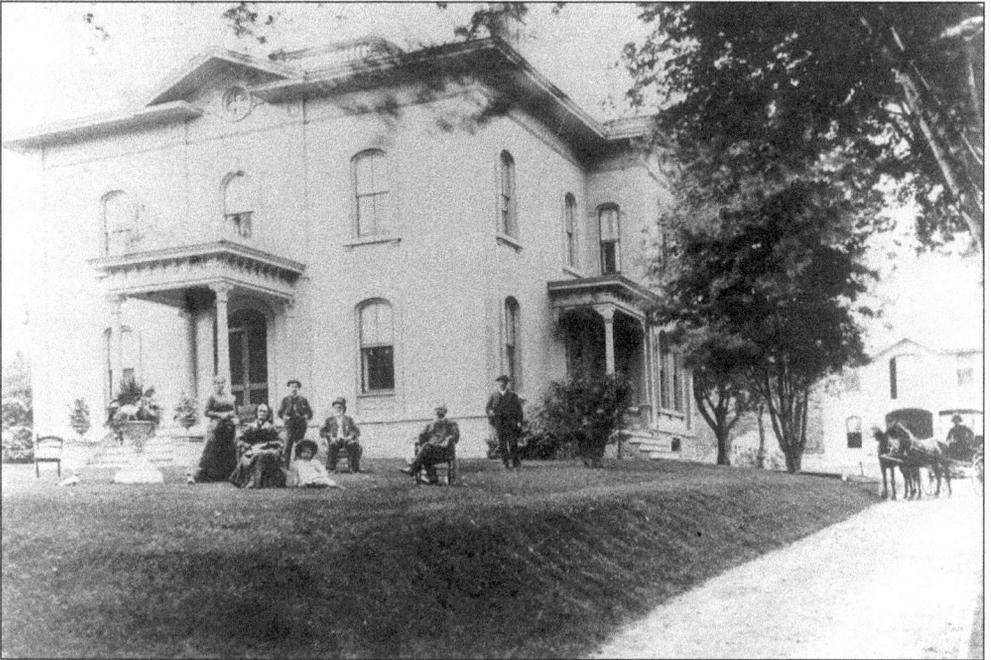

THE CONGDON HOME. Just east of the Chandler Home lived partner G.B. Congdon. This Greek Revival style mansion was used in the early 1900s as part of the Hillcrest School for Girls campus.

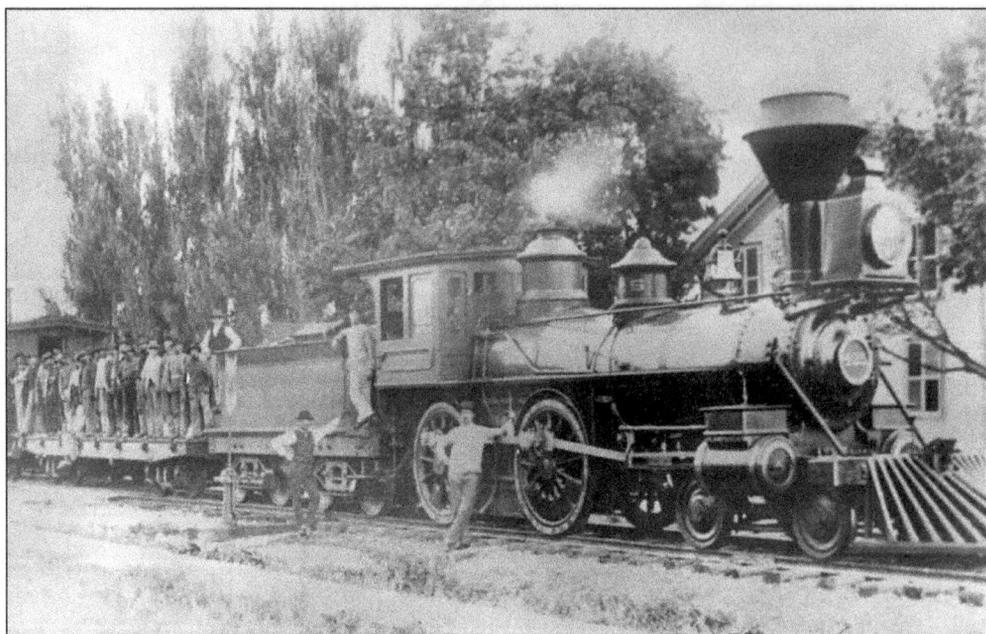

THE RAILROAD ARRIVES. On April 24, 1856 the Lacrosse and Milwaukee Railroad roared into the outskirts of the city at the old depot on North Spring Street. Its coming was to be greeted by a grandiose celebration including an honor guard of the local militia. But the meticulously planned reception soon took on the semblance of a Keystone Cops' silent movie. The train was scheduled to arrive at 1 p.m. in the afternoon. A procession of townsfolk and a band had just begun its parade from the downtown to the depot at 12:30. The artillery-company, decked out in new uniforms, was marching in military step when the crowd was stunned to hear the blare of the railroad whistle. A chase broke out as women, men, and children in their Sunday finest all frantically sprinted the nearly 10 blocks of city streets to hail the rail's arrival. But the train delayed until the celebration could reach its destination.

THE OLD SPRING STREET DEPOT.

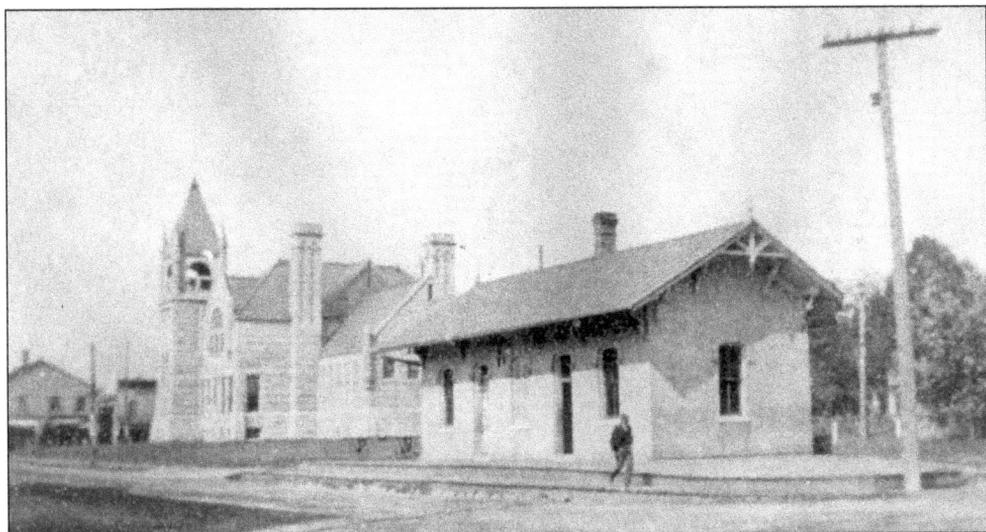

THE DOWNTOWN LIMESTONE DEPOT. It had been more than 30 years since Beaver Dam officials and businesses had petitioned the Lacrosse & Milwaukee Railroad for a downtown line and station. In 1881, fed up with the rail's failure to act, civic leaders opened negotiations with the Northwestern line, which was establishing a line north from Milwaukee. Almost immediately, word was received from the Lacrosse & Milwaukee Railroad bigwigs that a line would be forthcoming. The line was nicknamed the "frying pan" because of its unique loop shape through the downtown industry sector. The line followed southerly along Spring Street, past the new limestone passenger depot, over the factory mill pond, into the local industrial quarter, onto the depot to load passengers, and then traveled back out parallel to Spring Street where it reconnected with the main line.

THE DOWNTOWN BRICK DEPOT. The white limestone depot would be replaced in 1901 by the current red brick depot. After the railroad abandoned the frying pan line, this depot was first used to house the Dodge County Historical Society from 1953 to 1981. It is now home to the Beaver Dam Chamber Of Commerce.

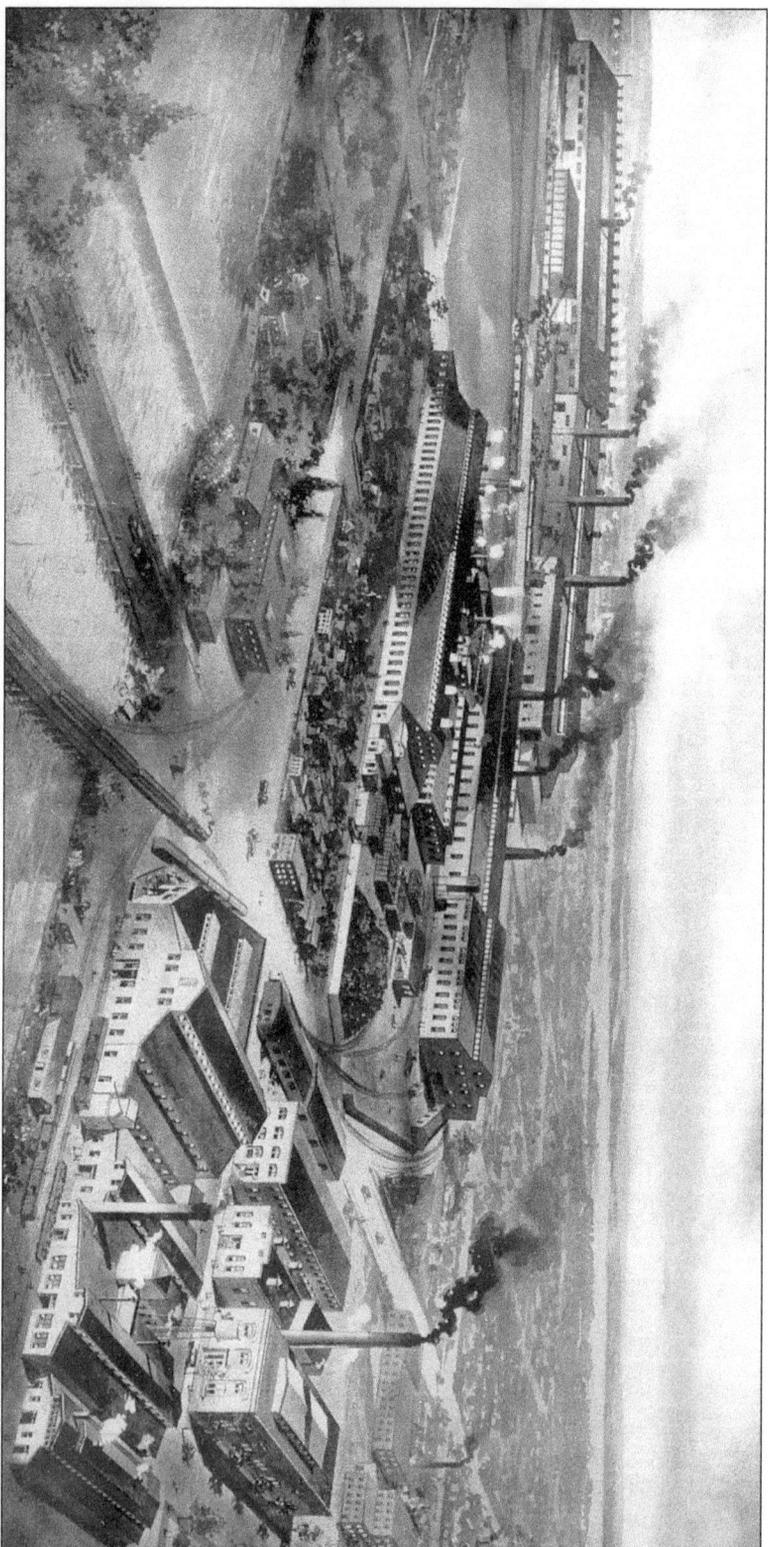

AERIAL VIEW OF WESTERN MALLEABLES, INC. In 1892, one of the most significant industries ever to call Beaver Dam home was established. It began as the Beaver Dam Malleable Iron Works Company. Originally begun as an adjunct to the Rowell Manufacturing Company's production of farm equipment, the company grew to titan proportions. Its name changed over the years, but was eventually called the Western Malleables, Inc.

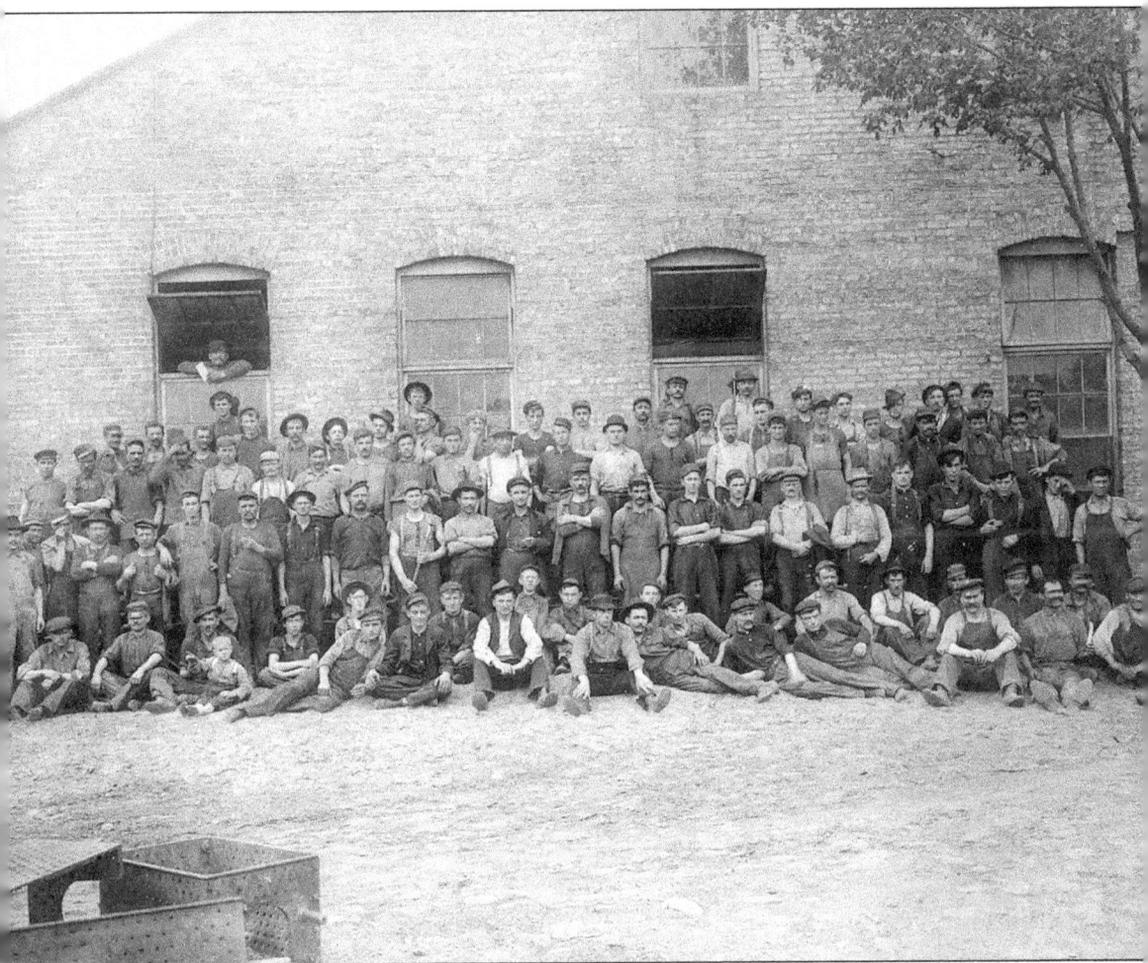

WESTERN MALLEABLES, INC. WORKERS. In its heyday, the company employed over 1,500 workers and acclaimed as one of the largest foundries in the United States. The employees pictured here worked in the Elm Street plant.

KELLER FARM. Beaver Dam is located at the center of Dodge County, Wisconsin. The county has long been known as the largest agricultural county in the state. The advent of the railroad coincided with the mass German migration of the 1850s. In droves, people of German ancestry descended upon Wisconsin and Beaver Dam. They became the backbone of its agriculture. Pictured here is the Keller farm located on Park Avenue. The house still stands as the only remnant of the farm.

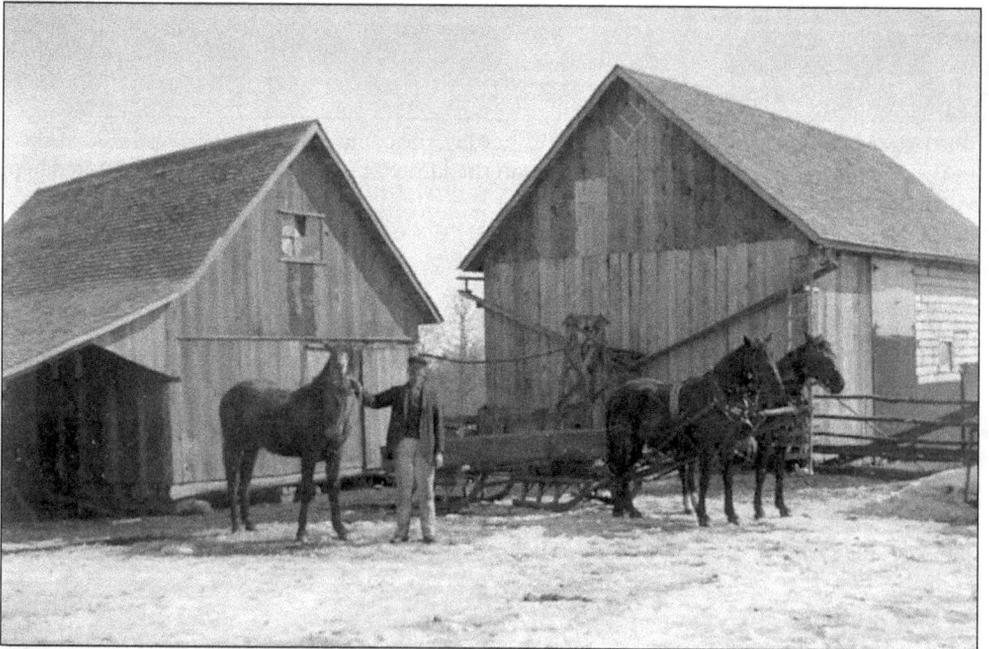

TERRY FARM. Farmer F.H. Terry stands in front of his barn and granary with horse Jumbo and plow team Dolly and Prince.

32

CLOUGH FARM. Frank Clough and Mr. and Mrs. Donald McLaughlin (son-in-law and daughter of Frank Clough) display the fine set of horse stock used to maintain the homestead. The house to the right is identified as the Parker home.

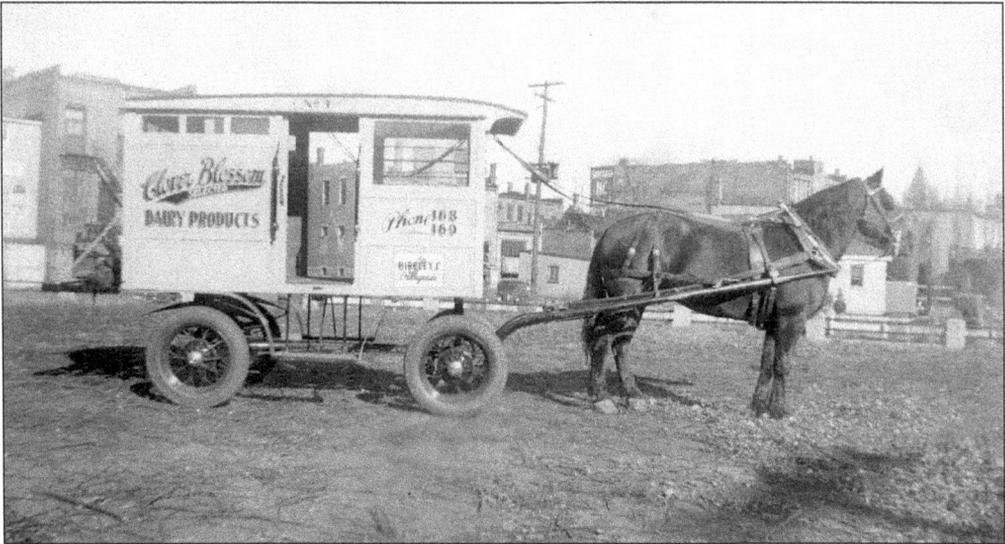

CLOVER BLOSSOM CREAMERY. The main focus of Beaver Dam agriculture was the dairy farm. To service these dairies, numerous creameries were founded. The earliest began in 1887 next to the Goeggerle Brewery on Madison Street. The plant was sold and moved to Parallel Street at the turn of the century. It was at this location that the creamery acquired the name Clover Blossom Creamery. The creamery expanded its operation to a new plant on South Center Street. In 1924, the South Center Street plant would be taken over by the Kraft Phenix Cheese Company.

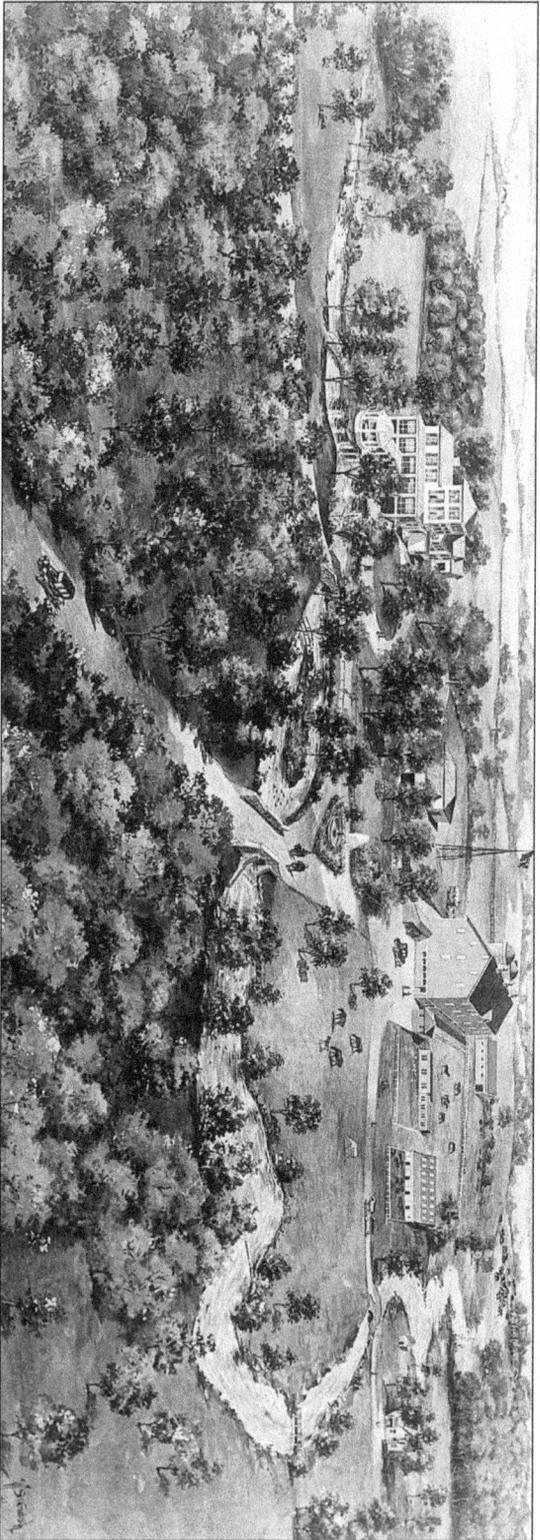

SPRING BROOK FARM. Located just outside the city, Spring Brook Farm was considered one of the finest farms in the state. Originally settled in 1842, it would be nearly 40 years before the acreage was turned into a gentleman farmer's paradise. In 1880, F.B. Sherman envisioned the 240 acres as a possible health resort. Never realizing his dream, Sherman did transform the property into a fine estate, constructing a palatial three-story colonial mansion. The estate changed hands over the years and deteriorated. In 1916, F.W. Rogers, a local industrialist, took title, reviving the farm to its previous splendor. Rogers added 40 acres and landscaped the entire grounds surrounding the manor.

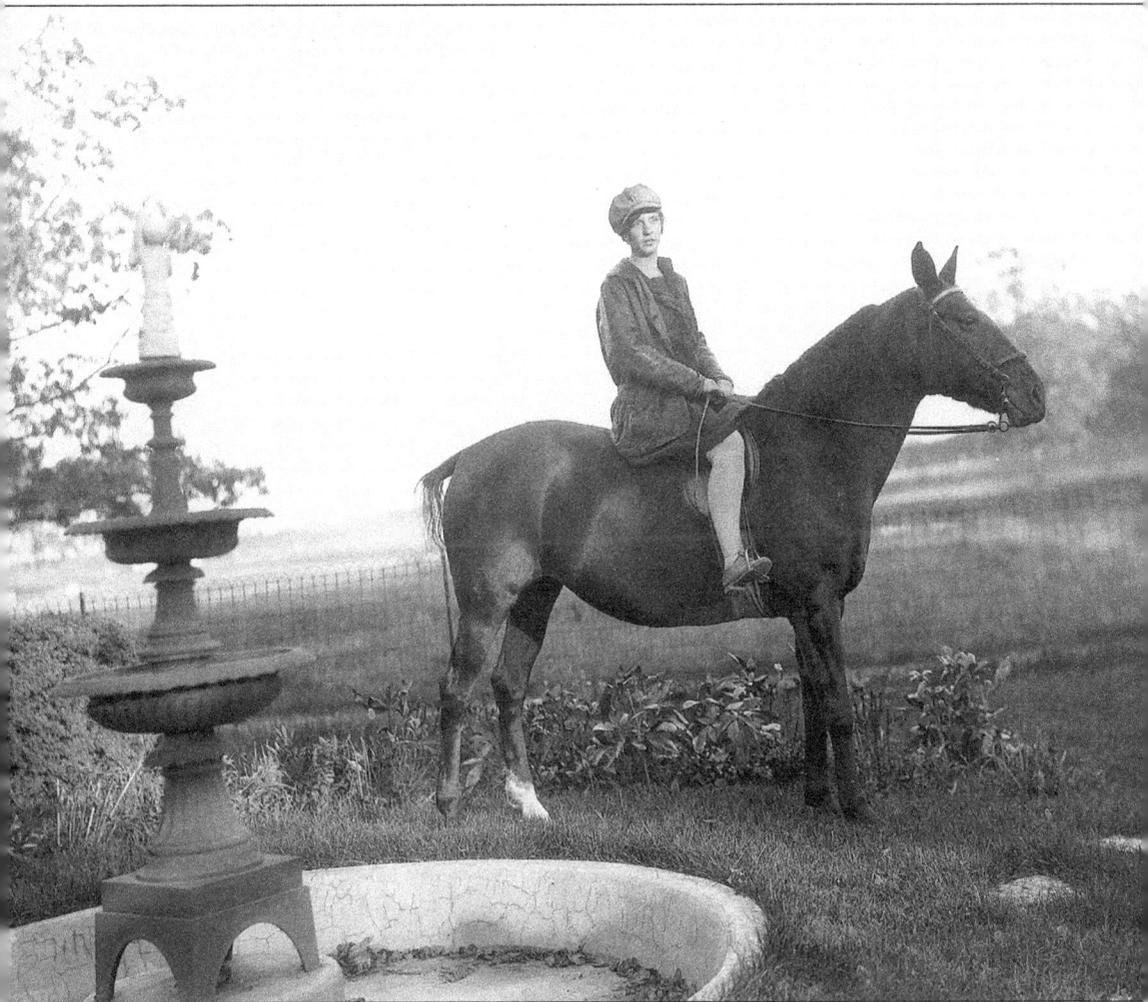

ANNE ROGERS AT SPRING BROOK FARMS. Spring Brook Farm housed one of the foremost stables in the country. Pictured above is Anne Rogers, daughter of F.W. Rogers, riding one of the many horses boarded at the estate.

DR. JOSEPH BABCOCK. Dr. Joseph H. Babcock arrived in Beaver Dam in 1850. He immediately engaged in the practice of medicine, partnering with Dr. Ezra Hoyt in the healing arts, and as his co-owner in the Old Corner Drugstore. He held the civic positions of town and city treasurer as well as school board member for 12 years. However, his greatest contribution was the construction of the Concert Hall.

THE CONCERT HALL. Built in 1856, this three-story brick building, a creation of the Babcock family, became the hub of all city activity for nearly a half century. Over the years, it would be the home of the city council, city library, roller rink, dancehall, numerous businesses such as the *Daily Citizen*, and of course, its main purpose, a venue for traveling entertainers. Luminaries such as Mark Twain, Tom Thumb, and Harry Houdini appeared there. Noted stock drama companies performed the standards of the day. Everything from *Uncle Tom's Cabin* to *Our American Cousin* graced the stages of the concert hall. It would take the arrival of the nickelodeon in the early 1900s to usher out Beaver Dam's concert hall era.

TOWN HALL TONIGHT TOME. In 1955, Dr. Babcock's grandson, Harlowe J. Hoyt, wrote what most critics consider the quintessential reference work about small town country theaters of the 1880s and 90s. Through personal recollections of his boyhood experience at the family's Concert Hall in Beaver Dam, Hoyt weaves a tale of what it was like to experience firsthand those festive days of traveling performing artists. The text is still required reading by numerous universities across the country that offer theater and history majors.

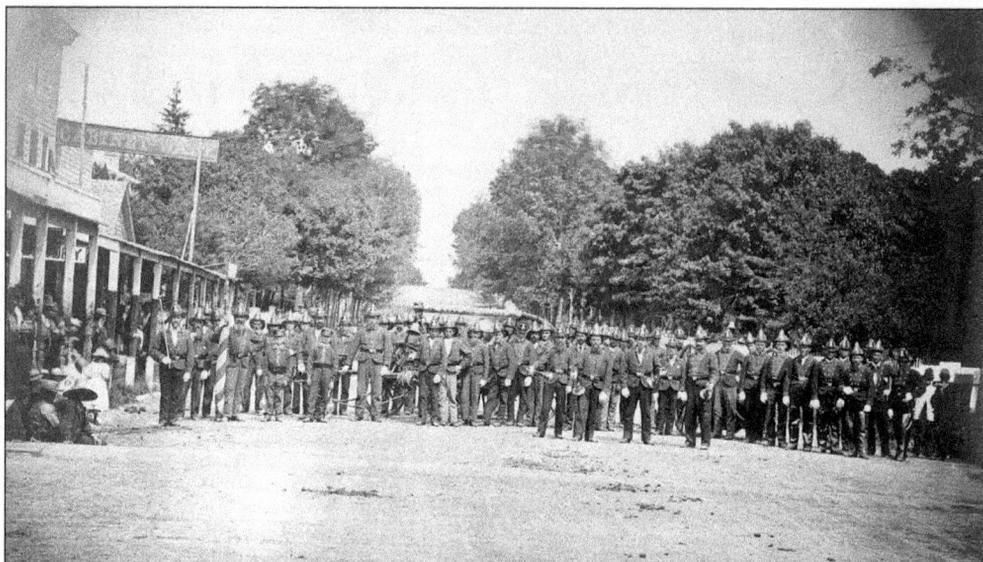

THE GERMANIA COMPANY. With the destruction of Beaver Dam's downtown in the great fires of 1863 and 1866, the need for a fire department was recognized. The Germans were the first to respond by establishing the Germania Fire Company in 1866, which comprised 93 volunteers. A pump was ordered and on May 6, 1867, "Old Able and Willing" arrived to the cheers of onlookers. It was housed in a small barn adjacent to the Cotton Mill on Madison Street. Within a year, a fire bell and tower were added. In 1878, the Germania merged with the newly formed Hook and Ladder Company No.1. Theodore Huth was the first chief.

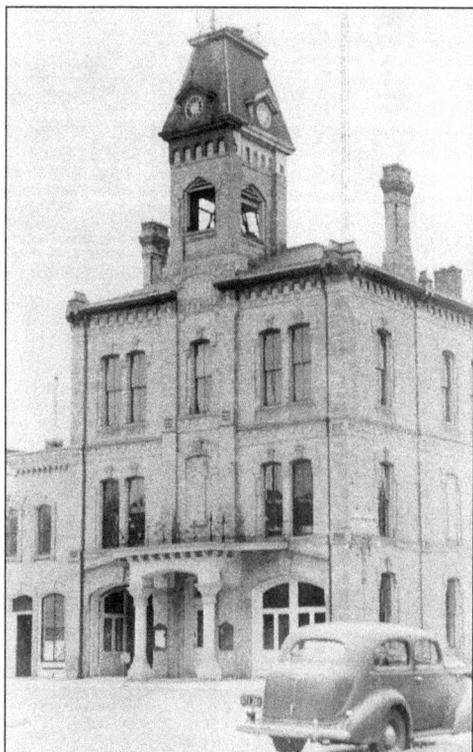

CITY HALL. In 1880, the city unveiled its most recent jewel, the new city hall, located at the corner of Spring and Maple. The three-story brick building housed city government, as well as the water, engineering, police, and fire departments. It also served as the home of the library and skating rink.

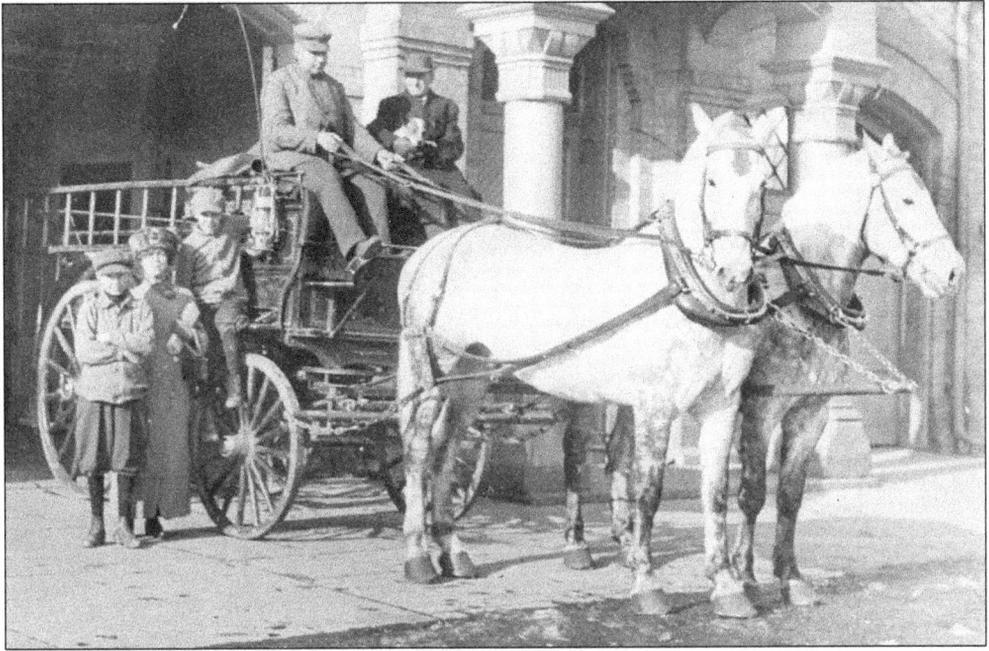

HORSE DRAWN FIRE TRUCK. The fire department eventually outgrew its Madison Street Barn and relocated to city hall. Horse drawn hose and ladder trucks replaced Old Able and Willing, but the city did not have the horses to pull the trucks, so a system was devised that upon the ringing of the fire bell, local team owners would race to the station to hitch their teams to the trucks. The owner of the first team to reach city hall received $5; the second team, $3. Needless to say, the race to the station was frequently more exciting than the fire itself. The station sometimes hosted boisterous confrontations between team owners debating who arrived first. But by the time of this picture in 1917, the city had purchased its own teams of horses. The woman in the picture is identified as Ida Roedl. The driver is George Sage.

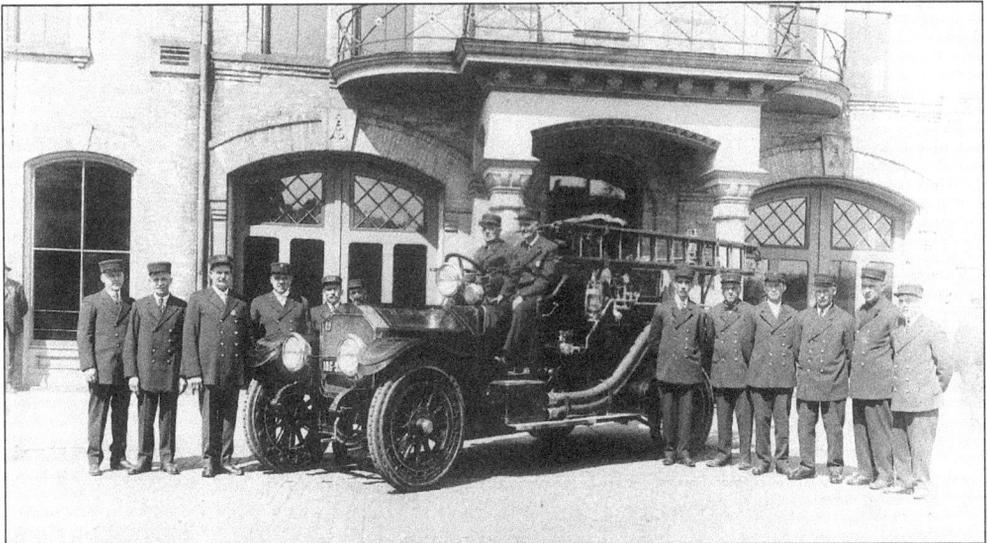

DOWNTOWN MERCHANTS FIRE CREW. Horse drawn fire trucks were replaced by motorized fire trucks as a new hose truck arrived in 1919 and a new hook and ladder truck in 1924.

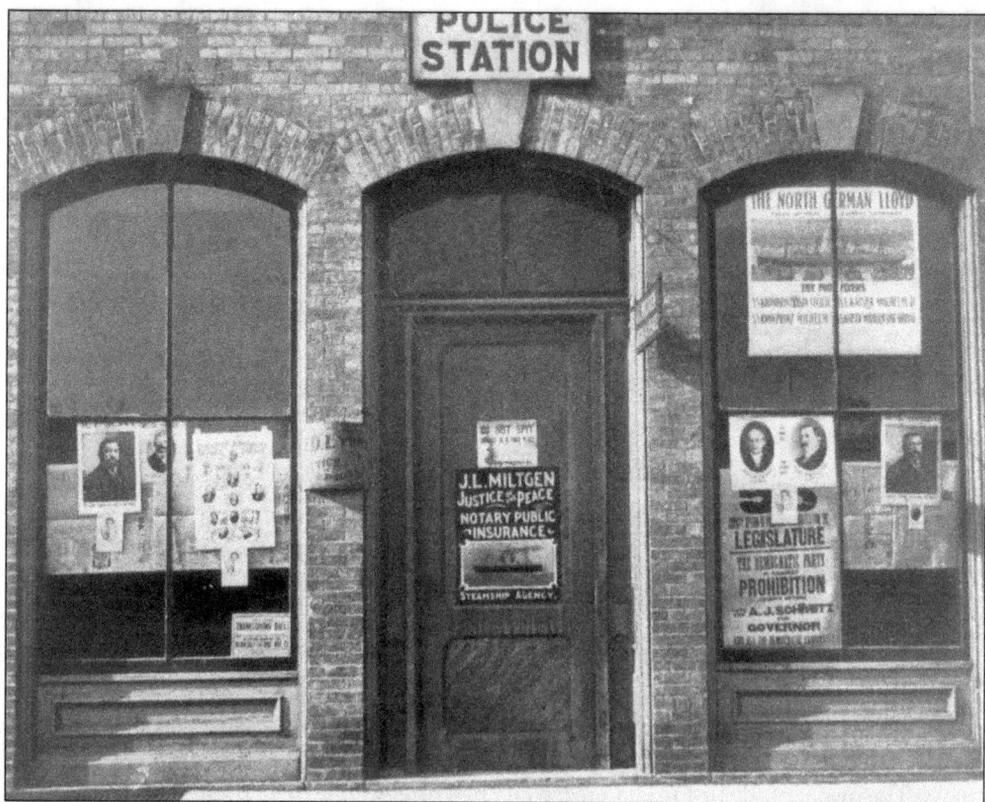

THE POLICE STATION. The new city hall would also be the home of the police station. Just behind city hall stood the jail.

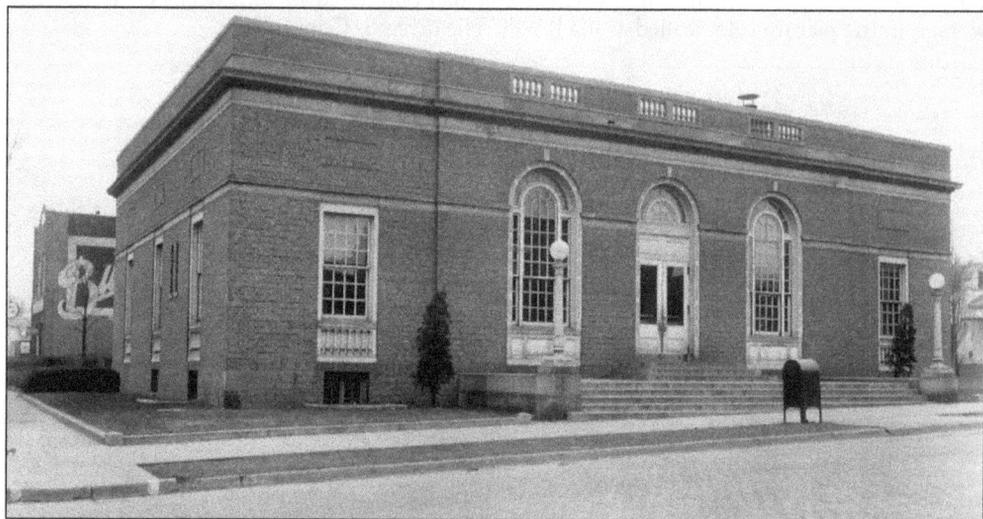

THE POST OFFICE. The conclusion of the 1910s would see the opening of the new Federal Post Office at the northwest corner of Spring and Maple. The building was noted for its ornate marble pillars and floor. This federal building exemplified a long tradition beginning back in 1844, when the transition from P.O. box pickup to city door to door service began, which ultimately evolved into rural route delivery in 1902.

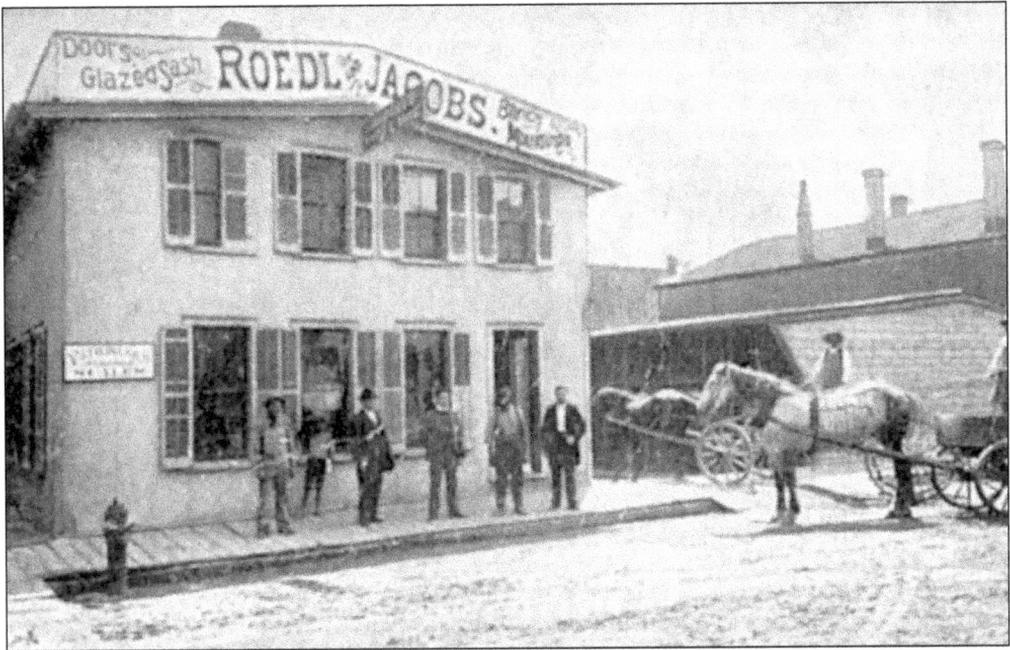

ROEDL & JACOBS LUMBERYARD. Directly across the street from city hall stood the Roedl & Jacobs Lumberyard. This enterprise commenced in 1887 under the name Roedl, Jacobs & Hall Lumberyard. John W. Hall left the partnership in 1893. The company offered a choice supply of lumber, building materials, and fuel. The building shown here was razed and replaced by the Hotel Rogers in 1924.

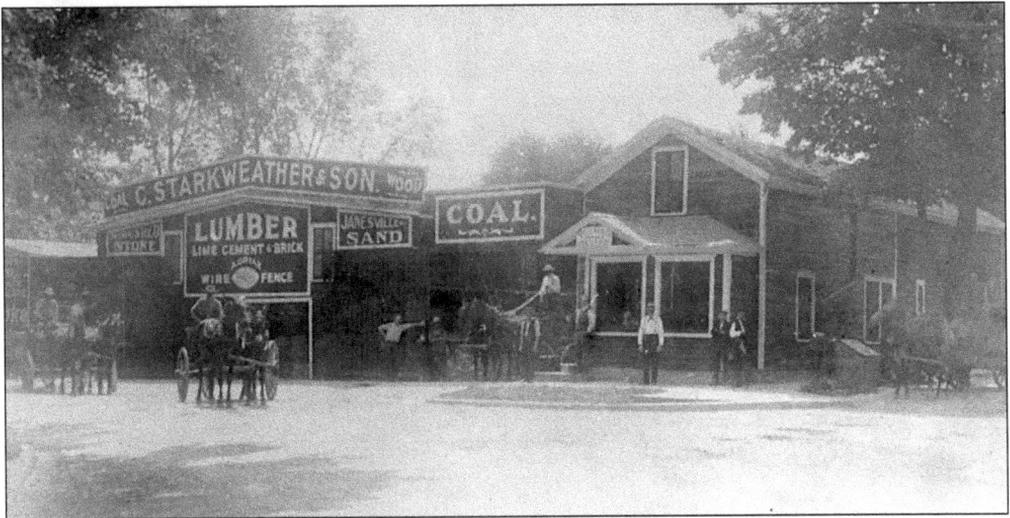

C. STARKWEATHER & SON LUMBERYARD. Just three blocks north of the Roedl & Jacobs Lumberyard sat C. Starkweather & Son Lumberyard. Its owner, Courtney Starkweather, arrived in Beaver Dam in 1874. It was in that year that he partnered with Mr. Cleveland to establish the Starkweather & Cleveland Lumberyard. In 1900, Starkweather purchased Cleveland's share and withdrew from the business, leaving the management of the firm to his son, Charlie. In 1909, the company incorporated under the name C. Starkweather & Son, Inc. The company was well known for its lumber, building materials, and coal delivery.

41

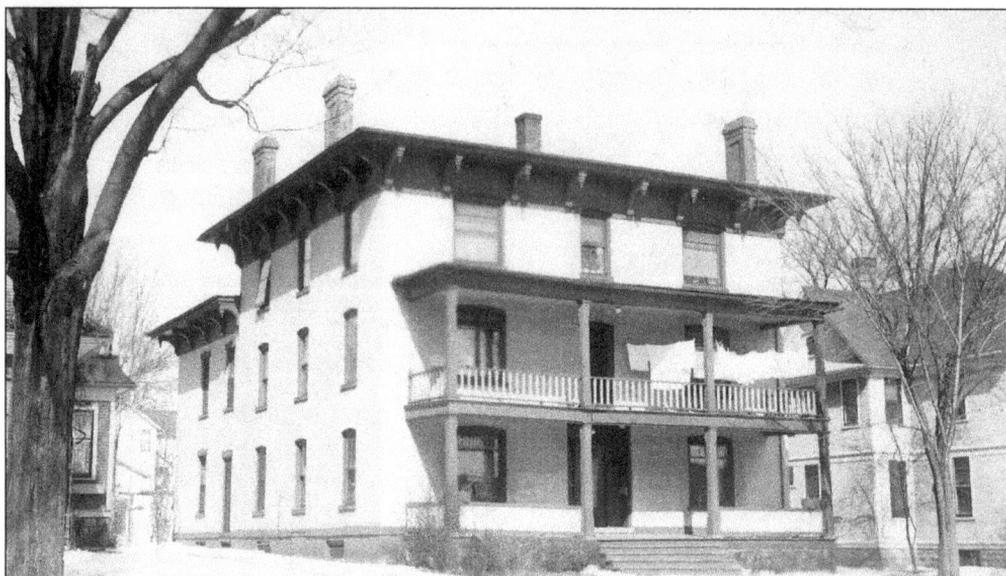

BEAVER DAM'S FIRST HOSPITAL. Beaver Dam's original hospital cared for its first patient in 1912. The 2-story Bogart manor at 212 West Maple was renovated into a 3-story, 21-room facility.

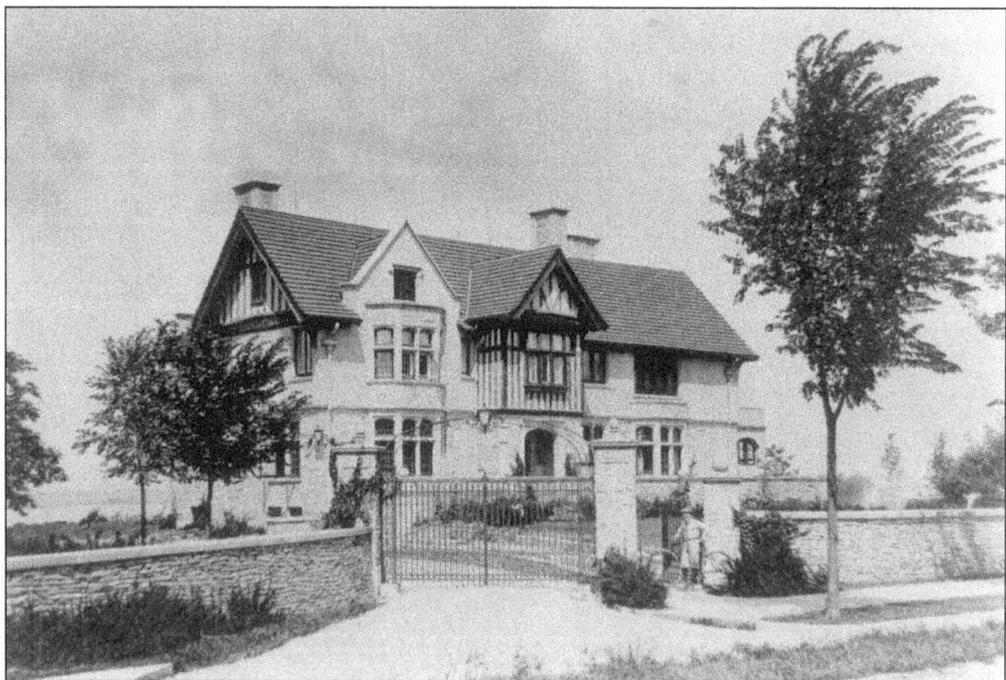

THE LUTHERAN DEACONESS HOSPITAL. Beaver Dam's first hospital closed its doors in 1920. This necessitated a quick search for a replacement. The answer came from the Lutheran Deaconess Association. The Association agreed to run the hospital if Beaver Dam businessmen raised the funds necessary to build and equip the new health center. In 1922, the Lamoreaux mansion on Lacrosse Street was purchased. Renovations to the building were completed by January 29, 1922, its opening day.

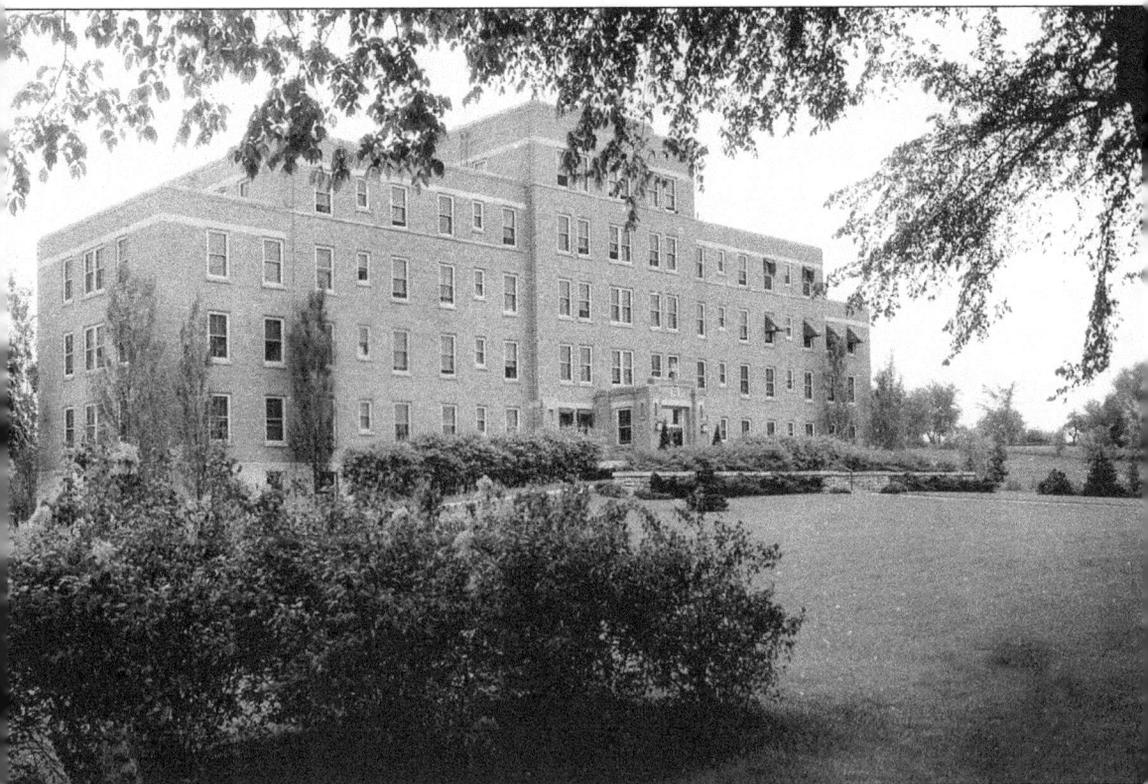

ST. JOSEPH'S HOSPITAL. St. Joseph's Hospital, a 60-bed facility on University Avenue, was erected in 1938. The five-story care center was financed by contributions of $50,000 from local residents and $150,000 from the Sisters of St. Francis of Milwaukee, who then ran the day-to-day operations.

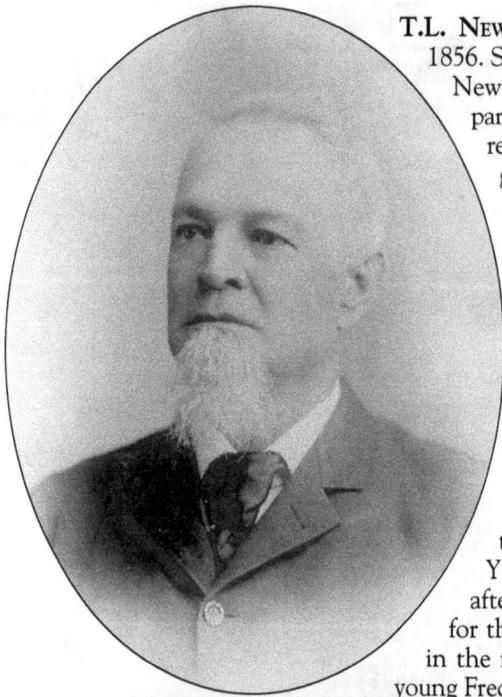

T.L. NEWTON. T.L. Newton arrived in Beaver Dam in 1856. Starting as a clerk in the A.P. Lawrence Grocery, Newton opened his own grocery store within a year in partnership with Horace Damon. In 1865, Newton removed himself as a grocer to concentrate on general merchandising. For the next 35 years, he maintained a store of the highest quality and retired in 1900. But the Newton name would remain on Front Street storefronts for the next six decades.

Below: **THE NEWTON Y.M.C.A.** T.L. Newton's service to the community even survived his death. After his death in 1920, his will provided for the Newton homestead to be donated to the local chapter of the Y.M.C.A. The Meta Newton Y.M.C.A., named after Newton's deceased daughter, served the City for the next 60 years. For those celebrity watchers, in the first row, standing second from the right, is a young Fred MacMurray.

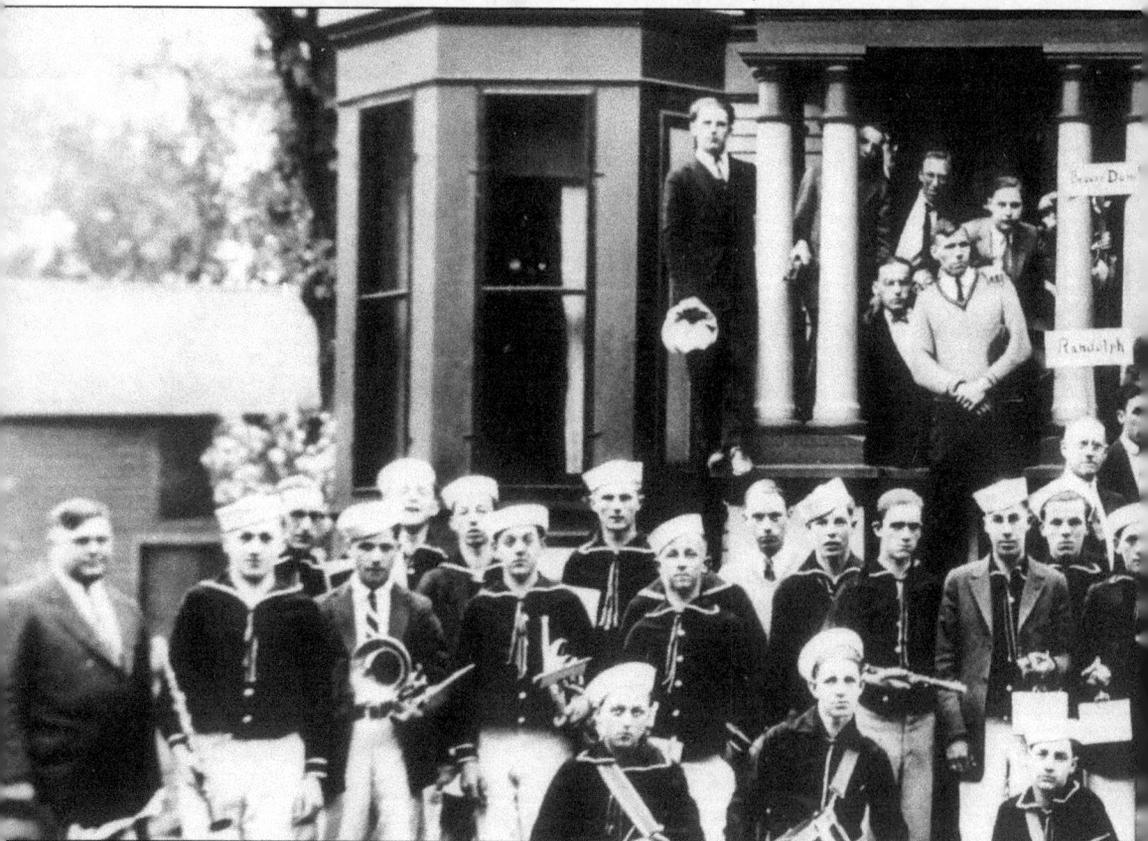

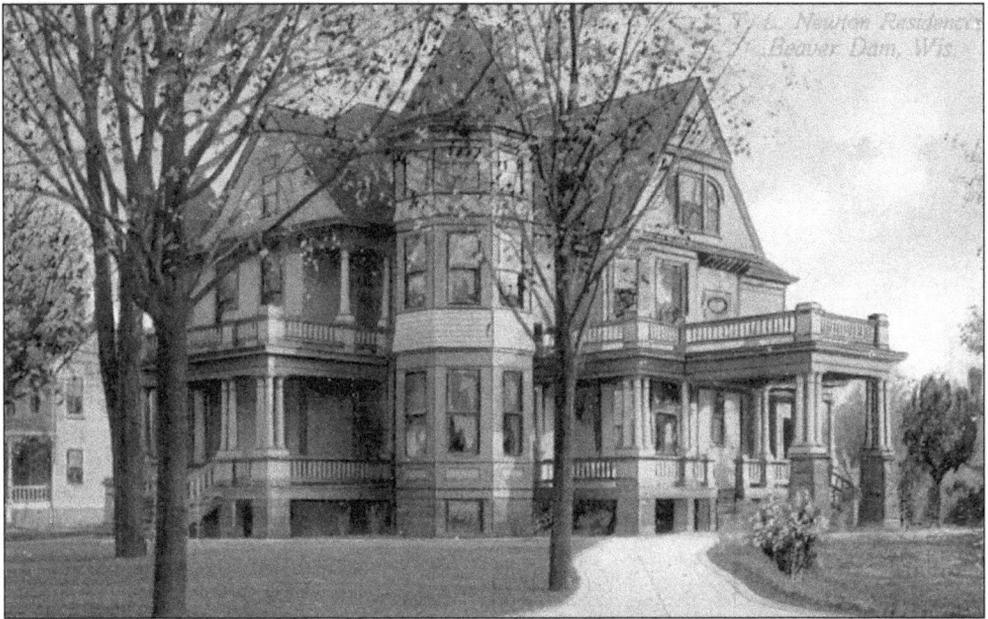

THE NEWTON MANSION. One of the finest houses in the city, the Newton home lay in the middle of the 100 block of Park Avenue.

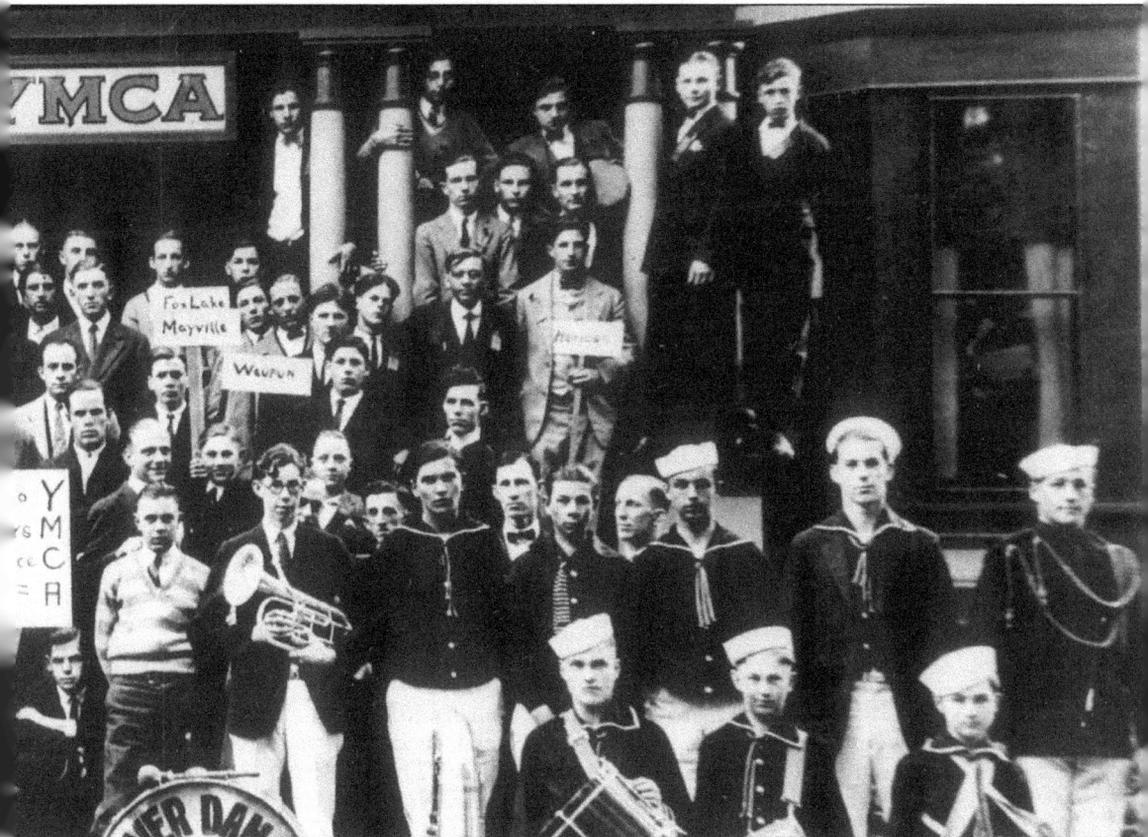

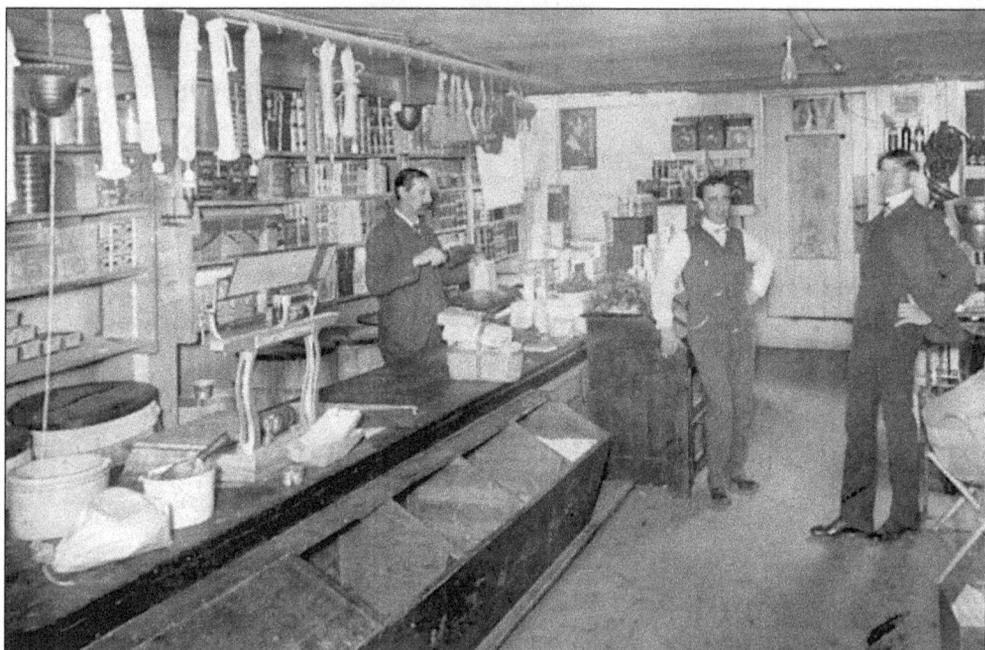

NEWTON-WENZ BASEMENT GROCERY. For more information on Newton see previous page. Picture taken *c.* 1904. The man in the middle is George Elser.

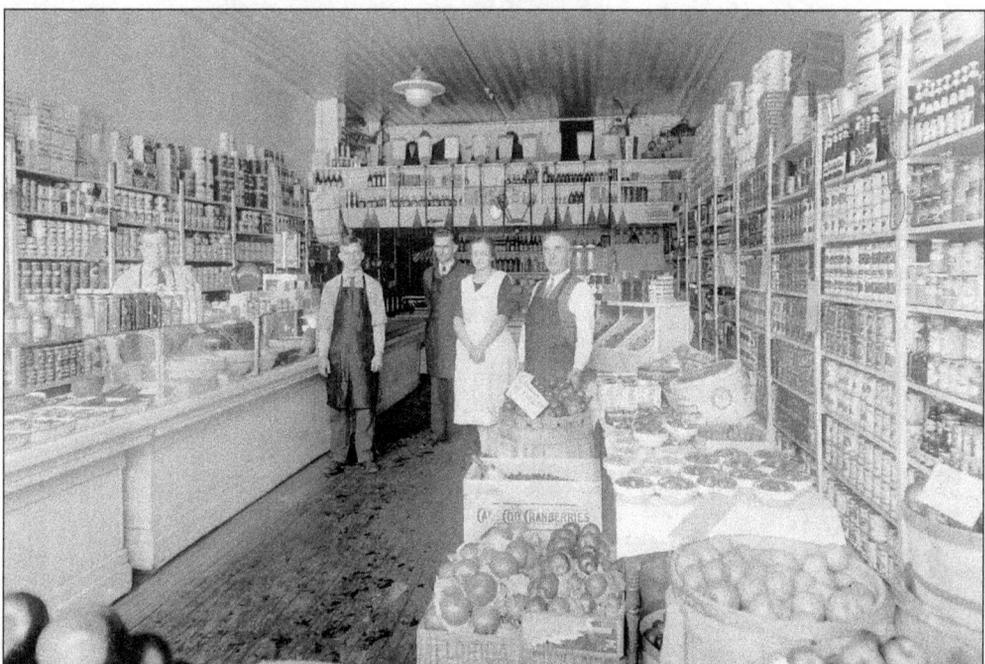

ELSER'S GROCERY. George Elser arrived in Beaver Dam in 1903. For four years, he worked for the Newton & Wenz Company Grocery. In 1907, he commenced his own store on North Spring. One year later, the enterprise moved to 144 Front Street. The Elser name would be connected with Beaver Dam grocers for over 20 years. Pictured from left to right are Elmer ?, Alex ?, Harold Elser, Florence ?, and George Elser.

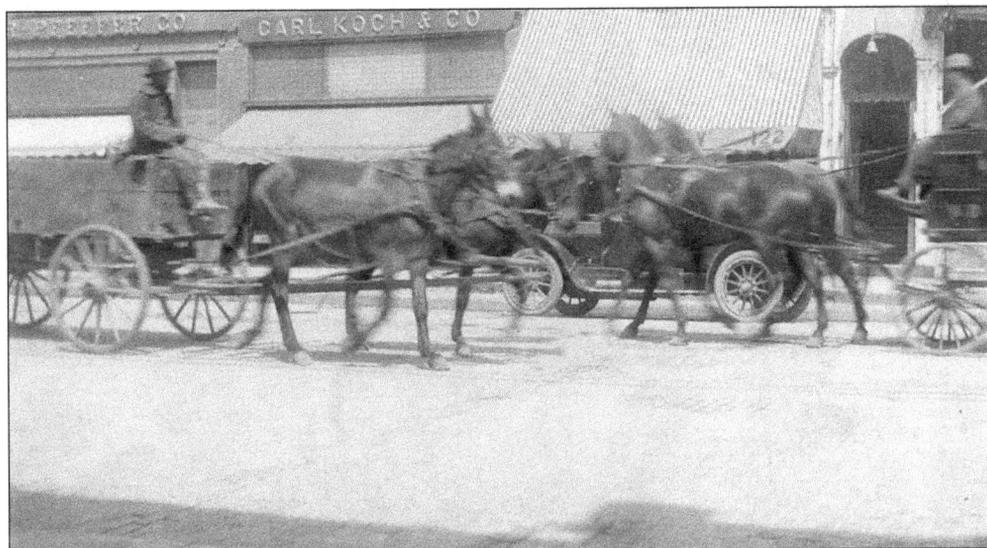

FRONT STREET, C. 1910. Shown here is a typical scene of Front Street just prior to World War I. Pictured are two of the finest and longest running clothing stores, Zander & Pfeffer and Carl Koch & Co.

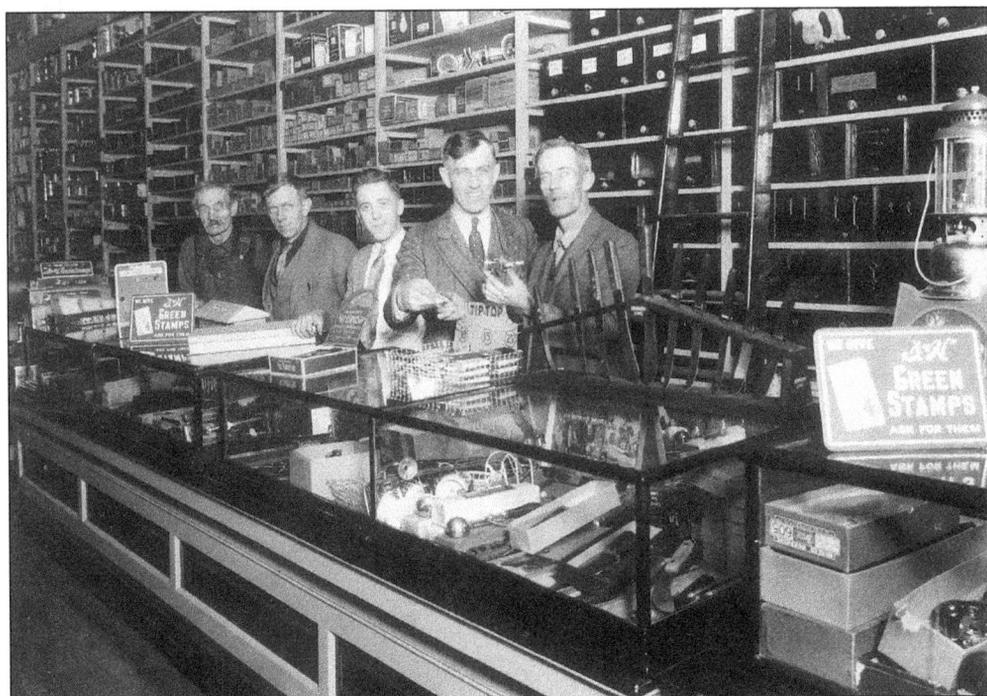

VOLKMANN HARDWARE. Both Art and brother Ed Volkmann worked as bartenders during the early years of the 1910s. Then in the mid-1910s, the brother team ventured into hardware as they opened Volkmann Hardware at 114 North Spring Street. This picture, taken in 1919, shows staff and ownership. From left to right are Chas. Sitzkorn, Ed Volkmann, Gilbert Bauer, Art Volkmann, and George Owens.

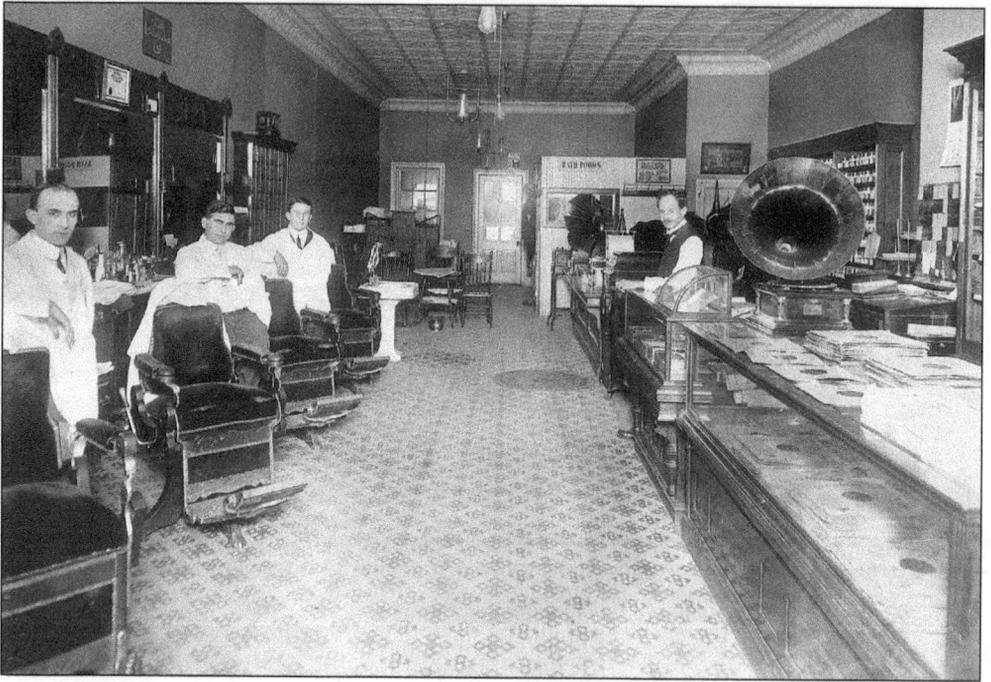

LAMBECK BARBER SHOP & MUSIC EMPORIUM. Lawrence Lambeck was one of the first merchants to recognize the potential of the new Victrola records. His four-man barbershop soon became a multi-purpose store offering the latest in Edison cylinders and Victor 78s. Pictured above from left to right are Wm. Haider, James Mantes, Elmer Schmiler, and Lawrence Lambeck. Picture taken c. 1912.

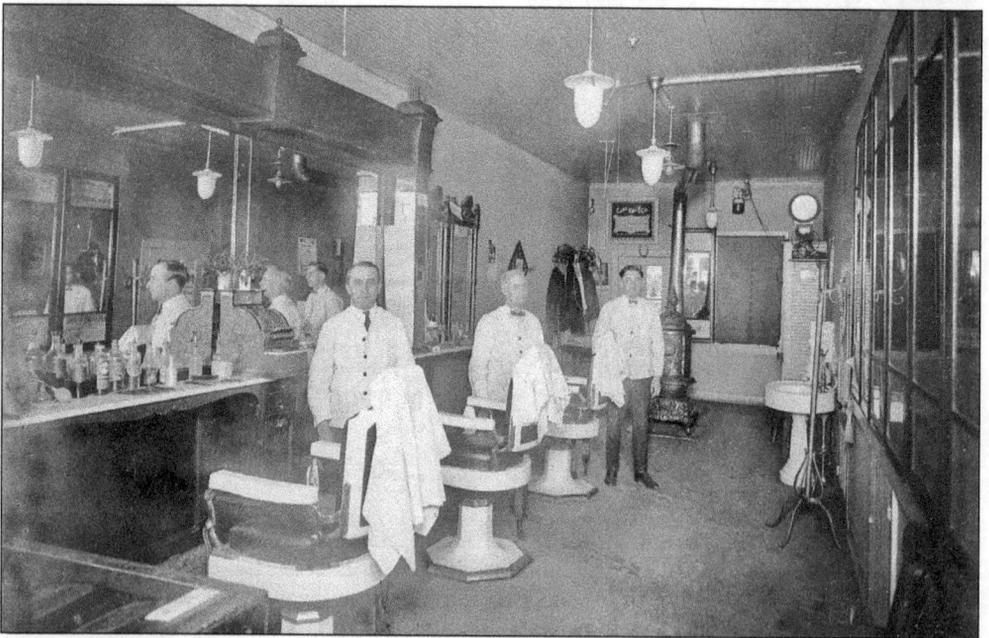

FRANKE'S BARBER SHOP. This barbershop was located at 400 South Spring Street c. 1928. The barbers, from left to right, are Richard Rake, George Keefer, and Joe Yaroch.

BEAVER DAM'S FIRST COMMERCIAL AUTOMOBILE. Sam Rowell, President of the Rowell Manufacturing Co., purchased this 1902 Rambler in Kenosha, Wisconsin. The couple pictured in the car is George Rowell and Helen Shepard Spry. This car can be viewed at the Dodge County Historical Society Museum.

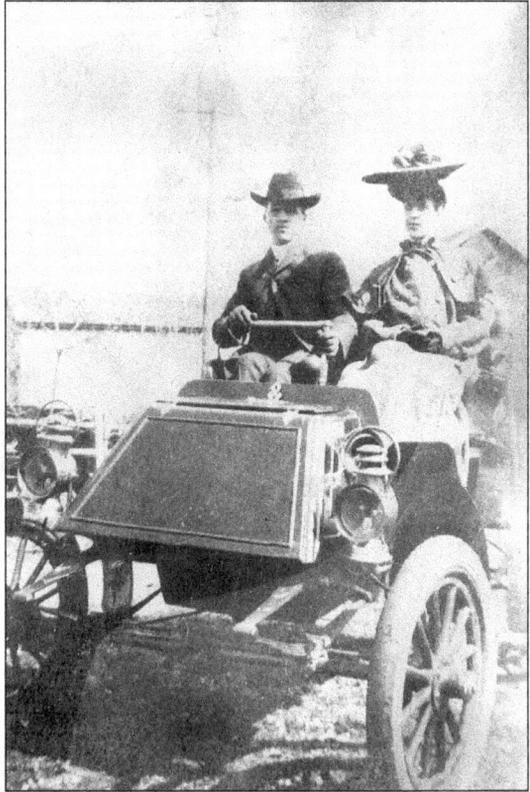

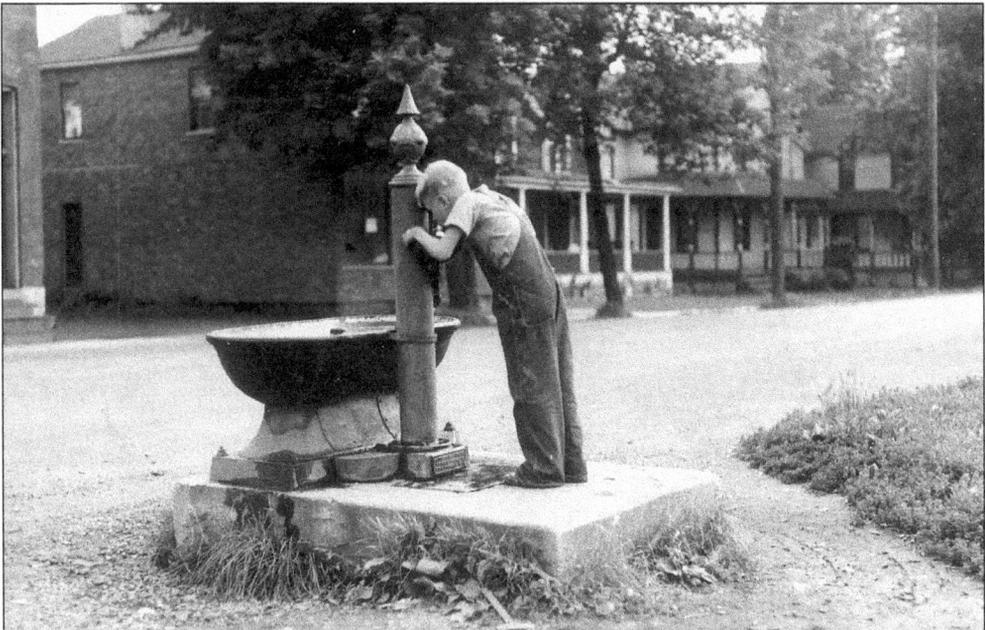

HORSE TROUGH AND WATER FOUNTAIN. With the arrival of the automobile, the horse troughs and water fountains as pictured above disappeared from the Beaver Dam landscape. The picture was taken at the corner of Mill and Center in the early 1900s.

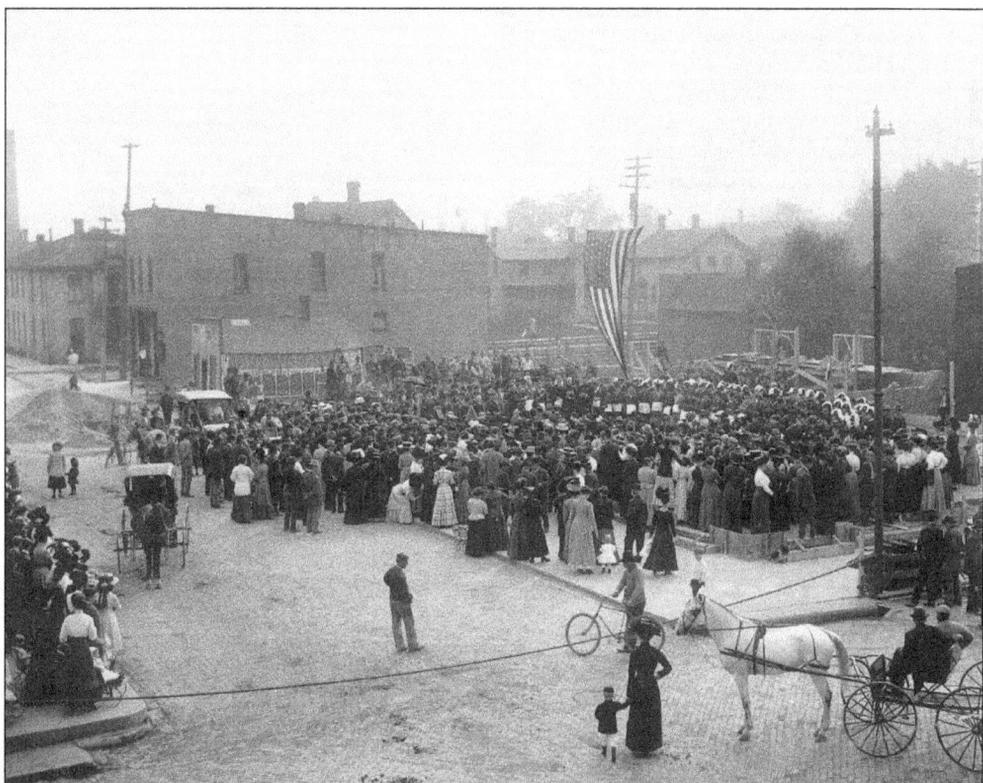

DEDICATION OF MASONIC TEMPLE. In 1911, the Masons constructed one of the cornerstones of Beaver Dam's downtown. Located on the southwest corner of Front and Center, the building would be home to numerous shops throughout the years.

COMPLETED MASONIC TEMPLE BUILDING. Picture *c.* 1920.

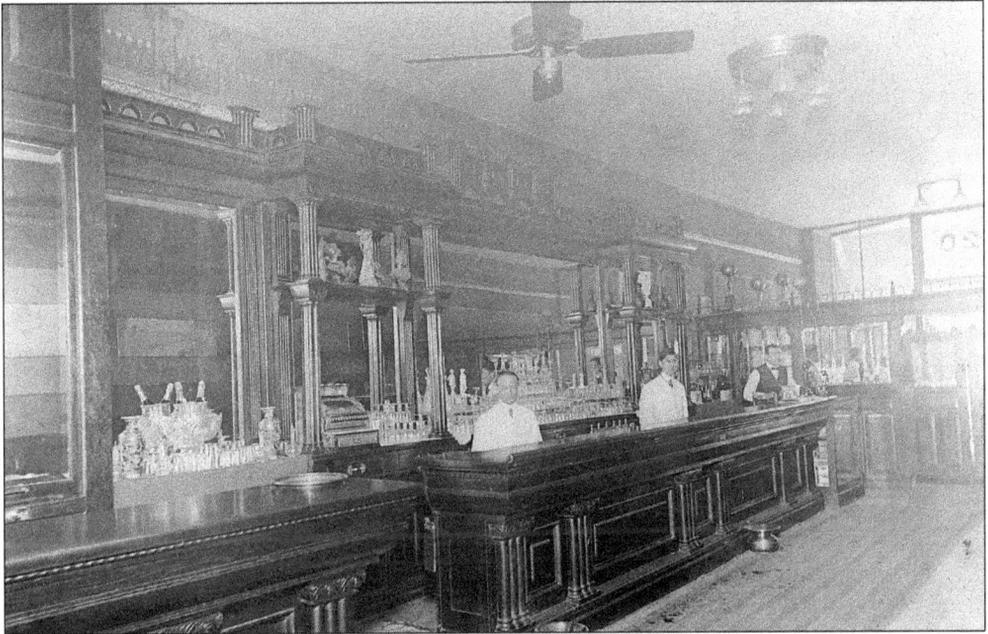

JACOB MARTIN'S SALOON. Jacob Martin arrived in Wisconsin in 1849. He dabbled in many enterprises: farming, milling, operating a cooper-shop, owning the Bon Ton Bottling Works and the saloon pictured here, located at 120 Front Street. Appearing in this 1914 photo, from left to right are John Kohler, Arthur Martin, and George Zepp.

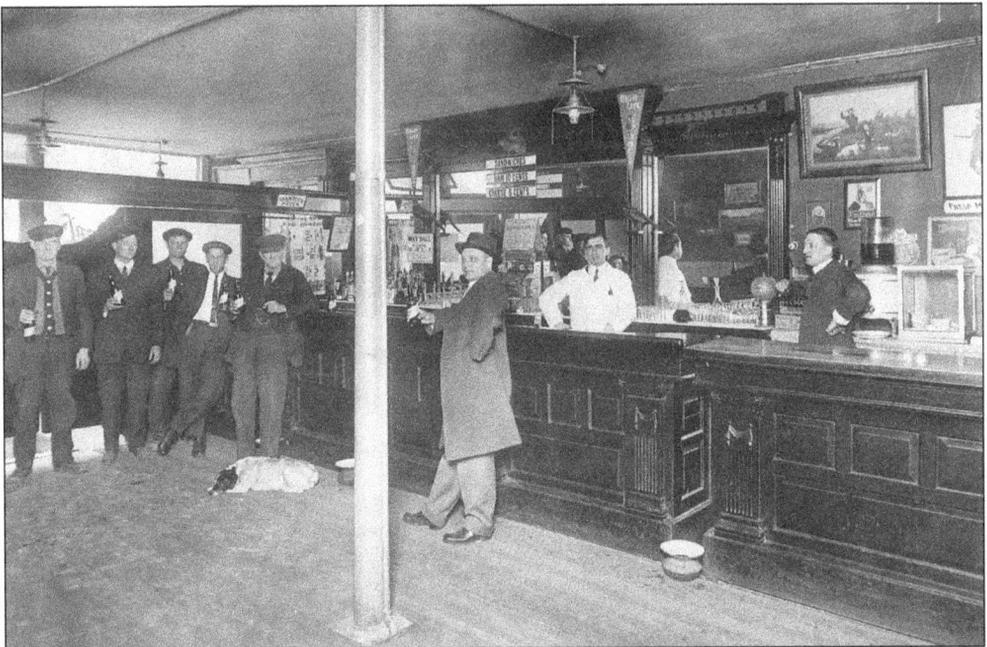

HOPF TAVERN. Located at 111 Front Street, the Henry Hopf Saloon was another favorite watering hole in 1912. From left to right are Andy Black, Joe Hartl, Zeke Zellinger, Alvin Dimel, Chas. Hopf, Aug Monti, and bartenders Mike Kohler and Heinie Hopf. The dog's name is Troubles.

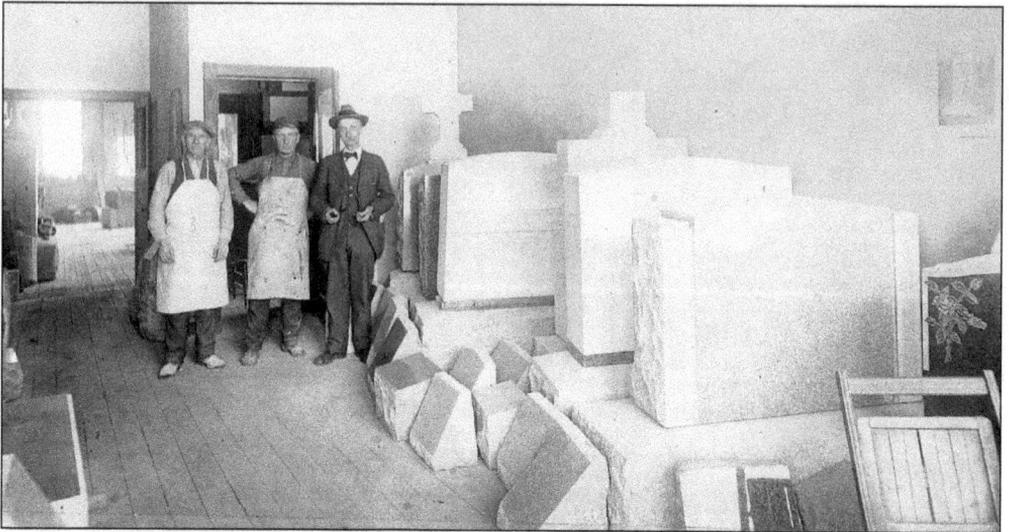

BEAVER DAM MONUMENT CO. Joseph D. Hillier was born in Fox Lake in 1858. An accomplished marble cutter, he took over the business of Turner, Miller & Blumenthal in Beaver Dam in 1910, changing the name to Beaver Dam Monument Co. The company was located at 110 Park Avenue, across from the Williams Free Library. It would continue for decades and eventually ownership passed to Joseph's son, Ira. Pictured from left to right are John Hoefs, Ira Hillier, and Joseph D. Hillier.

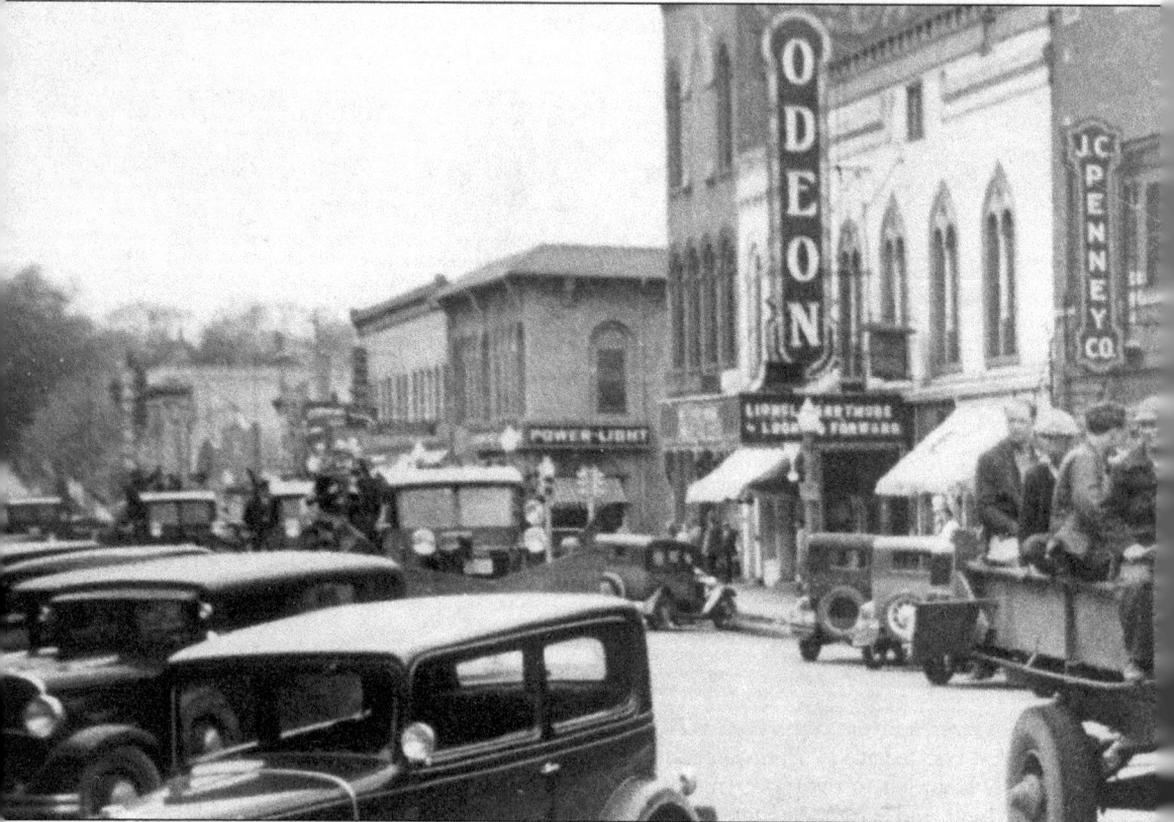

THE ROGERS PHARMACY. In the early decades of the 20th century, Beaver Dam's downtown was primarily occupied by groceries, clothiers, and drug stores. Here is an example of one of those pharmacies. The Rogers Pharmacy, owned by Joseph Rogers, was located at 105 Front Street. Picture c. 1914.

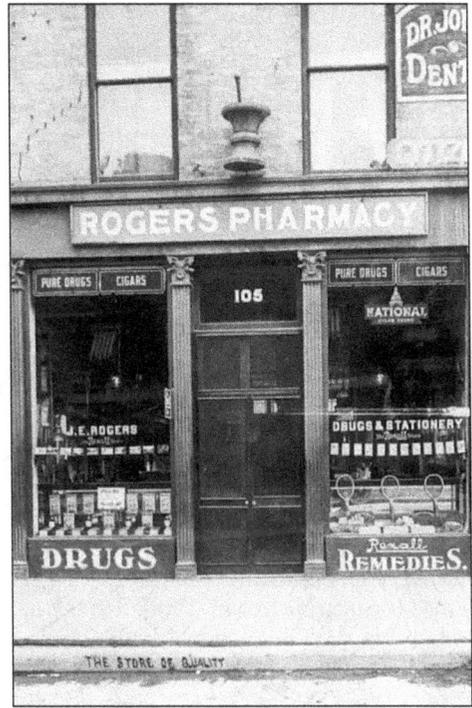

Below: MACHINERY ON PARADE. This 1933 picture of downtown Beaver Dam is representative of the development of the downtown after the turn of the Century. In the 1910s, the New Odeon would transform from a small-time nickelodeon to a premier movie palace accommodating 1,000 theatergoers. The 1920s saw an influx of chain stores like the J.C. Penney Co. In the 1930s, downtown development ground to a halt, and the Old National Bank building was the only new structure erected during that time.

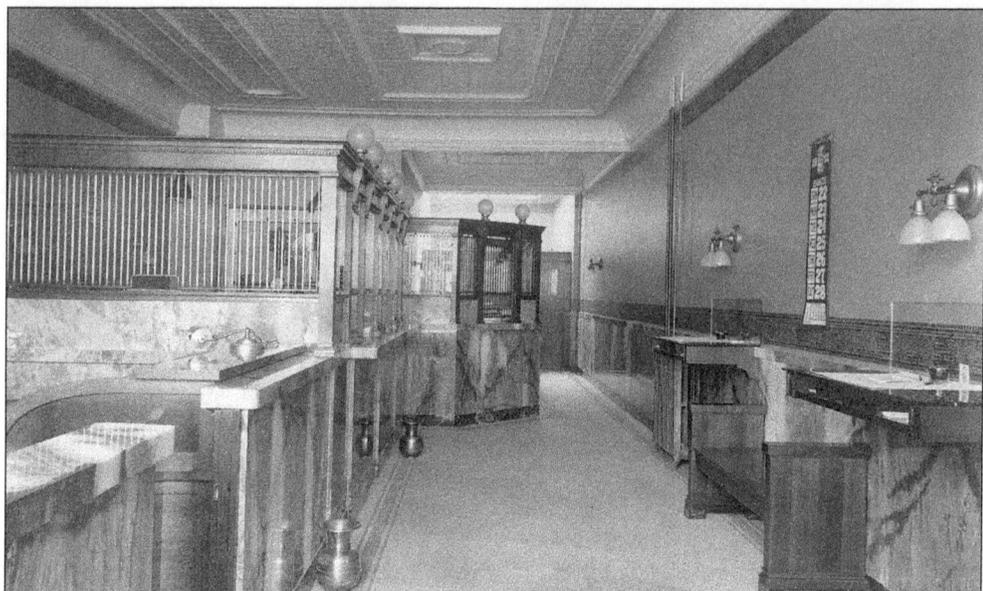

THE GERMAN NATIONAL BANK INTERIOR. Beaver Dam residents were limited to the city's only bank, the Old National Bank, until 1891 when the German National Bank opened its doors. The Bank's interior (pictured here in 1912) was known for its lavish marble inlay. At the beginning of World War I, anti-German sentiment was so strong that the German National Bank changed its name to the American National Bank.

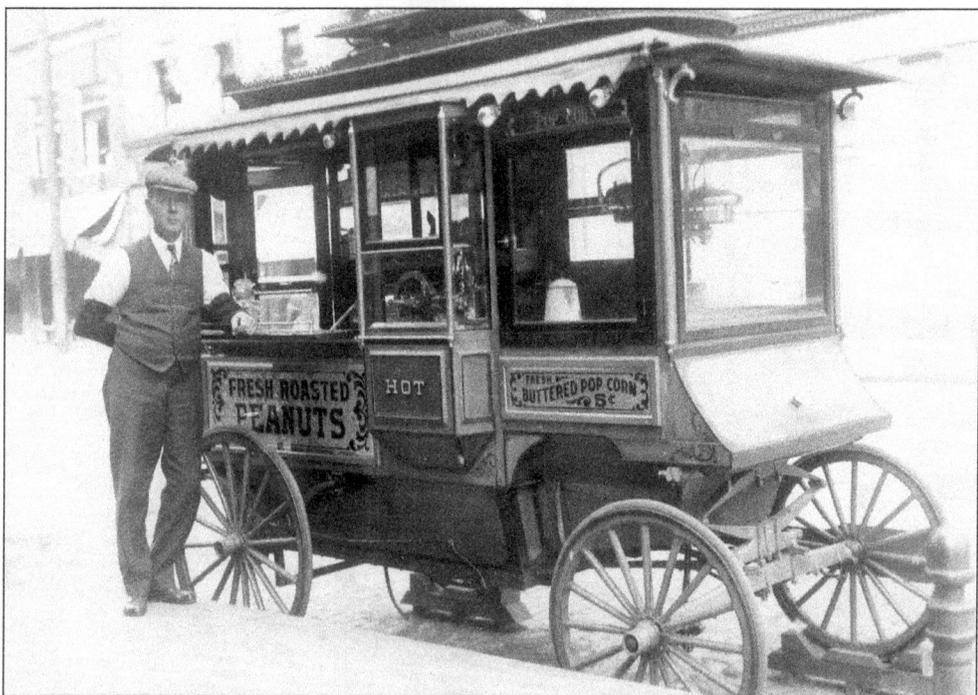

FRANK ROWELL'S POPCORN WAGON. Located at the corner of Front and Spring, the popcorn wagon was a favorite stop for child and adult alike. Frank Rowell is pictured next to his wagon in 1914.

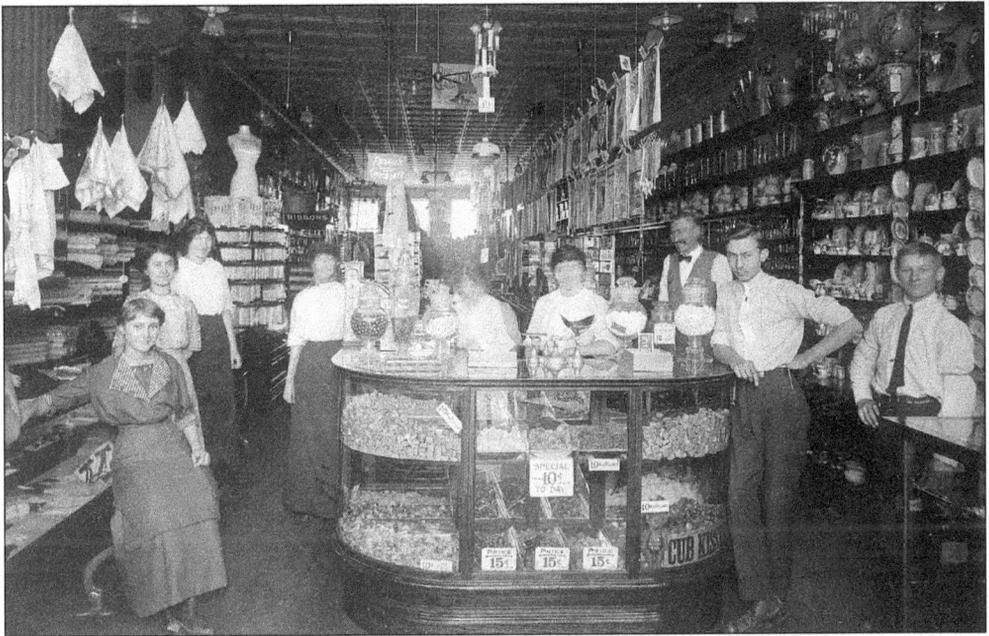

BECKEN'S SUCCESS STORE DEPARTMENT STORE. W.H. Becken journeyed to Beaver Dam in 1903 to establish a jewelry business. After proving himself successful in this adventure, he sold the company in 1909 and opened a general merchandise store, the Success Store. The store prospered through the 1920s.

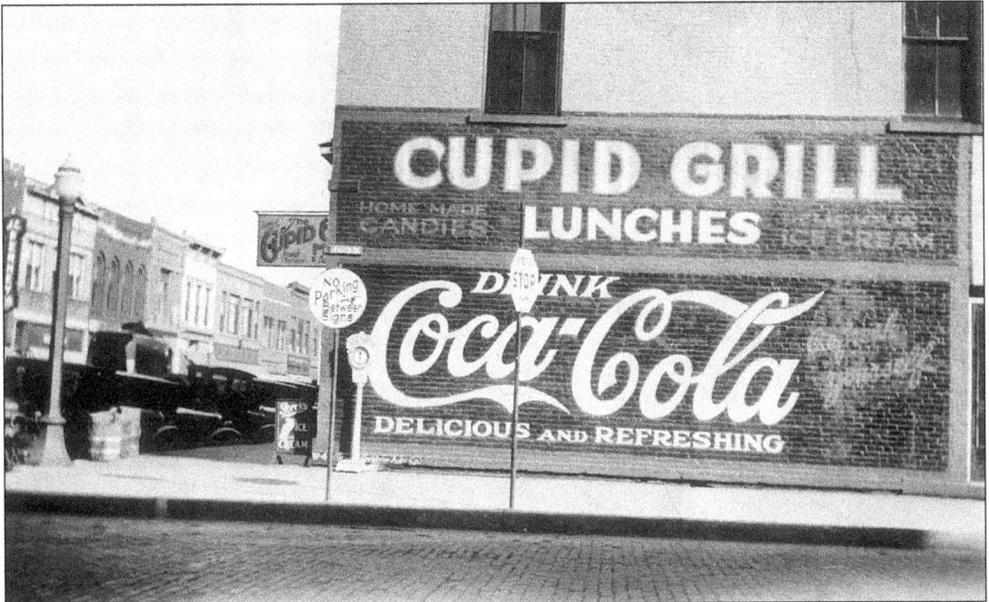

THE CUPID GRILL. Over the decade of the 1920s, the downtown would play host to many restaurants and diners. Establishments with names like the Green & Gold, Palace Quality, and the Wedge were staples of Front Street. And one of the most popular was the Cupid Grill, situated at the corner of Front and Center.

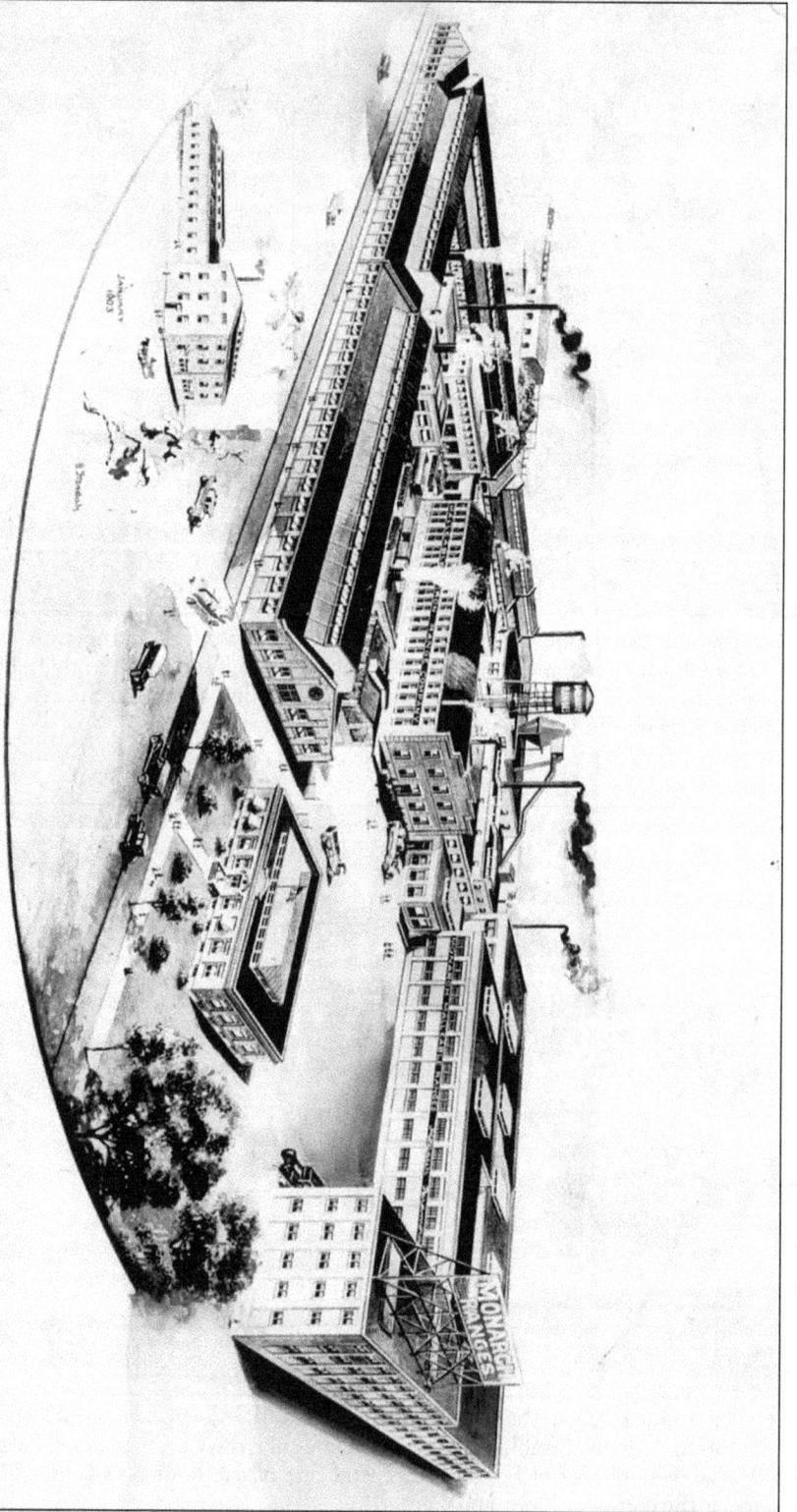

THE MALLEABLE IRON RANGE COMPANY. In 1903, the relocation of an Omaha, Nebraska industry by the name of Dauntless Manufacturing Company would prove to be Beaver Dam's most significant business concern over the next 60 years. The firm would soon change its name to the Malleable Iron Range Company.

THE MONARCH STOVE. The Malleable Iron Range Company's initial foundry on Spring Street would grow into the manufacture of the world-renowned Paramount and Monarch stoves. The stove would earn a reputation for unsurpassed reliability. Its greatest test would come when Admiral Byrd specifically requested a unit be designed for use on his expedition to the South Pole in Antarctica.

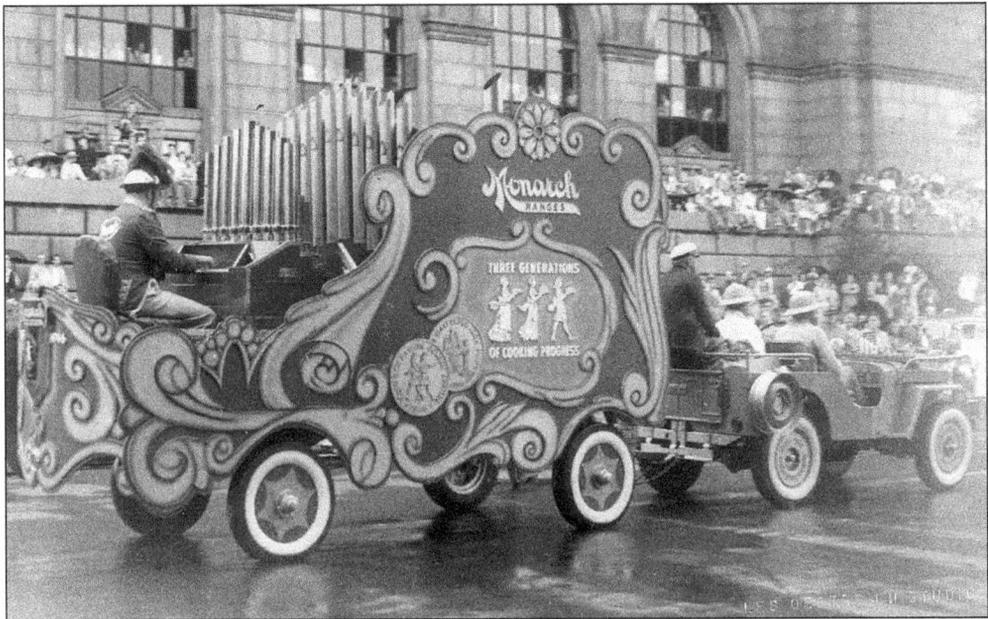

THE MONARCH CALLIOPE. The Malleable Iron Range Company supported the Beaver Dam community in numerous ways. One example was the creation of the Monarch Calliope. The calliope was made available for any special event being held in the city and nearby area. Otto Windy Jacobs is the musician most fondly remembered for playing the instrument.

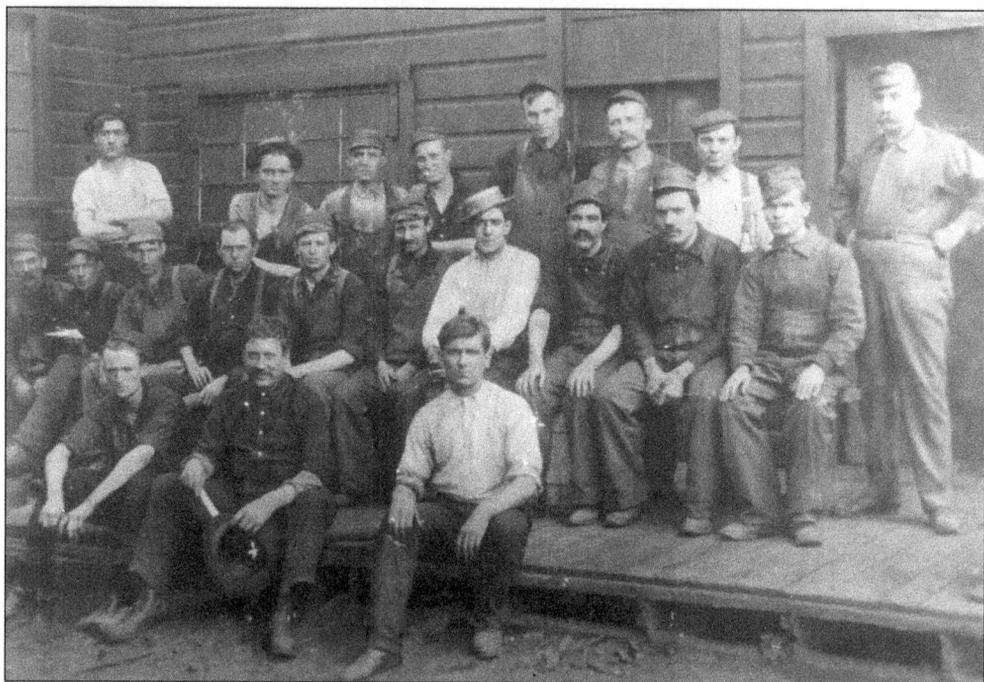

HUGH KIRSH AND KIRSH FOUNDRY. During the Great Depression, as businesses were closing in dramatic fashion, a few brave men were willing to attempt to create jobs by starting new ventures. Hugh Kirsh would pick up the pieces of Rassman and Western Malleables, Inc. to form Kirsh Foundry Inc. Kirsh Foundry not only would prove successful throughout the Great Depression but would also become a mainstay of the community through management by three generations of Kirshes. The picture shows Hugh Kirsh Sr. (in straw hat) surrounded by workers he oversaw while acting as supervisor for Western Malleables, Inc.

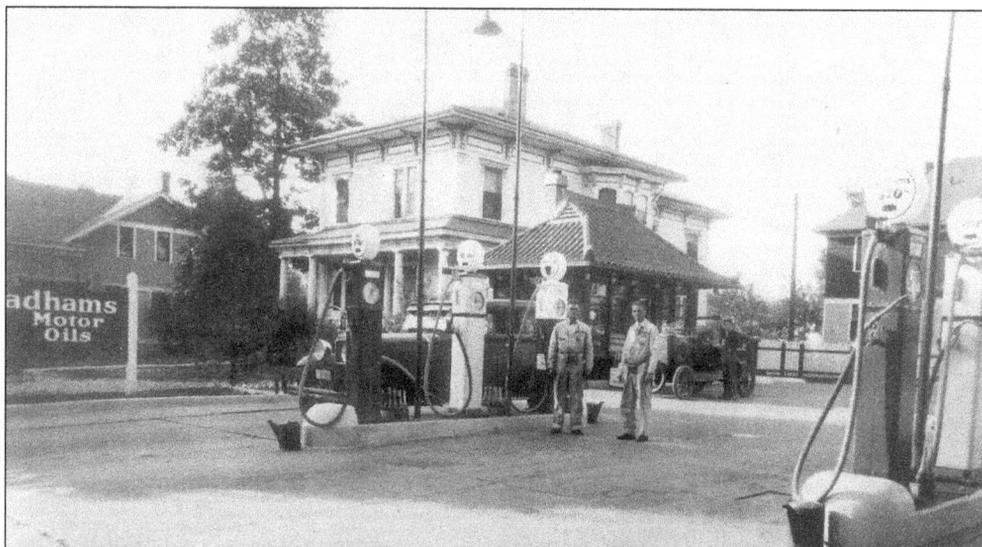

WADHAM'S OIL COMPANY. With the ever-increasing number of automobiles on city streets, the need for gas stations became obvious. By 1930, the city boasted 16 stations. The Wadham's Oil Company owned two of them. This station was located at the corner of Park and Lincoln.

Three

FAITH

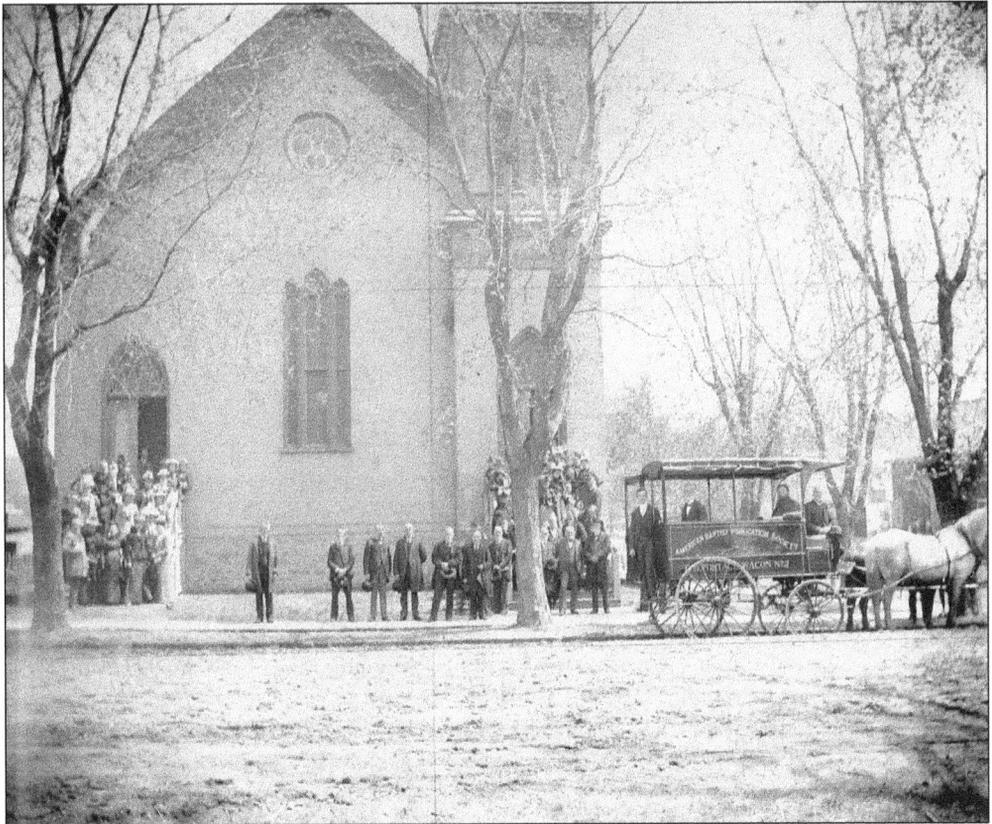

THE OLD BAPTIST CHURCH. Though the Baptists have called many churches home since arriving in Beaver Dam in 1844, residents refer to this Baptist Church located at the corner of Spring and Maple as the Old Baptist Church.

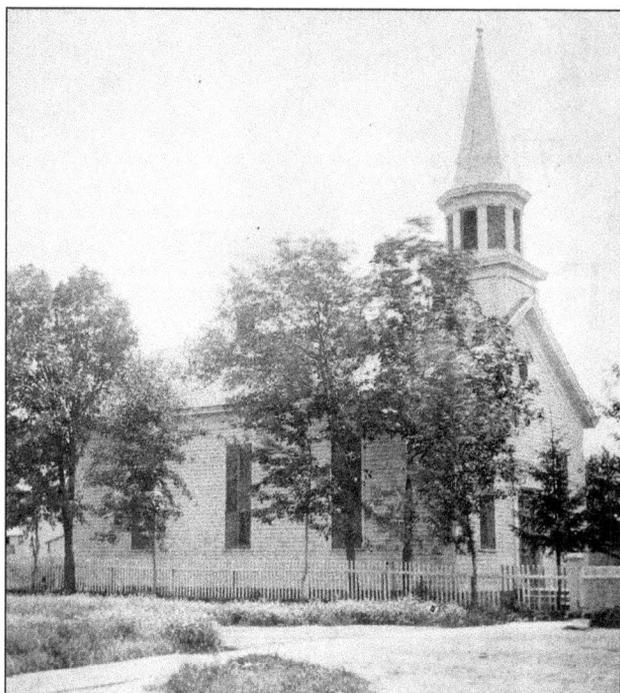

THE ASSEMBLY PRESBYTERIAN CHURCH. The Presbyterians organized the first church in Beaver Dam under the guidance of Reverend Moses Ordway. The first church building was located on Lincoln Avenue. This picture was taken in 1877. (Courtesy of the Wisconsin Historical Society.)

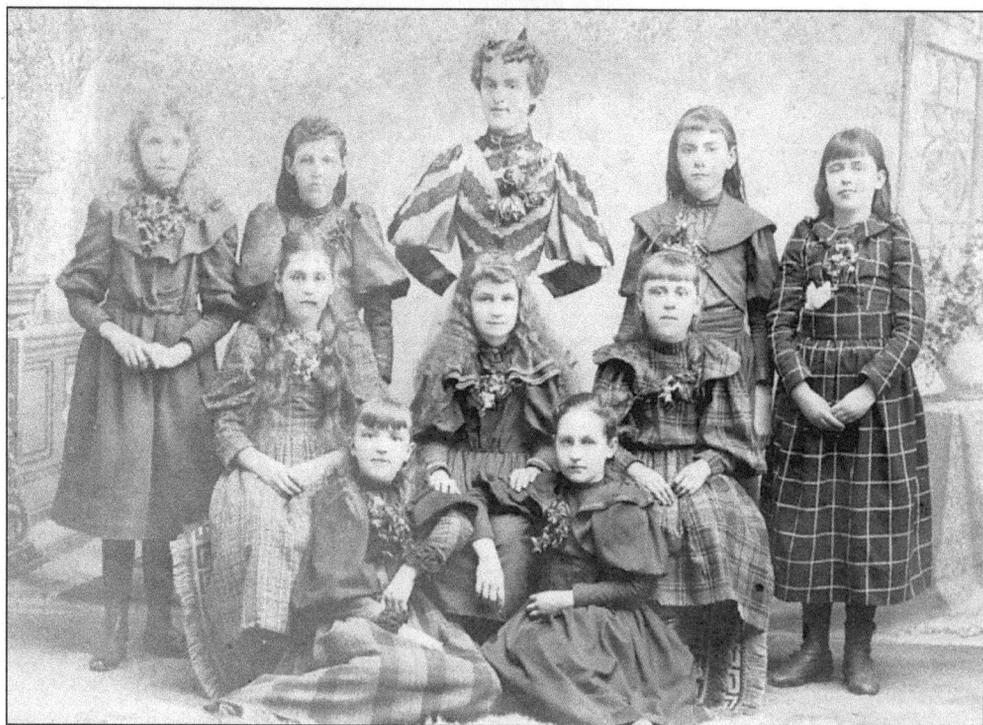

ASSEMBLY PRESBYTERIAN SUNDAY SCHOOL. The participants of this Sunday School, taught by Miss Addie Davenport in 1880, are pictured from left to right: (standing) Fannie Groling, Belle Riding, Miss Davenport, Ruth Mason, and Jennie Freeman; (seated) Bertha Noyes, unknown, and Edith Osterthun; (seated on floor) Bertha Herr and Mary Johnson.

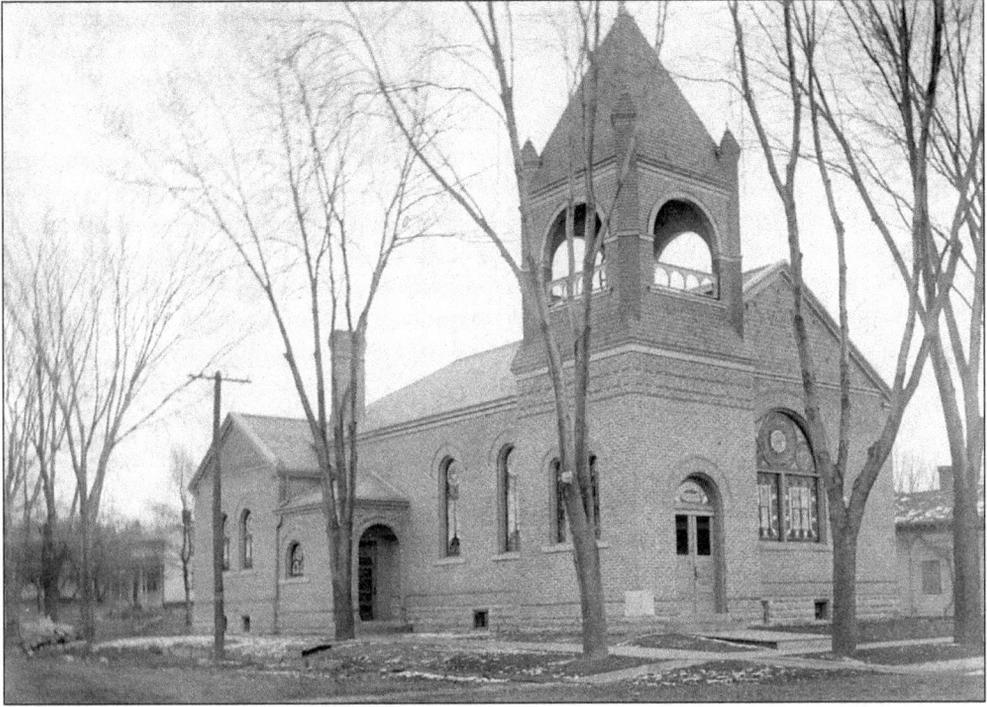

ASSEMBLY PRESBYTERIAN BRICK CHURCH. The Presbyterian wooden church was replaced by a brick church located at 117 Division Street (now Lincoln Avenue). Picture c. 1914.

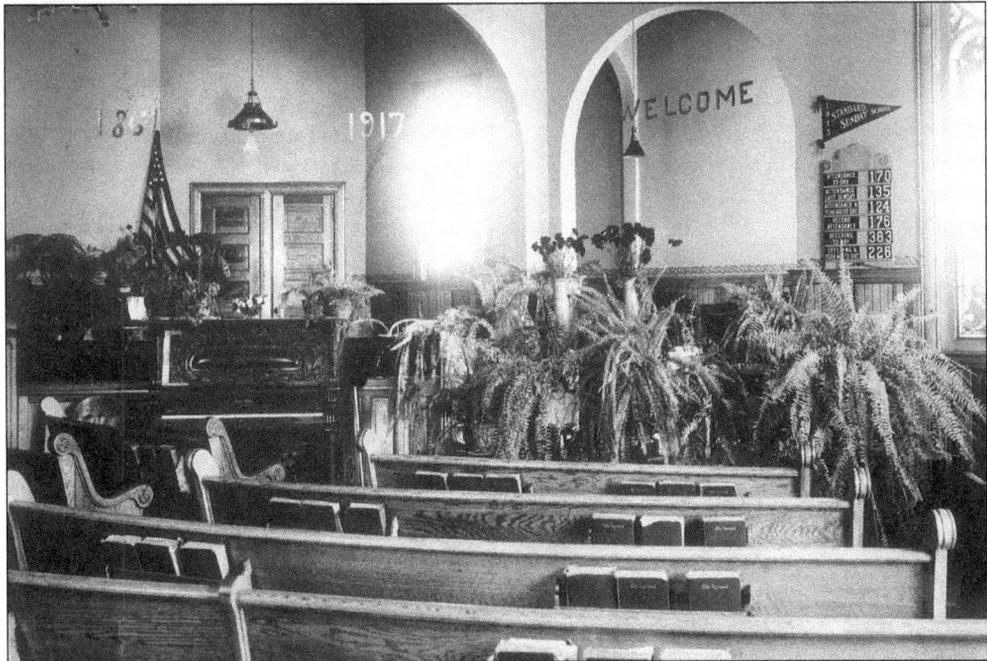

ASSEMBLY PRESBYTERIAN CHURCH INTERIOR. A 1917 view of the interior of the Assembly Presbyterian Church is shown here. The church is decorated in honor of Pastor T.S. Johnson's 15th anniversary. (Courtesy of the Wisconsin Historical Society.)

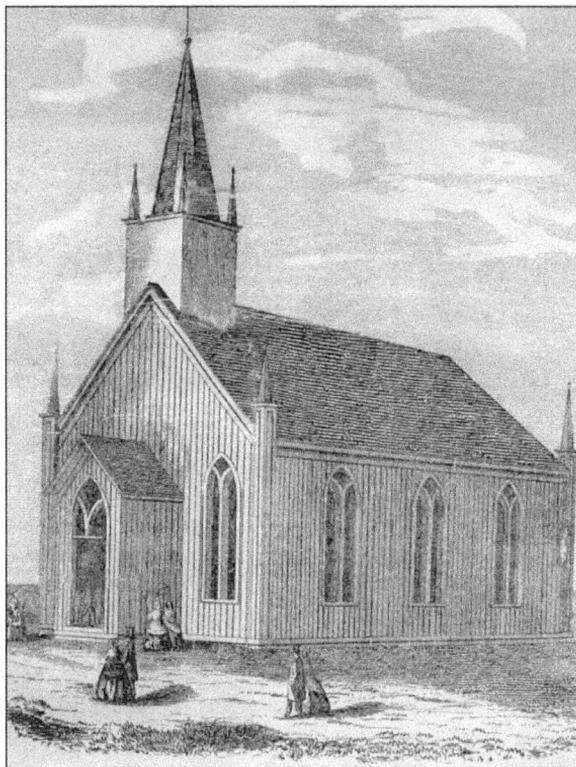

ST. MARK'S EPISCOPAL CHURCH. In 1858, the Episcopalians founded St. Mark's, which was originally located at the corner of Beaver and Front. It was later moved to the corner of Lincoln and Maple where it still stands today. The building currently houses a daycare.

Below Left: **ST. MICHAEL'S CATHOLIC CHURCH.** Polish Catholic families established St. Michael's Church on Madison Street in 1874. The small stick church was replaced by this brick edifice in 1904.

Below Right: **ST. MICHAEL'S CATHOLIC CHURCH INTERIOR.** Father Lepak is shown with unidentified children.

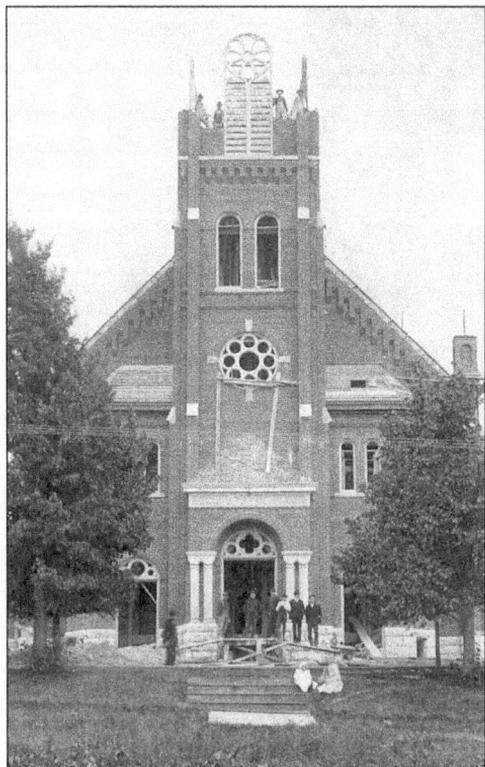

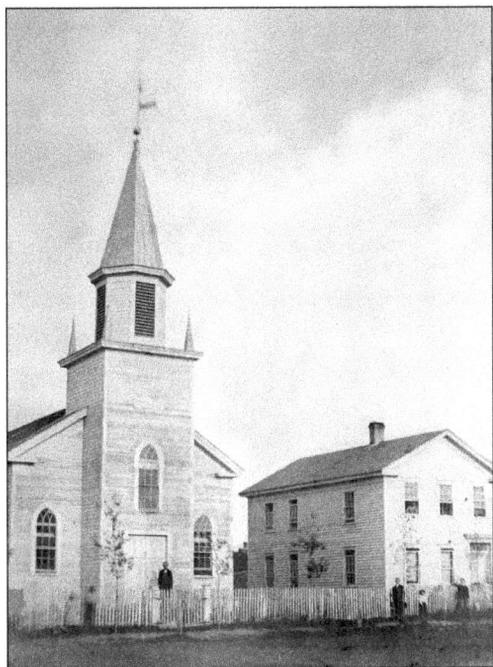

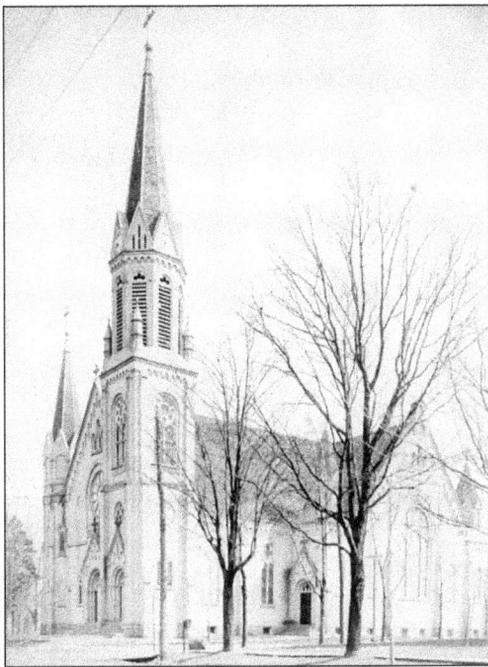

Above Left: **THE FIRST ST. PETER'S CATHOLIC CHURCH.** In 1854, the congregation of St. Peter's Catholic Church was established. The next year, this modest frame church was erected on North Spring Street.

Above Right: **THE CURRENT ST. PETER'S CATHOLIC CHURCH.** In 1900, the church went through its final transformation as this epic structure was created to service an ever growing German Catholic assembly.

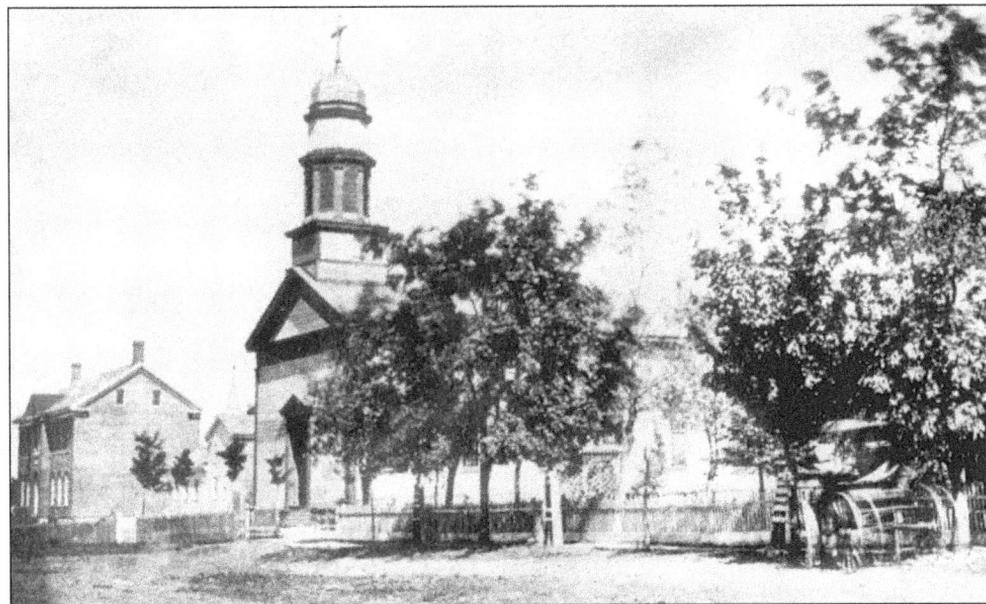

THE SECOND ST. PETER'S CATHOLIC CHURCH. The congregation soon outgrew its small house of worship and a second large frame church was built. The photo was taken in 1870.

THE ORIGINAL ST. PATRICK'S CATHOLIC CHURCH. This wooden church, created in 1863, served as the first church for the Irish Catholic population of Beaver Dam.

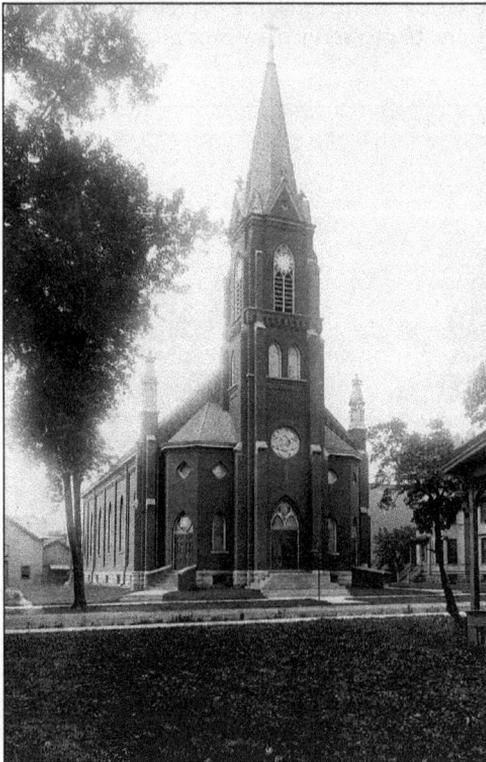

THE CURRENT ST. PATRICK'S CATHOLIC CHURCH. In 1907, the construction began on a new St. Patrick's Church for its parishioners.

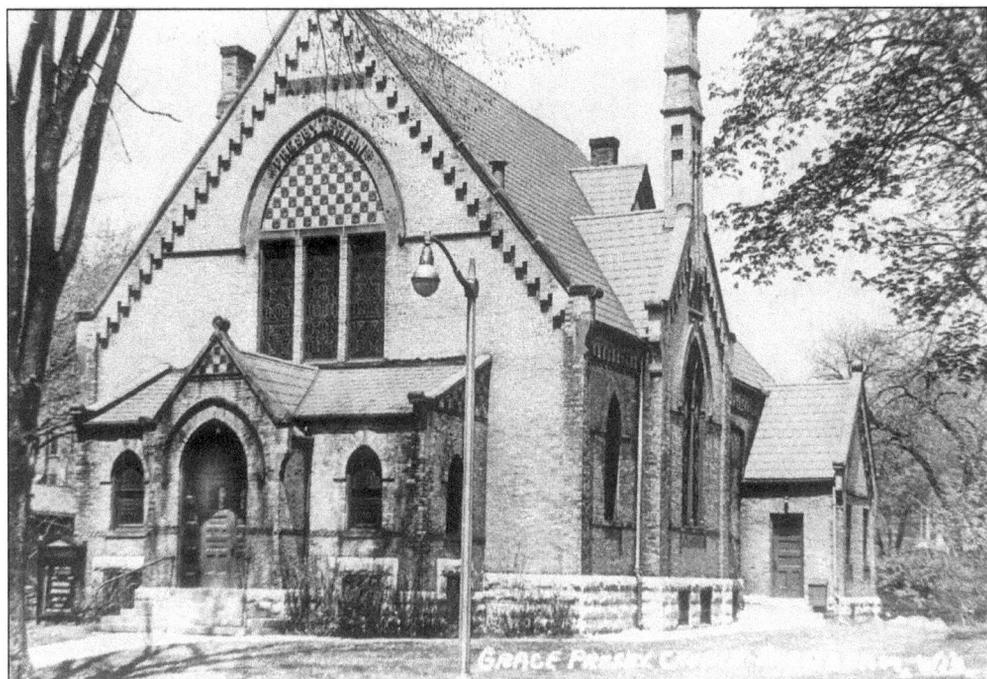

GRACE PRESBYTERIAN CHURCH. Another Presbyterian sect shot off from the original Moses Ordway church. Named the First Presbyterian Church, the congregation built this ornate brick place of worship in 1889. In 1929, the two Presbyterian congregations merged and were renamed the Grace Presbyterian Church. As a side note, Fred MacMurray's grandfather, Reverend J.T. MacMurray, served this congregation from 1901 until 1904.

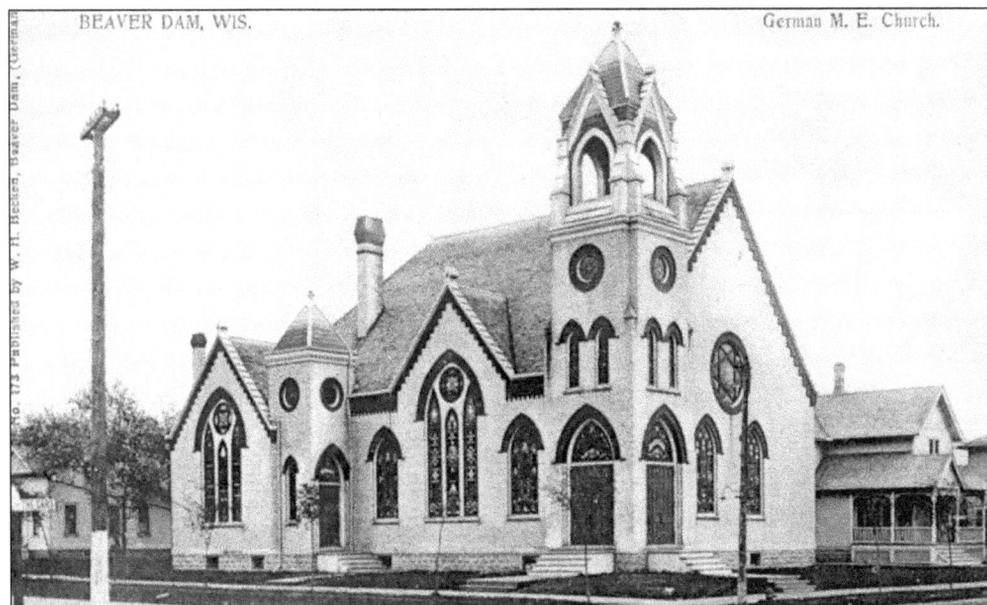

THE GERMAN METHODIST CHURCH. The Methodists arrived in Beaver Dam as early as 1847. Several different congregations were formed. The Germans would construct the German Methodist Church in 1895. It was located at the corner of Spring and Washington.

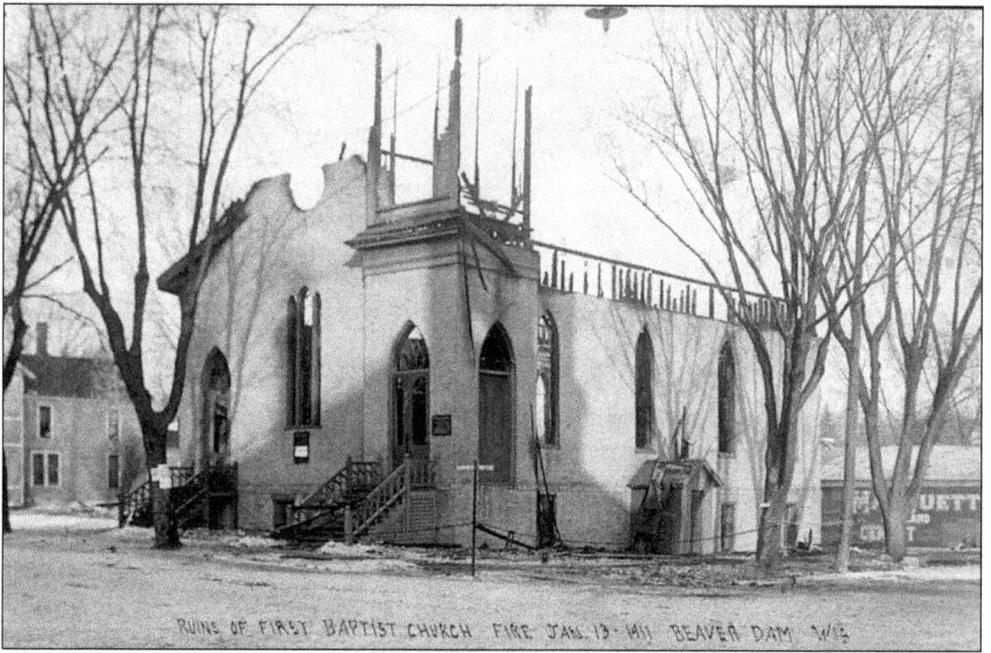

THE OLD BAPTIST CHURCH FIRE. On a bitterly cold night in January of 1911, candles left unattended created a blaze that would destroy the Old Baptist Church. (See page 59.)

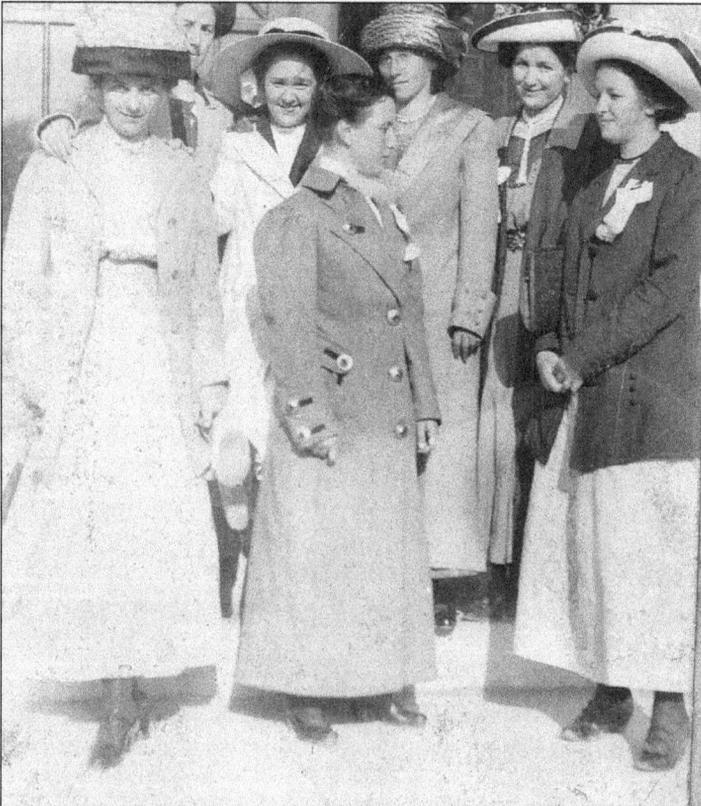

BAPTIST SERVICES AT WAYLAND The Baptists also held sevices at Wayland University. Pictured here is a group of young female students congregating after Chapel *c*. 1900.

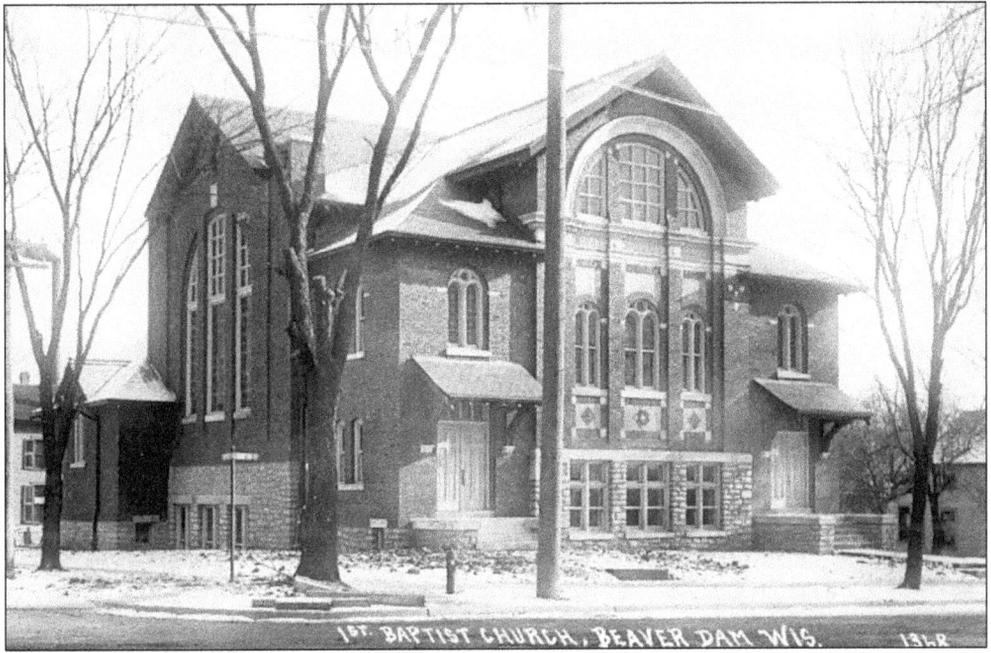

THE NEW BAPTIST CHURCH. Within two years, the Baptists would rebuild and relocate their church one block north to the corner of Spring and Maple. This building is the current home to the Beaver Dam Area Community Theatre.

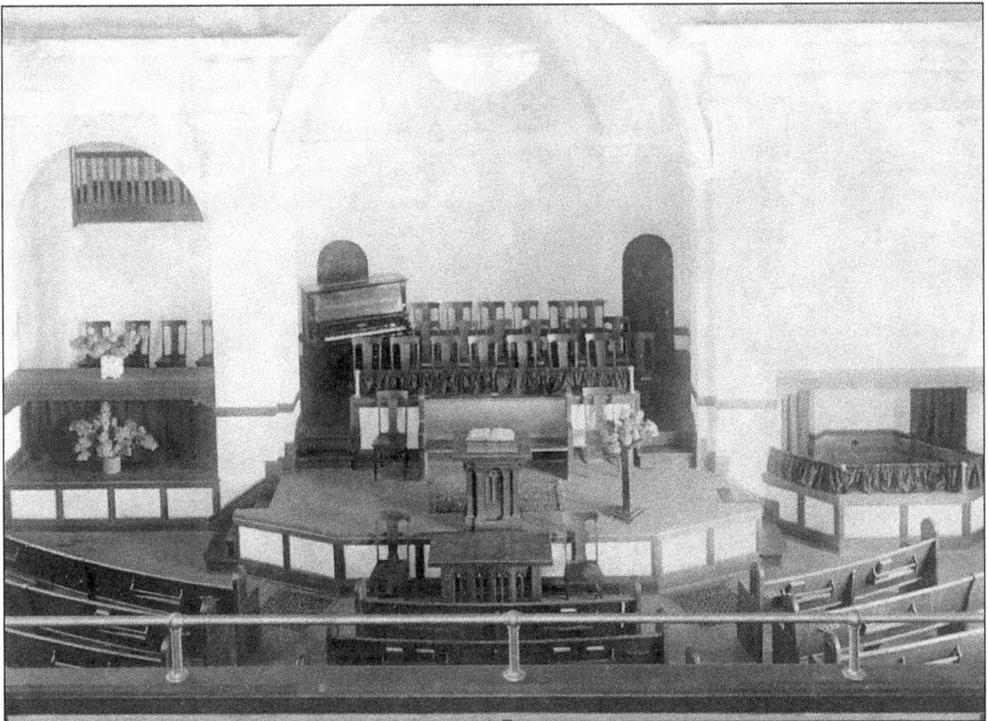

THE INTERIOR OF THE NEW BAPTIST CHURCH. Taken in the late 1910s, this picture shows the interior of the New Baptist Church. Note the baptismal bath to the right.

First Evangelical Lutheran Church. The First Lutherans were established in the city in 1860. This was their first church. In 1893, a new structure was built at 416 North Center Street.

Four

EDUCATION

1902 SECOND GRADE: UNION SCHOOL. This group of seven-year-olds pose for their class picture in front of the Union School. Pranksters would soon turn the name "Union" into the "Onion" school. The joke would become reality when a group of boys placed a large supply of the odorous chemical, Asafetida, into the furnace. Even the youngsters could not have predicted the incredible stench created. The school needed to be aired out for four days before classes could resume. The school acted as both grade school and high school. Beaver Dam City Hall currently stands on this site.

THE FIRST PUBLIC SCHOOL HOUSE. As early as 1842, Beaver Dam retained Margaret J. Buck as schoolmistress for a twelve-week term in her home. Twenty-four children were in that first class. Her pay was $1.50 per week. Within three years, it was clear that a permanent schoolhouse was needed. The site chosen was where the current Y.M.C.A. stands. The building was a simple 24-by-30-foot box. That building still stands on Mill Street today.

THE SECOND PUBLIC SCHOOL HOUSE. The second school house in the city was a two story framed structure built at the current site of Wilson School in 1867. The structure was moved in 1892 to 320 West Maple Avenue and subsequently used as a family residence.

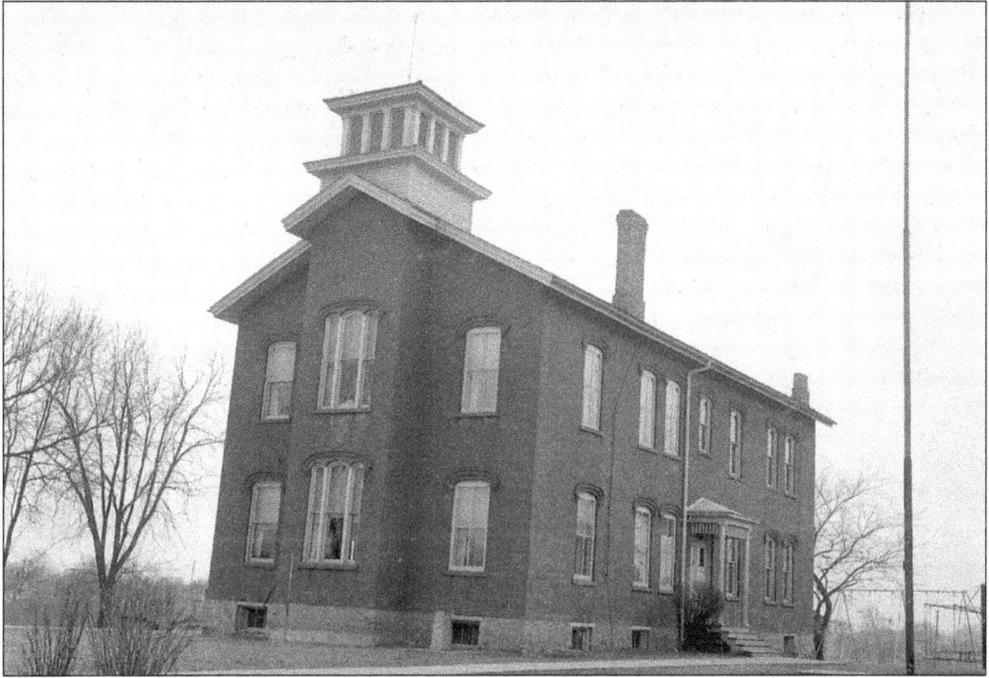

THE FIRST WARD SCHOOL. A school system that began with a small one room schoolhouse and grew in 1859 to include a two-story wooden schoolhouse proved woefully inadequate to meet the needs of an ever-growing student population. Large brick schoolhouses were the coming thing. In 1870, the 1st Ward School at the corner of Mill and Madison was finished.

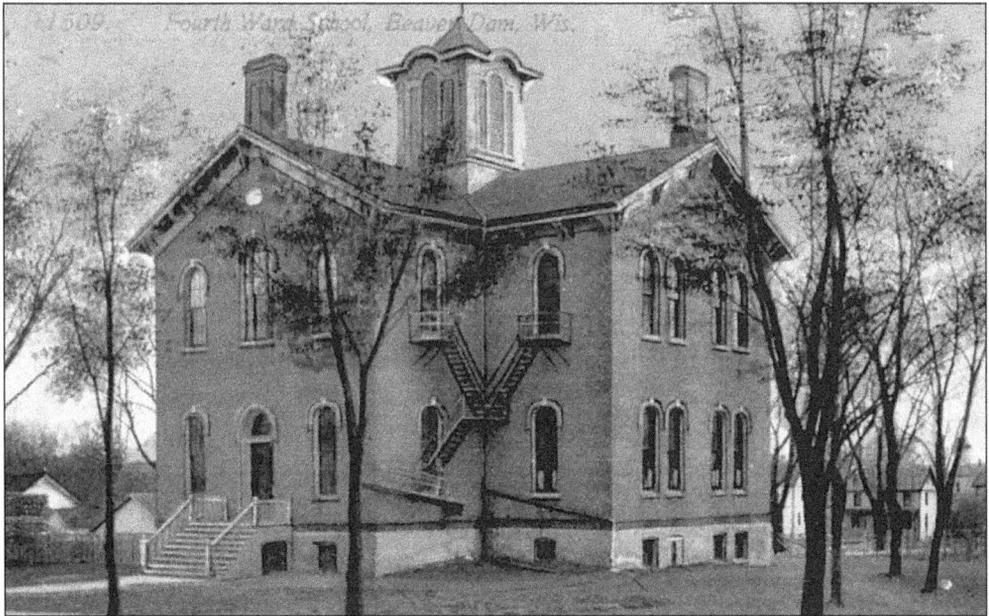

THE FOURTH WARD SCHOOL. Built on Mackie Street in 1876, the 4th Ward School was located behind the current middle school. In later years, it became the "Arts Building" and a part of Beaver Dam's Vocational School system named "John Swant's College of Industrial Education."

71

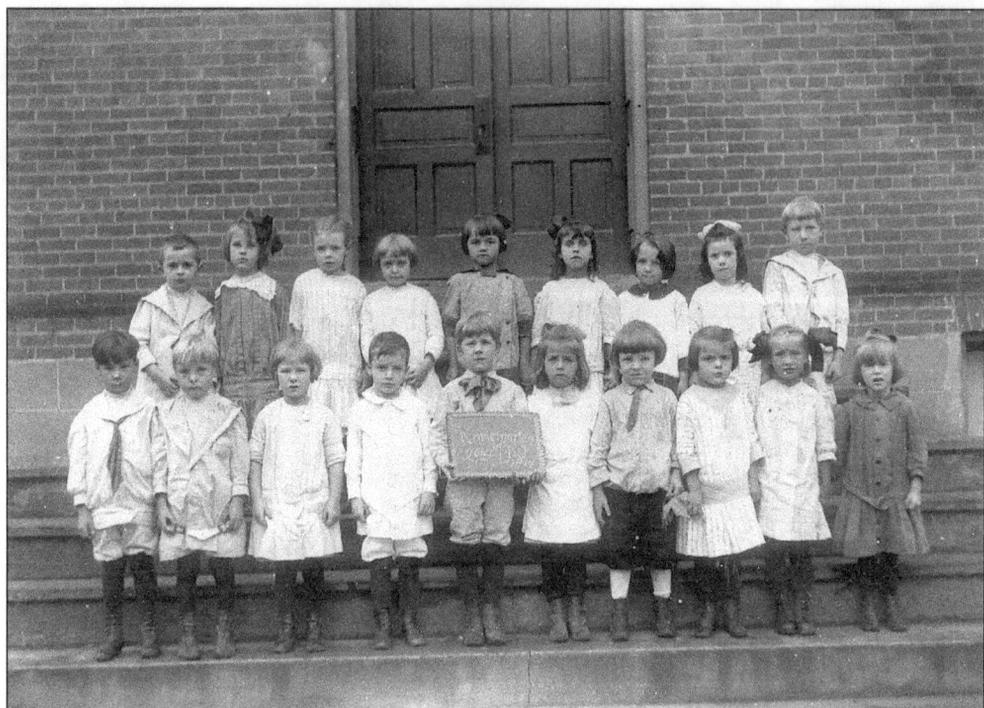

KINDERGARTEN AT 2ND WARD SCHOOL, C. 1914.

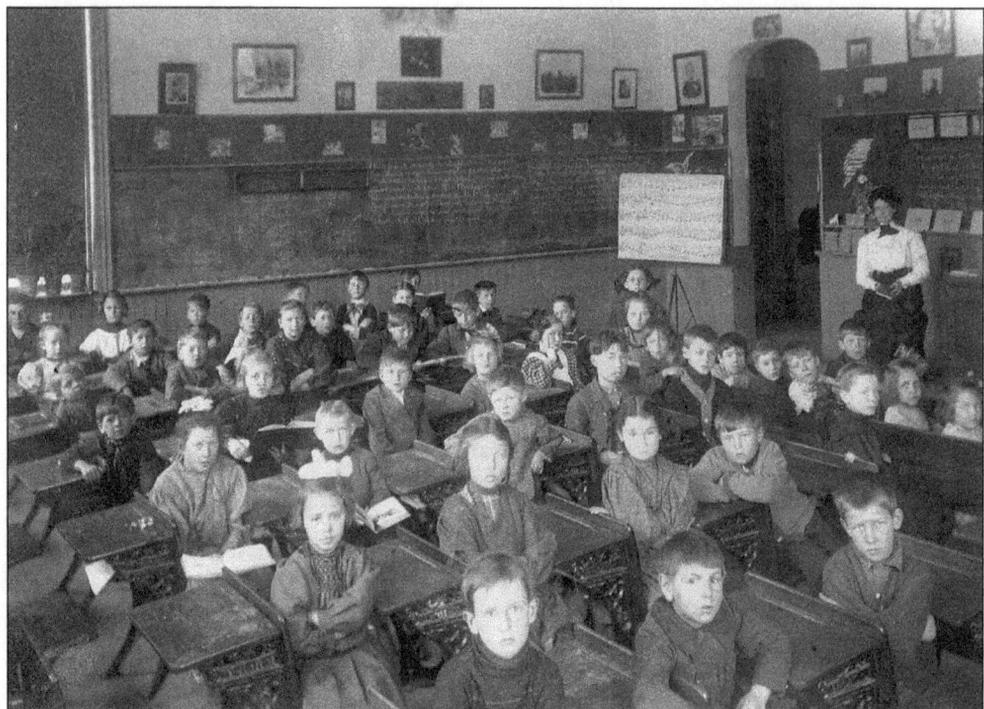

THE FOURTH WARD SCHOOL THIRD GRADE, 1921. The teacher is identified as Stella Powers.

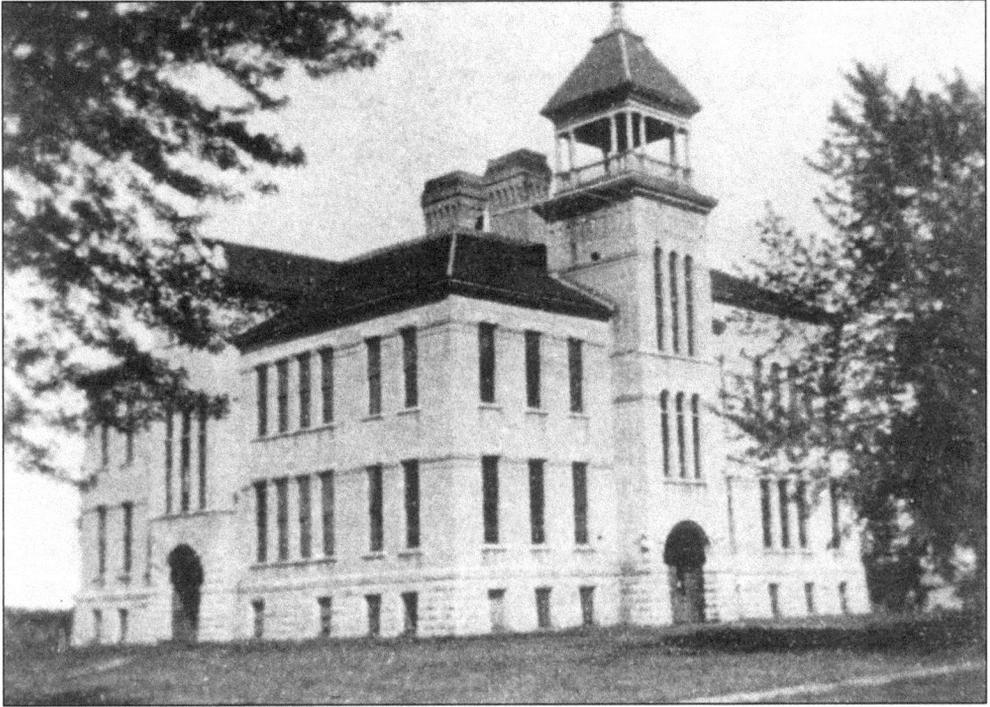

THE SECOND HIGH SCHOOL. In 1890, a new high school was built at the current Wilson School location. This high school would serve Beaver Dam for the next 34 years. But as the building neared its end, it was rumored to be unsound. Students would plot to exhibit the structure's defects, arranging to stomp their feet in unison. The edifice would literally shake to and fro as if in an earthquake. The demonstration proved effective as a new high school appeared on the city scene in 1924.

GRADUATION CLASS OF 1900. From left to right are: (seated) Ella Gergen and Alma Finch; (standing) Leonard Keefe, Bert Smith, Walter Dickinson, Lester Martin, Natha Thomas, Nellie Staab, Margaret Gallagher, Cathy Staley, Sadie Coxshall, Edith Congdon, Mabel Rogers, Grace Hambright, and teacher Carrie Marie Mershon.

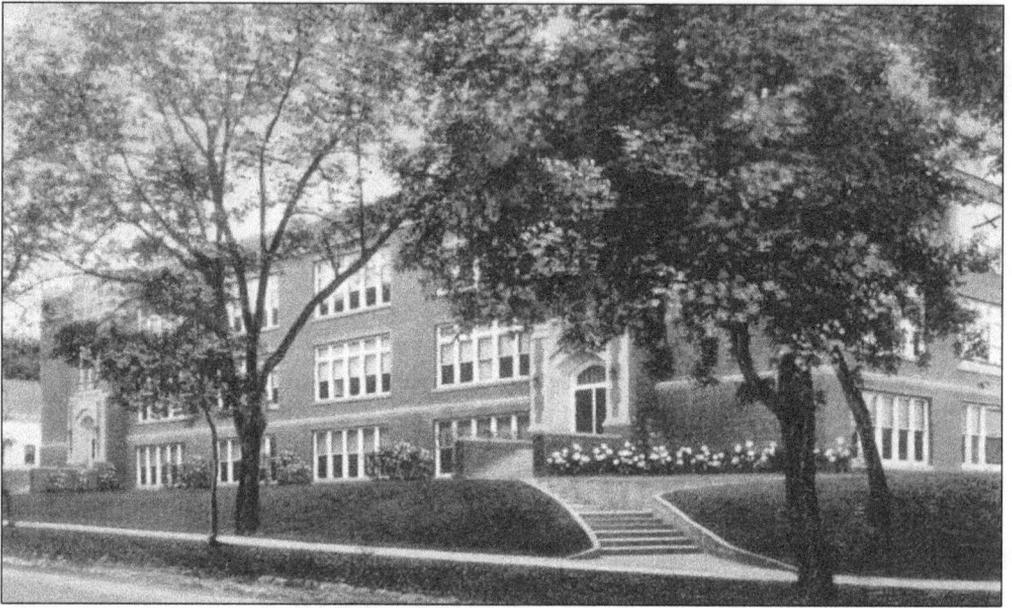

THE THIRD HIGH SCHOOL. In 1924, the third high school debuted. The school now provided a more central location on Fourth Street. The school would meet the needs of the district for the next 33 years. Today, it is the current location of the middle school.

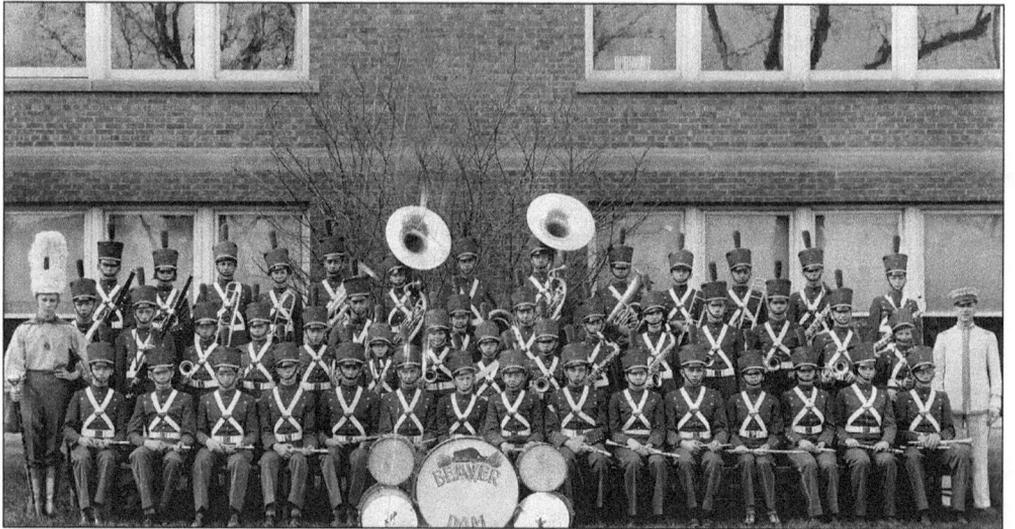

THE 1934-35 BEAVER DAM HIGH SCHOOL BAND. Pictured from left to right are: (first row) Clarence Stabb, Tabea Kohlmeier, Mike Krobert, Marcella Sawyer, Louis Butterbrodt, Elisabeth Pomeroy, Arthur Washtock, Arnold Frisch, Harvey Pfarrer, Vincent Vilker, ? DeVelice, and ? Quandt; (second row) Jerry Daniels, Bernard Maas, William Frey, ? Seyferth, Christenson, Richard Werner, June Sherman, ? Rhodes, Josephine Lehner, ? Fiebelkorn, Ted Bayley, ? Block, Clarence Firari, Phyllis Trione, ? Bartol, Junior McConaghy, Harry Radlund, Adaline Kastenmeier, and Director Jesse Meyers; (third row) Robert Schwinn, ? Wiese, Duke Miller, Duane Waddell, ? Rubnitz, Alfred Mayr, Bill Milarch, Harry Grant, Bob Roedl, Lorraine Mayr, Alfred Rake, ? Babler, Beata Kohlmeier, ? Davis, and Russ Heilmann.

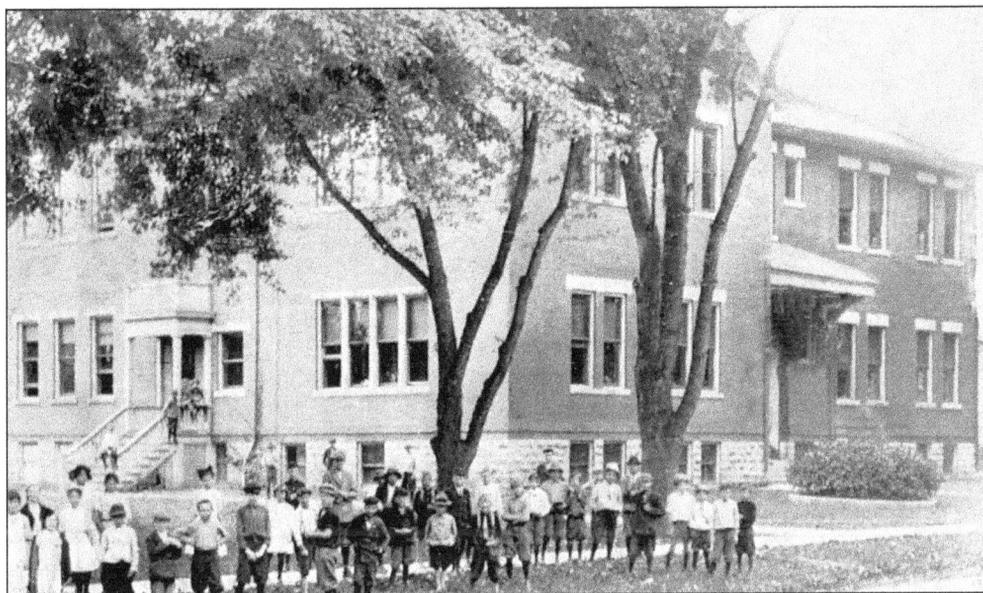

LINCOLN SCHOOL. In 1911, the city opened an additional grammar school at the corner of Lincoln and University.

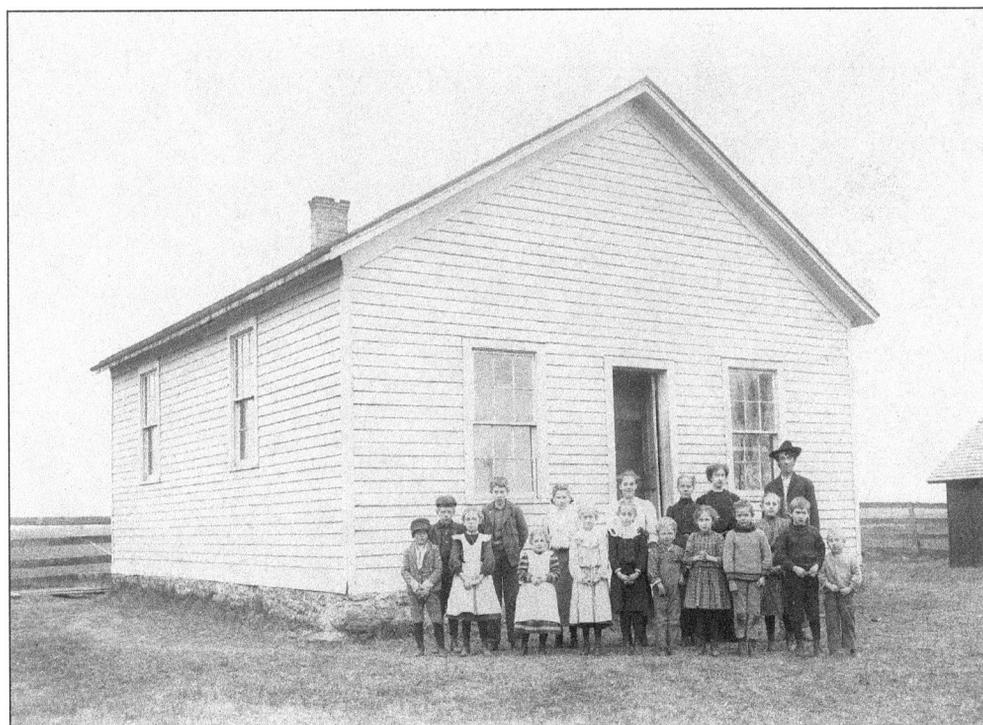

ONE-ROOM SCHOOL HOUSE. In the late 1800s and early 1900s one-room school houses dominated the countryside just outside the then city limits of Beaver Dam. Here is one example—the Holt/Hyland Prairie one-room schoolhouse.

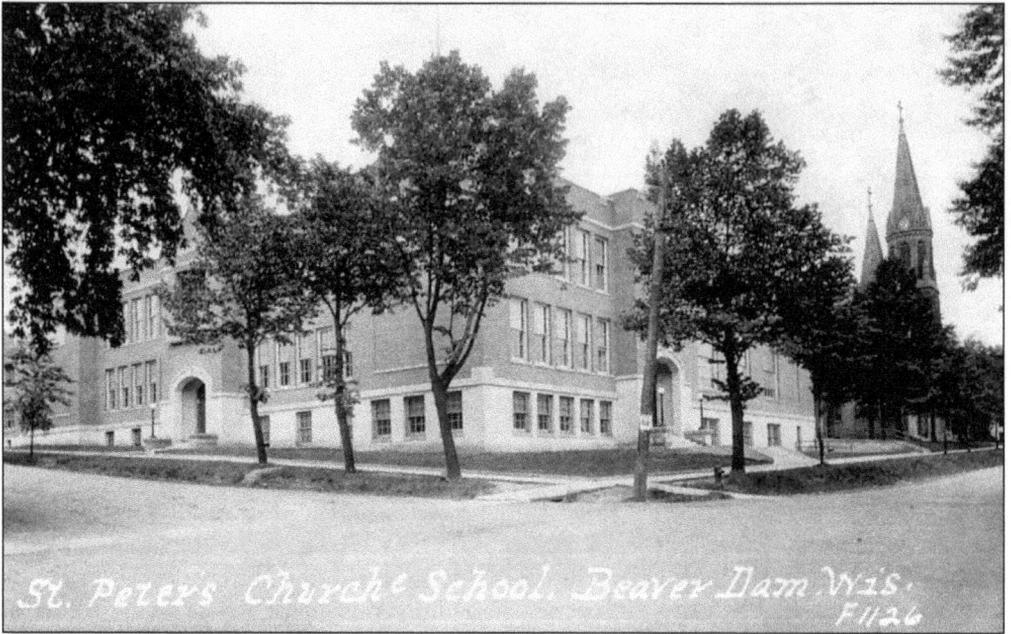

ST. PETER'S PAROCHIAL SCHOOL. St. Peter's Catholic Church established a parochial grade school as early as 1862 that was originally called St. Mary's. Eventually, over the years, the name would be dropped in favor of St. Peter's. In 1922, a brand new school building was erected.

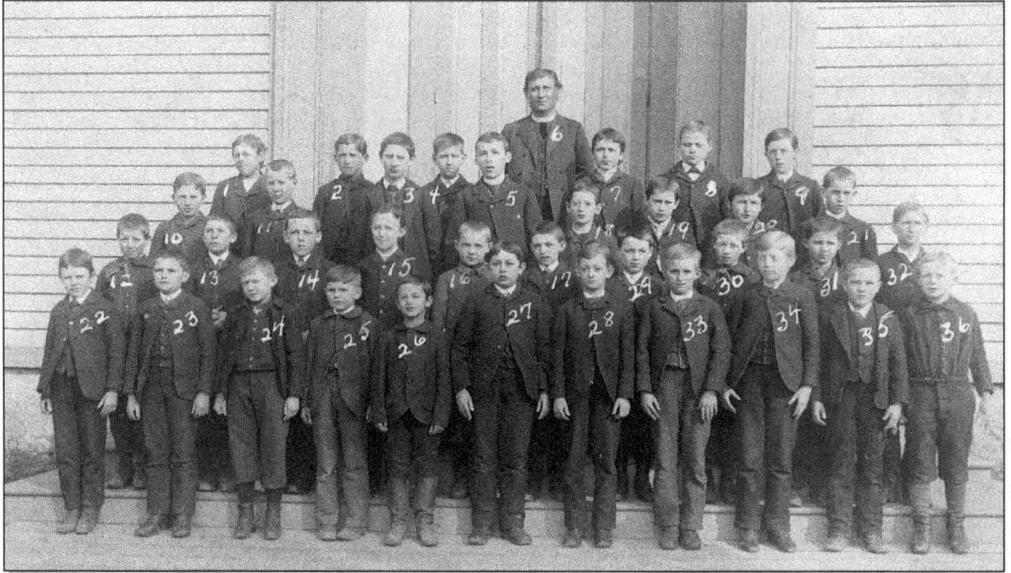

THE ST. MARY'S PAROCHIAL SCHOOL. St. Peter's First Church built in 1854 was replaced by a new church in 1861. One year later, the old church was transformed into a two-classroom parochial school named St. Mary's. This picture taken outside the school *c.* 1890 shows Father Dreis with some of the boy students. Those identified are: no. 4 John Daniel, no. 14 George Hall, no. 15 Joseph Milarch, no. 19 Frank Schingo, No. 20 Charlie Haase, no. 29 Richard Goeggerle, and no. 35 George Milarch.

76

St. Stephen's 1926 Graduating Class. The Lutherans would establish their first school in 1896. Two subsequent school buildings followed in 1913 and 1929 (the latter of which serves as the current school building). The members of the 1926 graduating 8th-grade class were Dorothy Klas, Carol Radtke, Amos Knaak, Wanda Mueller, Loretta Binder, Rodger Grueneberg, Marvin Mankowsky, Carleton Bergeman, Harvey Kachelski, and Elmer Kuecken.

The Original St. Stephen's School. This building was originally built as St. Stephen's church at the corner of Rowell and South Center Street. The congregation then purchased land at the intersection of West Maple Avenue and West Street. The church was moved across the bridge to this new location. School classes were held as early as 1896 in this building. In 1920, a new church was erected. The old church was then used exclusively as the St. Stephen's Elementary School.

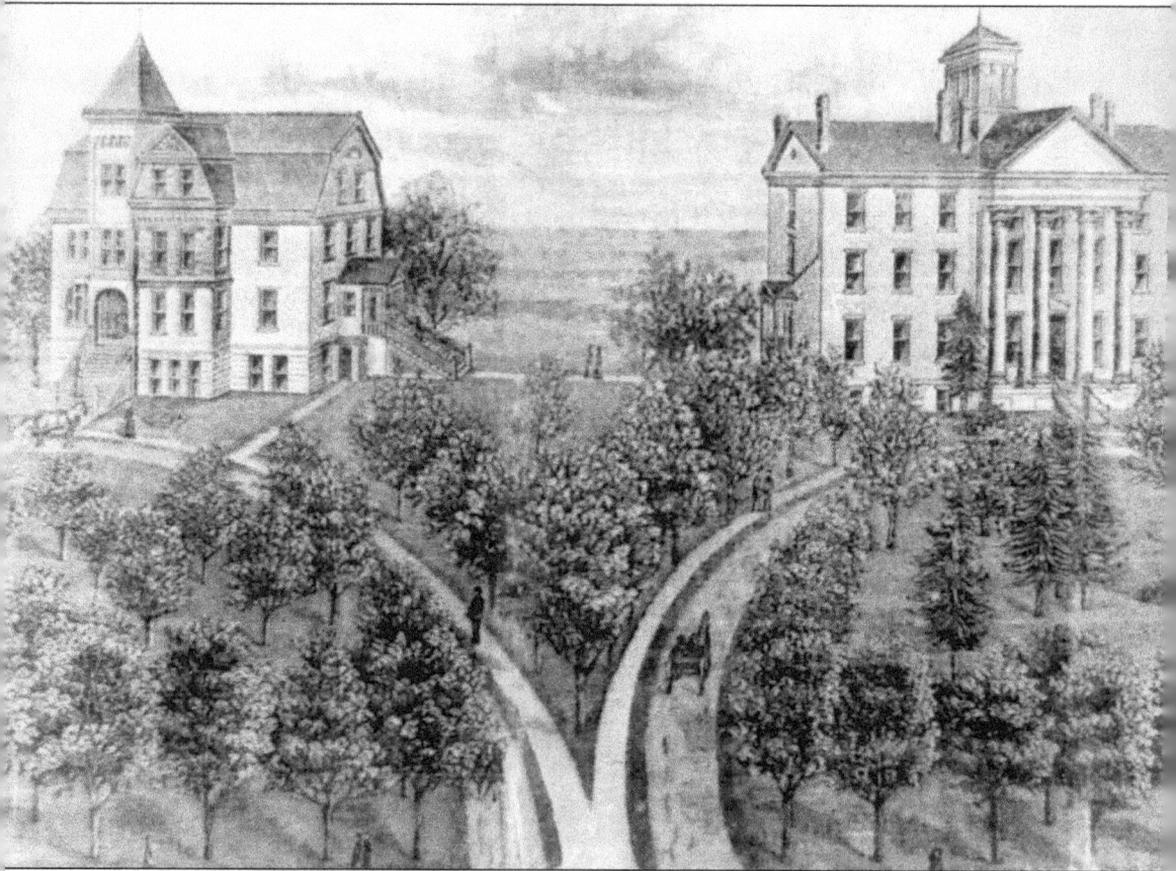

WAYLAND UNIVERSITY. In 1854, the Wisconsin Baptist Education Society formulated plans for the creation of a Baptist College for boys. After receiving a generous donation of land from town pioneer Abraham Ackerman, Beaver Dam was designated as the site for the school. The University was named after Francis Wayland, a noted educator and president of Brown University. The cornerstone of Wayland was laid on July 4, 1855.

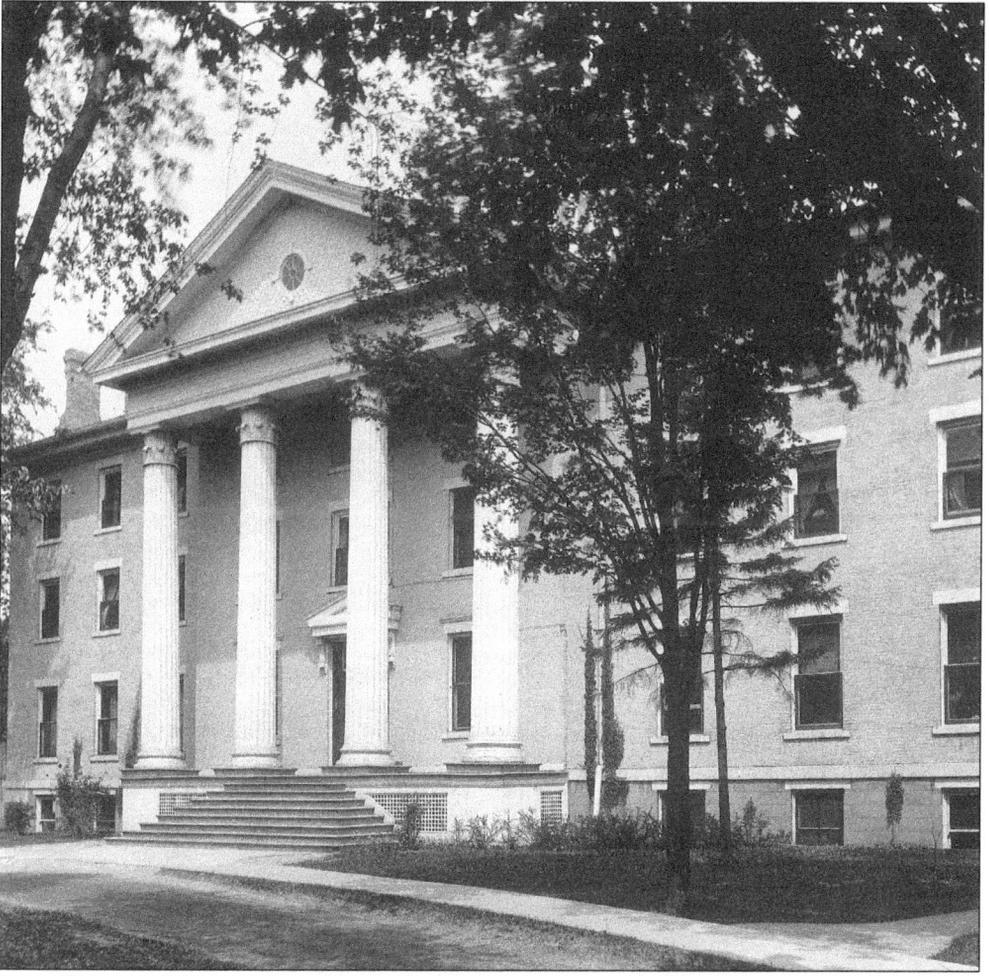

WAYLAND HALL. During its nearly 150 years, Wayland would go through many changes. It began admitting women in 1860, became a sister college to the prestigious University of Chicago in 1868, and turned into a strictly preparatory school in 1875. It added a junior college in 1937, and again returned to a preparatory academy in 1952. Throughout the years, it has gained a well-deserved reputation for providing its students not only an exceptional education but also a solid foundation for excellence in character and moral growth.

CITY HALL LIBRARY. In 1884, Beaver Dam citizens raised funds for the establishment of a one-room library to be housed in the reading room located in city hall. According to the Bowker Annual of Library and Book Trade (1964): "The Beaver Dam, Wisconsin public library was the first library in the United States to feature open stacks."

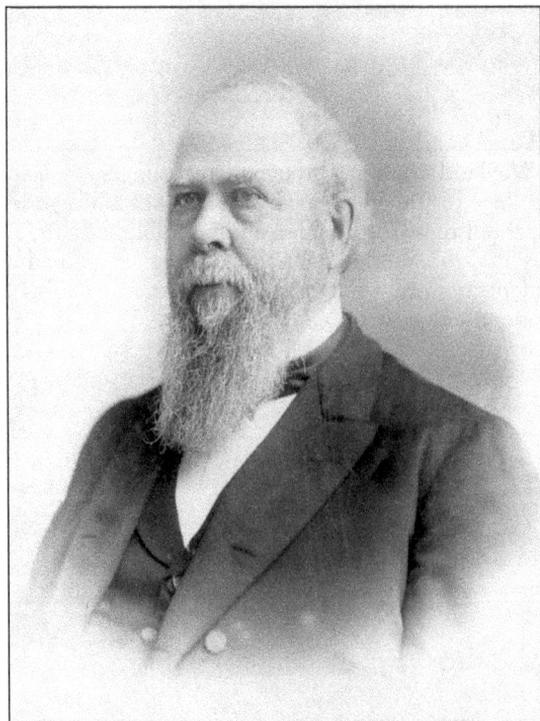

J.J. WILLIAMS. It was in 1890 that industrialist J.J. Williams noticed the intense interest enjoyed by adults and particularly children in the small one-room library housed in city hall and offered to provide $25,000 for a new library building. The city promptly accepted the offer, purchasing the two lots at the southeast corner of Park and Spring Streets.

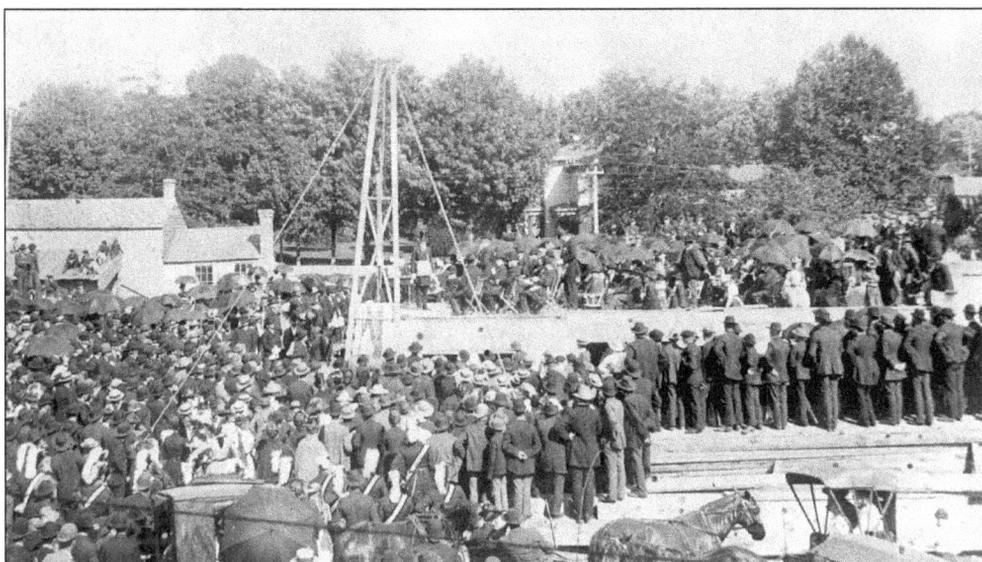

LAYING THE CORNERSTONE FOR THE WILLIAMS FREE LIBRARY. The prestigious architectural firm of Mix & Company out of Milwaukee would oversee creation of the imposing Romanesque structure to be appropriately called the Williams Free Library. On August 26, 1890, the cornerstone was laid. Fellow businessman William Drown, noting that a library is of little value without a fine supply of books, pledged $10,000 to furnish the library stacks. Not to be outdone, Williams added an additional $5,000 for the same purpose. Williams Free Library opened to the public on September 1, 1891.

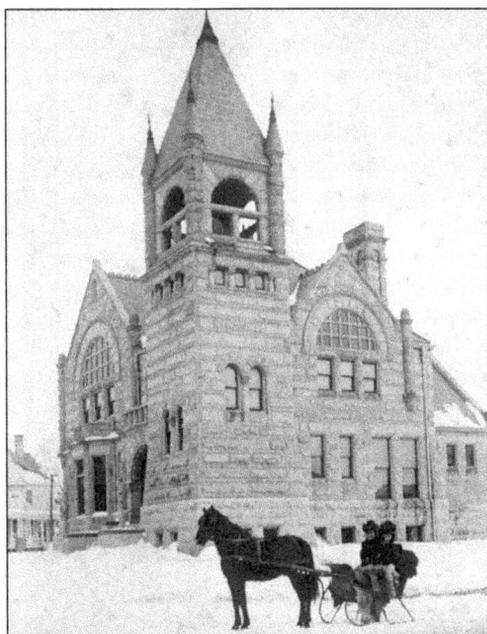

Right: **THE WILLIAMS FREE LIBRARY, C. 1900.**
Left: **LIBRARIAN HATTIE DOOLITTLE.** As the structure opened, Mary Doolittle was retained as head librarian. She would act in that capacity for the next 6 years, only to be replaced by her sister, Hattie Doolittle, for the following 47 years.

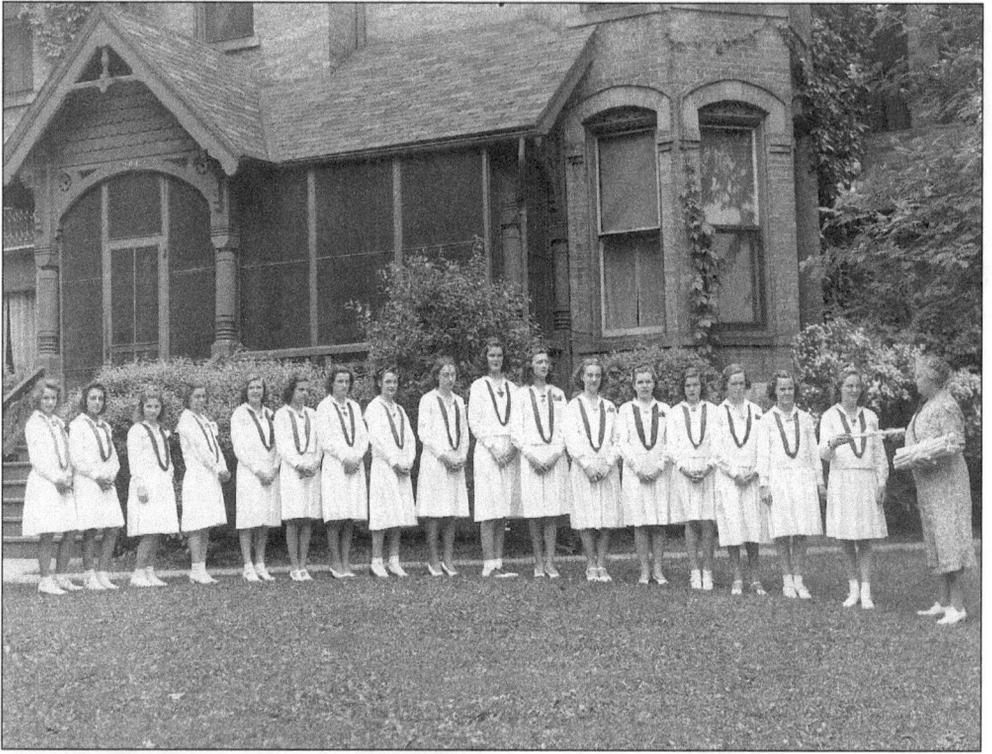

HILLCREST SCHOOL FOR GIRLS 1939 8TH-GRADE GRADUATING CLASS.

SARAH DAVISON. Sarah Davison established the Hillcrest School for Girls in 1910. The campus was first located in a home at Park and University. The home proved too small for the student body, and Miss Davison subsequently leased the J.J. Williams home on Park Avenue. Further size limitations would require one final relocation to the Chandler home on Park and Lincoln. The school had a fine reputation as a top-notch elementary boarding school. Its students hailed from as far away as Europe and Asia. The single school building soon expanded to a complex of buildings, with the addition of the adjacent Congdon home.

Five

RECREATION

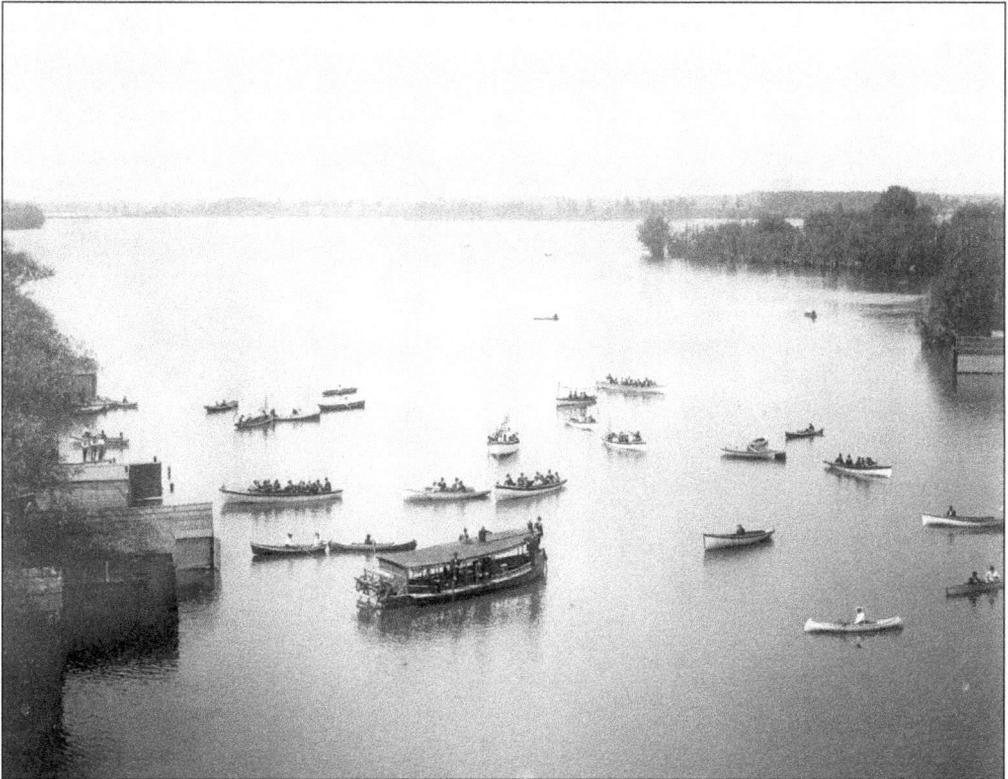

BOATING ON BEAVER DAM LAKE, C. 1906. It is ironic that the man-made lake created for the purpose of working the industries of the city would, nearly a quarter of a century later, become its main focus of recreation. The lake continues to be the center of leisure to this very day.

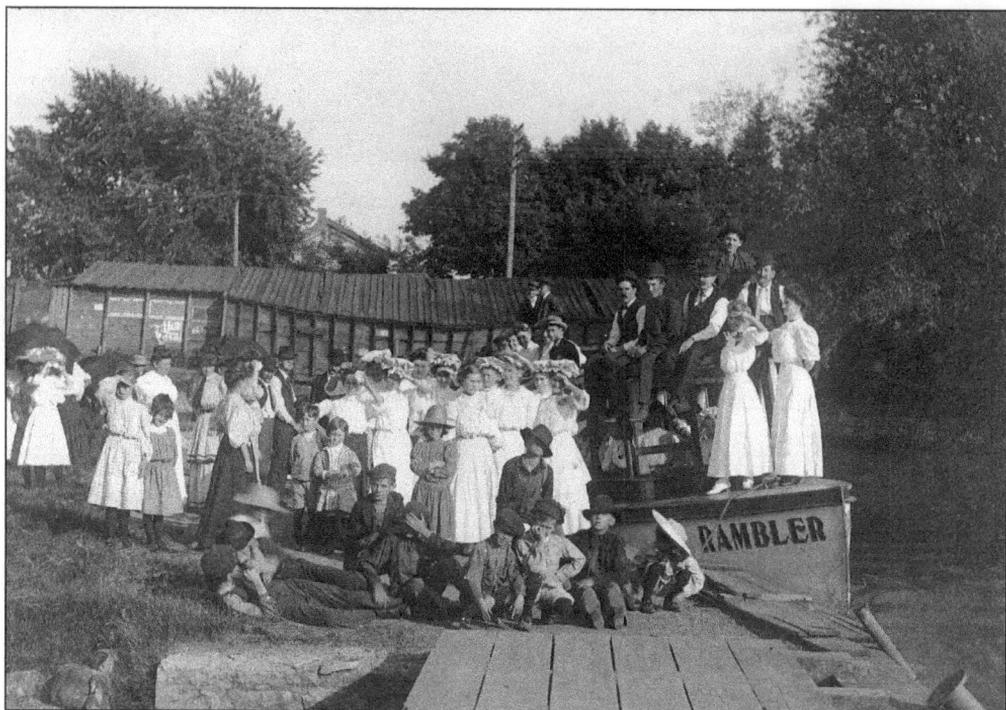

THE RAMBLER. In the summertime, the rage among the Beau Brummels and their ladies dearest included gliding over the water of Beaver Dam Lake in excursion steam ships with names like the *Belle Rowell*, the *J.S. Rowell*, and the largest, the *Rambler*, capable of escorting 75 people around the lake.

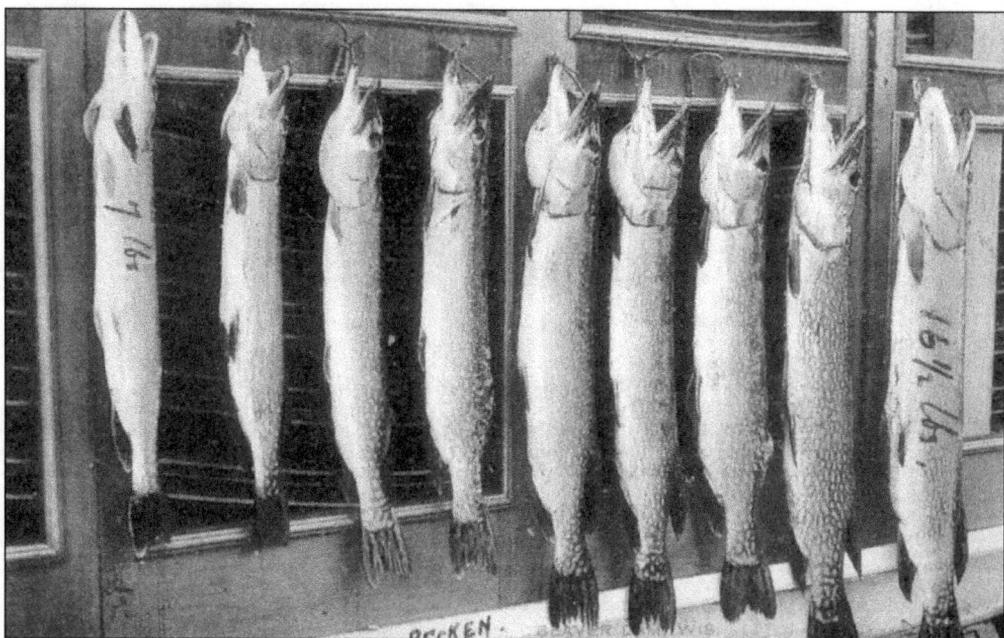

A HALF-DAY'S CATCH. Beaver Dam Lake became a popular spot for the proficient and amateur angler who time and again reeled in record sized northern, bass, and pike.

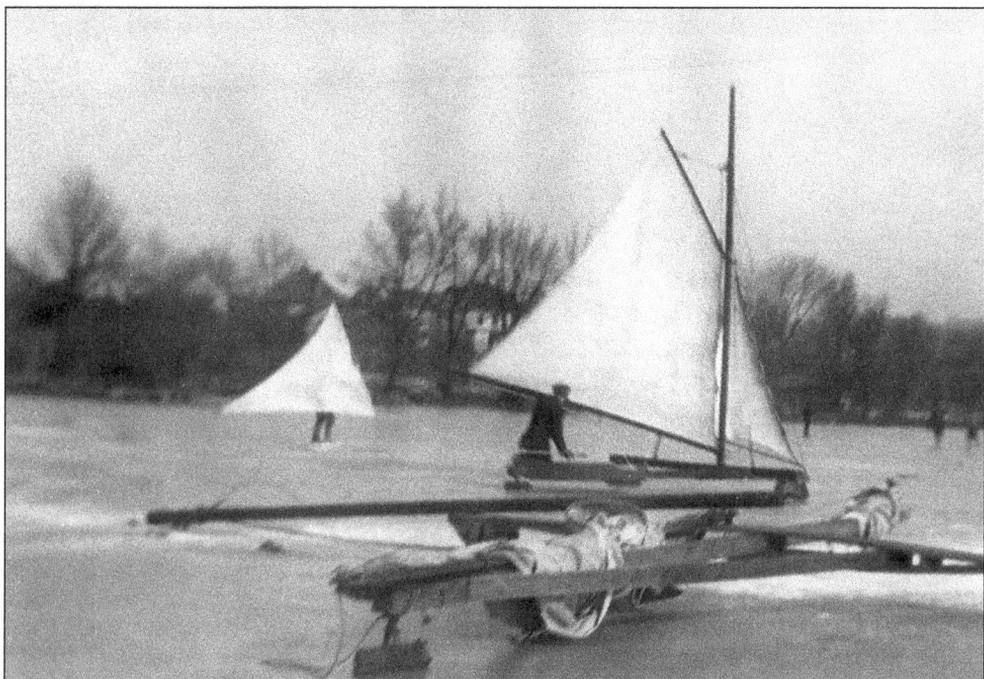

ICEBOATS ON BEAVER DAM LAKE. From the 1880s through the 1930s, young adventurers risked life and limb to race iceboats across the frozen waters of the lake.

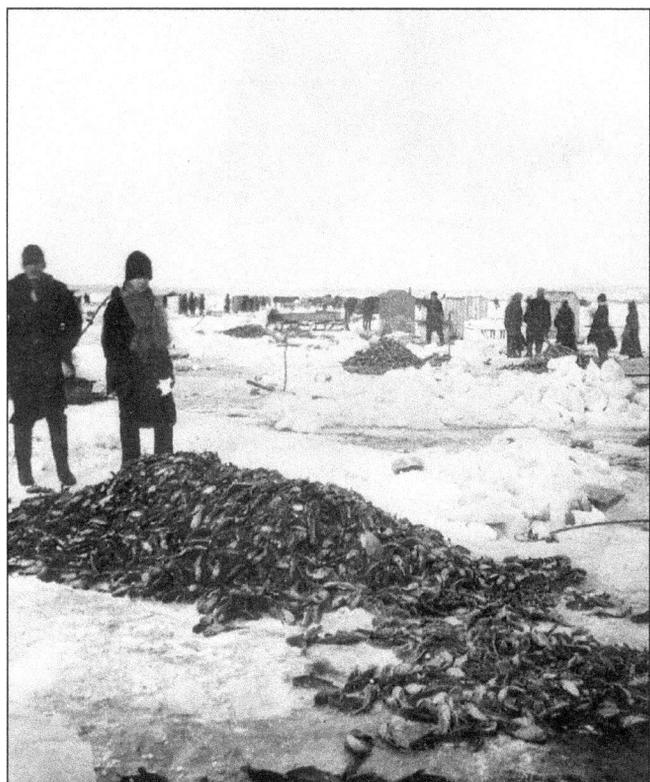

ICE FISHING FOR BULLHEADS. During the 1880s, it was common for literally thousands of bullheads to be taken out of the lake in wintertime. The fish would seek out springs for needed oxygen. As fishermen accumulated mounds of the seafood, farmers lined up with large sled carts to transport the bullheads back to barns to be used for farm animal feed.

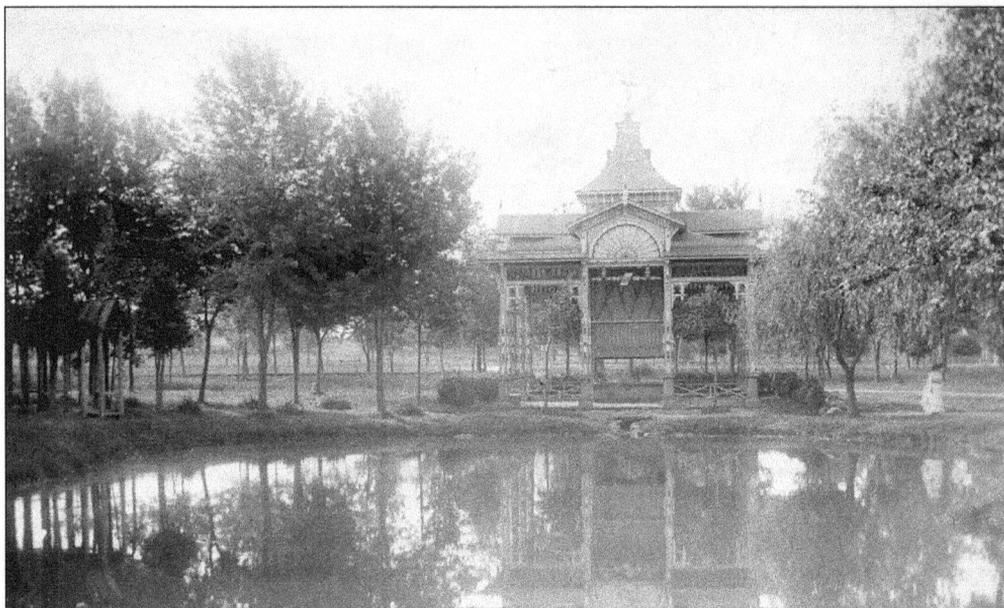

THE VITA PARK PAVILION. The spring's output of nearly 6,000 barrels a day was capped and an analysis revealed the waters' quality rivaled the liquid flowing from Waukesha's spring. Immediately, the grazing land was cleared. A landscape engineer, famous for his work at Lincoln Park in Chicago, was hired and transformed the acreage into a modern day Eden. Two thousand trees made up of elms, maples, basswood, butternut, and walnut were planted. Walkways and cart paths were laid out. A pavilion modeled after those in Waukesha and New York was erected over the spring.

DR. GEORGE SWAN. In June of 1879, Dr. George Swan, while looking for pastureland for his cow, wandered unto Abraham Ackerman's homestead adjacent to College Avenue (now University Avenue). There he would happen upon a bubbling spring. Native Americans had worshipped this spring. Swan, knowledgeable of the successful Bethesda Spring Spa in Waukesha, purchased the property and set about promoting his spring. He began construction of his own spa in 1880.

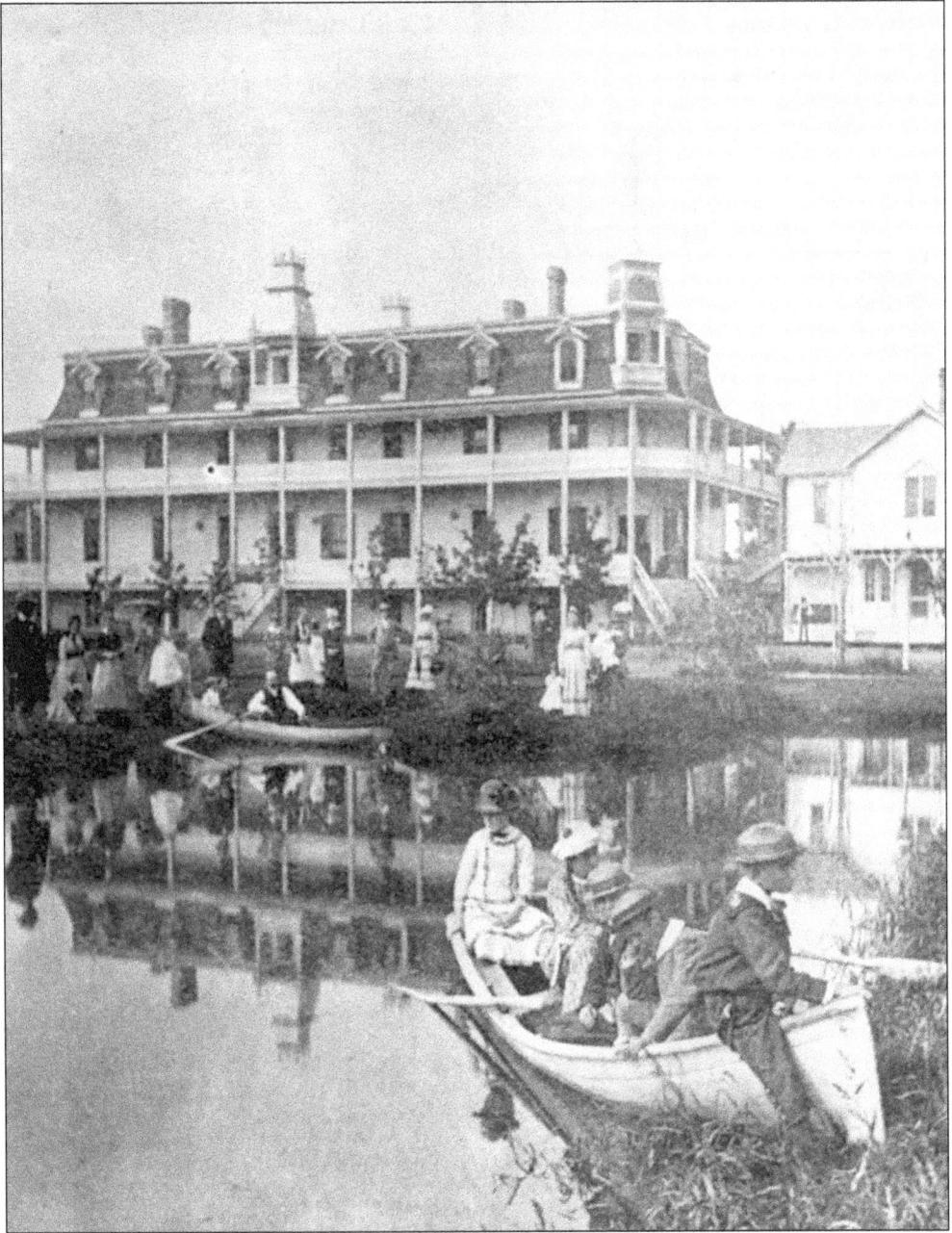

Vita Park Hotel. The grand opening of a large hotel and cottages on the grounds highlighted the summer of 1881. A bandstand stood halfway between the hotel and pavilion. The new park was named Vita Park and proved to be the center of outdoor activity for the next 10 years. Harder's Band performed concerts twice a week and on Saturday, played in the hotel for dancing. Visitors from as far away as Europe and South America journeyed to the spa's healthy waters and luxury. Hotel registries indicate that at the height of its popularity, 100 guests occupied the hotel daily. However, the spa's heyday ended in its 13th year in 1893, when the hotel closed. Nine years later, the building was sold and dismantled. Its wood was used to construct houses on West Mill Street.

MAYOR FRANK MILARCH. Vita Park, having been purchased by the city in 1905, was allowed to deteriorate to a horrendous condition over the following 10 years. Mayor Frank Milarch called upon civic pride to restore the land to its previous splendor.

Below: **RENOVATED SWAN CITY PARK.** In 1915, volunteers responded to Mayor Milarch's challenge. They cleaned the lagoons and planted flower beds and gardens. New boulder bridges now spanned the lagoons. The pavilions were refurbished. And the park officially reopened in June with a new name, Swan City Park. Harder's Band provided the entertainment as 6,000 people looked on.

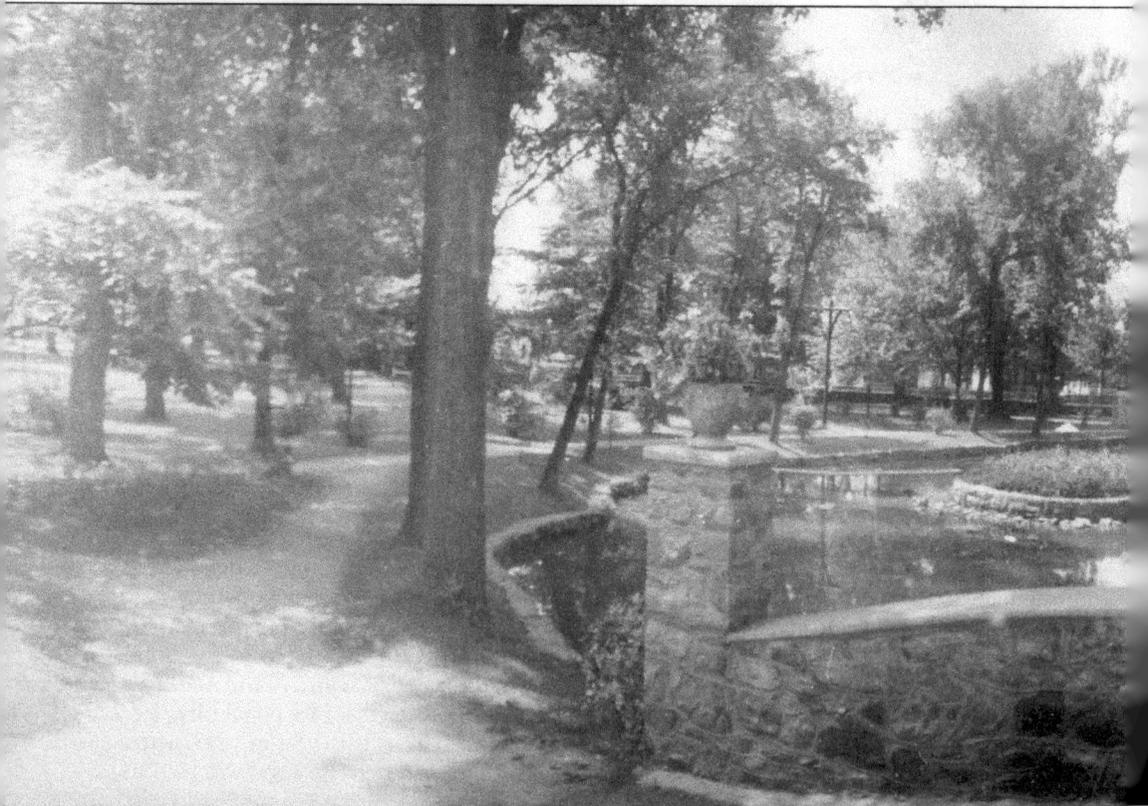

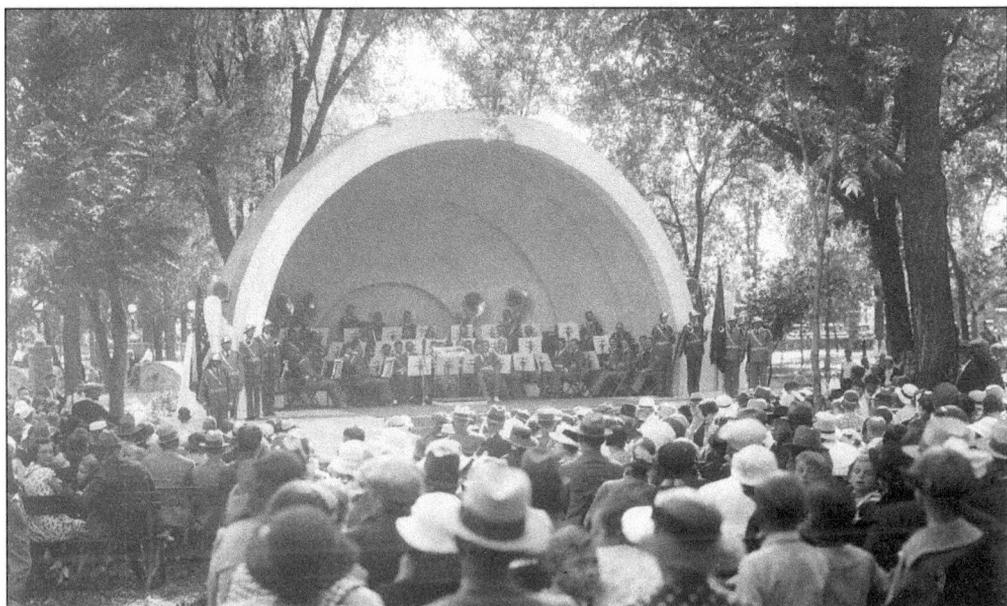

SWAN CITY PARK BANDSHELL. In 1935, Swan City Park unveiled its new bandstand modeled after those created for the Chicago Century of Progress World's Fair Exhibition. Orrin Hofferbert, the genius engineer of Monarch, devised a multi-colored light water show to front the stage area. Three years later, a large singing fountain was placed in the main lagoon, also lit by Hofferbert.

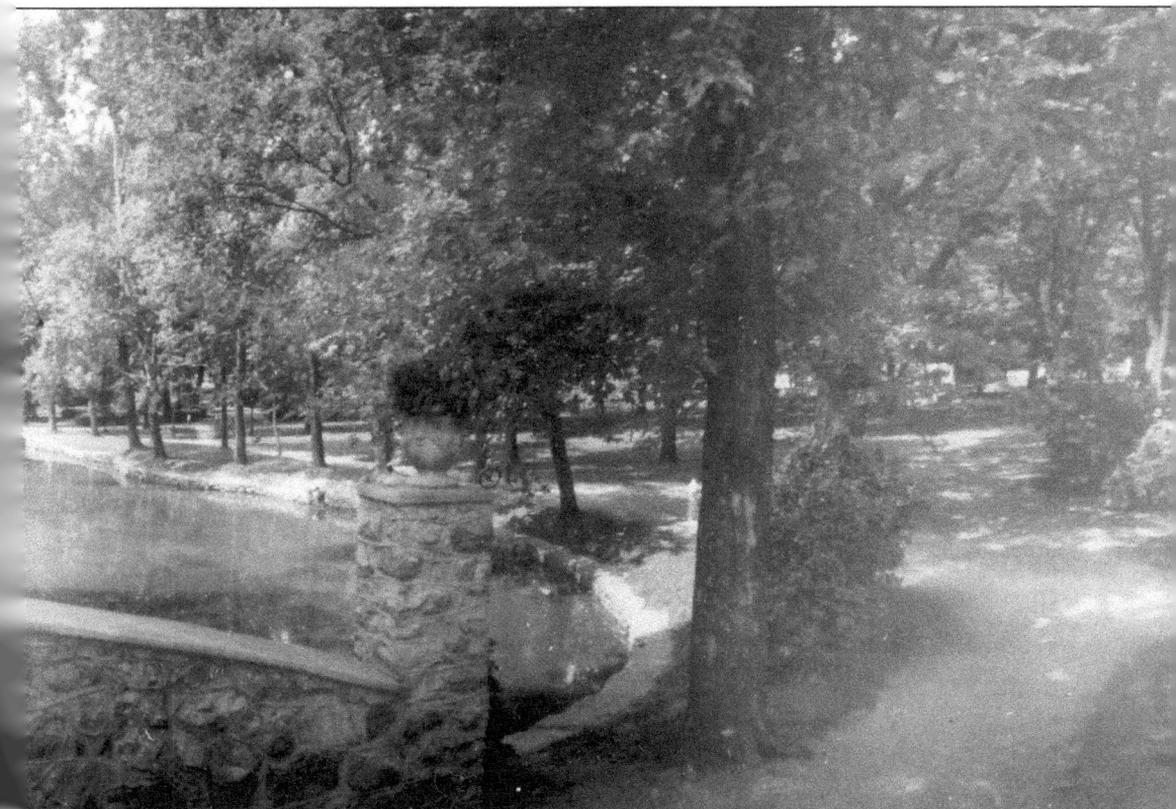

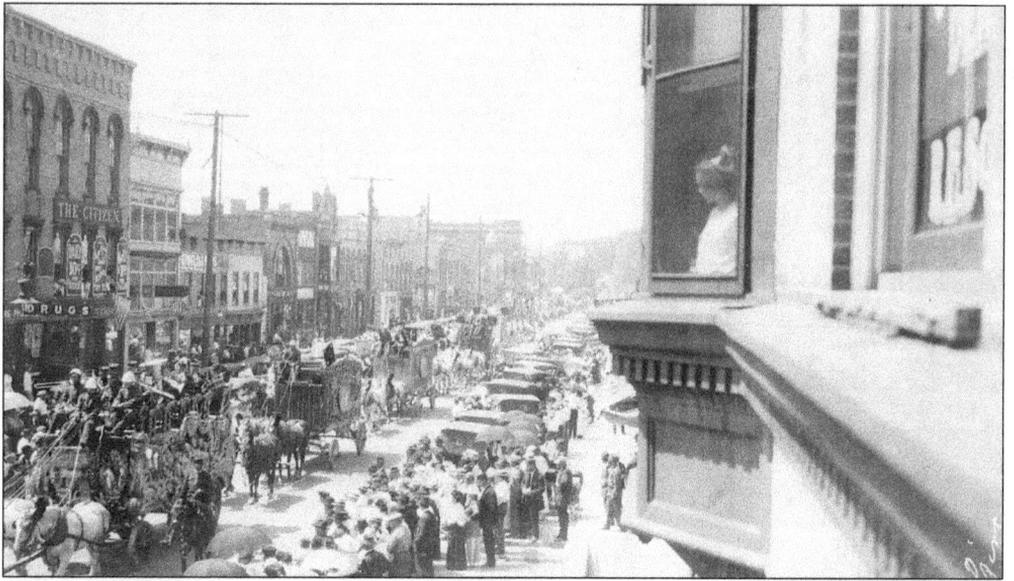

THE CIRCUS COMES TO BEAVER DAM. One of the most highly anticipated events by children and adults alike was the arrival of the circus.

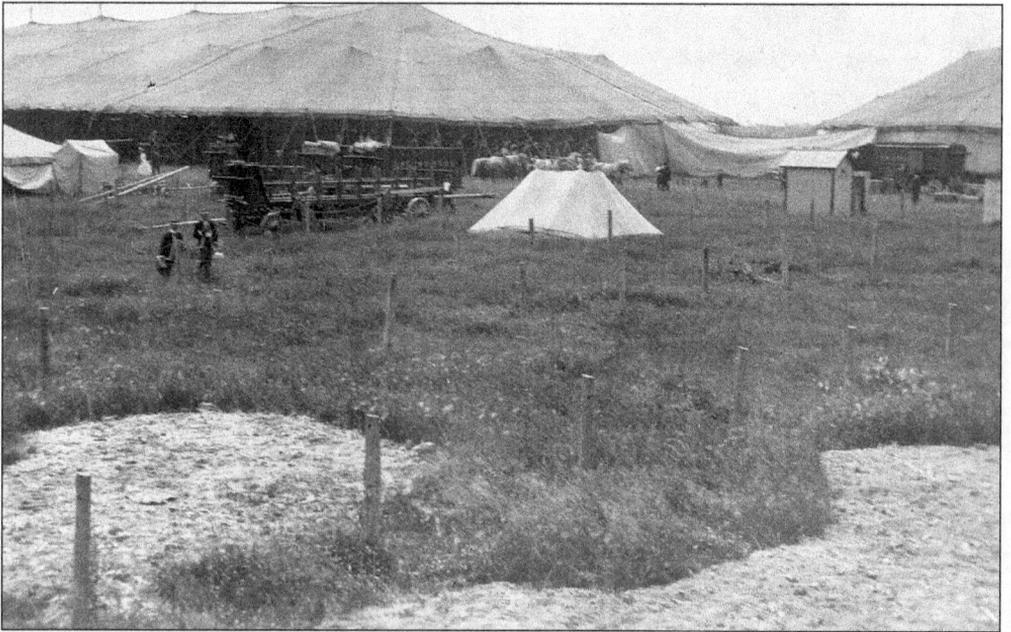

RINGLING BROS. BIG TOP AT THE DODGE COUNTY FAIRGROUDS.

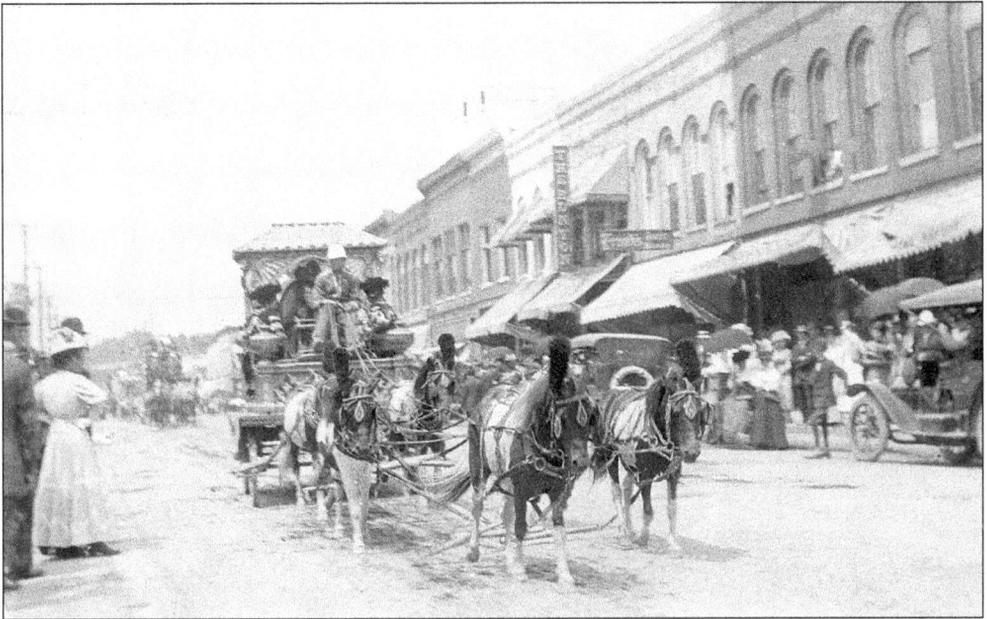

THE CIRCUS PARADE. Depending on the era, the circus would arrive either by rail or road. Prior to rail service, the circus would enter the city from the east on the Watertown to Beaver Dam Road. The procession proceeded through downtown, heading for its destination at a local park or the fairgrounds. If the troop traveled by rail, the circus would disembark at the old depot, parade south down Spring Street, past the business district, and then proceed to their destination, the fairgrounds.

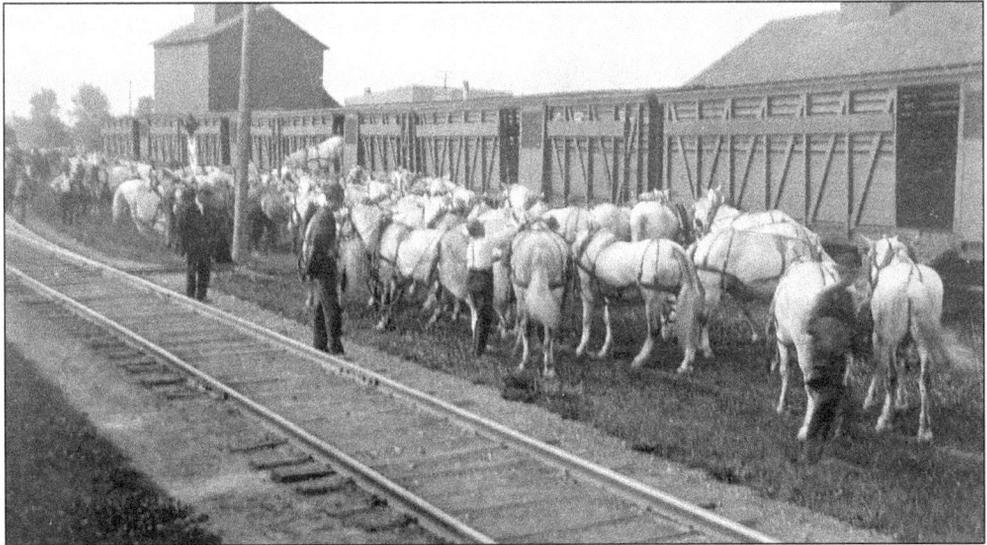

BEAVER DAM: THE HOME OF CIRCUS TROOPS. Wisconsin is known as the home of the American Circus, and Beaver Dam can certainly claim a portion of that renown being the home of three circus troops. The Haight and Dehaven Circus began in 1865, the Haight and Chamber Circus in 1866, and finally, the Haight and Wooten Circus in 1871. The Haight and Dehaven Circus holds a significant place in circus history, as it was the first circus to travel across the country by railroad.

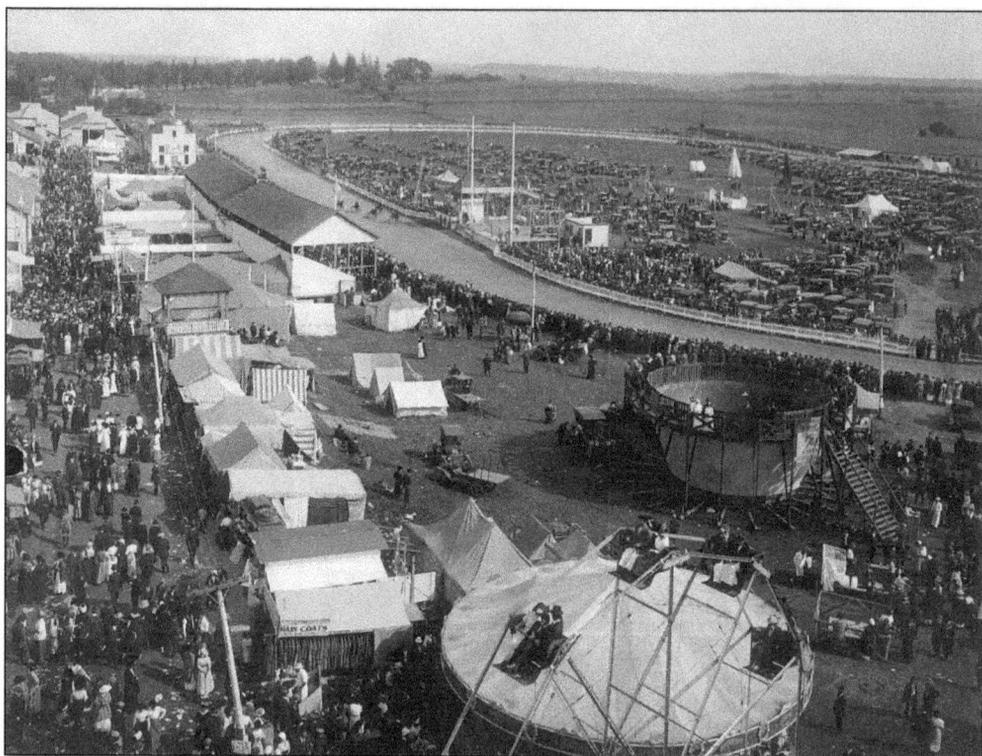

THE WORLD'S GREATEST COUNTY FAIR. The Dodge County Fair had been previously held in Juneau, but in the fall of 1886, the fair found a permanent home in Beaver Dam at the corner of Park and University, the current site of Wayland's fieldhouse. Nicknamed the "Worlds Greatest County Fair," its reputation for excellence reached across the nation. The U.S. secretary of agriculture called it the finest he ever attended.

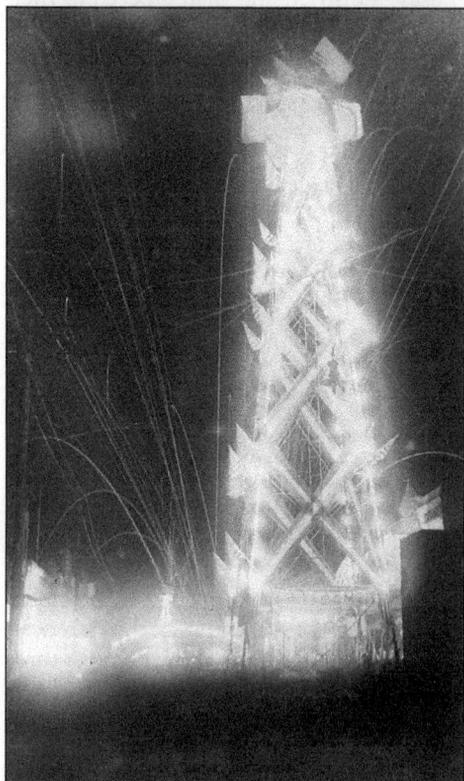

THE FAIR'S DOWNTOWN FIREWORKS, C. 1896. Special trains from Milwaukee and Chicago were commissioned to maintain a constant flow of fairgoers in and out of the city. In its heyday, the fair attracted 70,000 people during its one week run. They would come to partake in one of the greatest exhibitions of midway attractions, show animals, and horse racing. To entertain the throngs of visitors, every year a large tower more than nine-stories high was constructed at the corner of Spring and Front Streets downtown. The tower acted as a launching pad for a fireworks extravaganza that from all accounts would put to shame many modern day exhibitions.

THE FAIR'S FIRST BALLOON ASCENSION, C. 1900.
The fair witnessed its share of firsts and hosted,
for example, the city's first airplane landing and
balloon ascension.

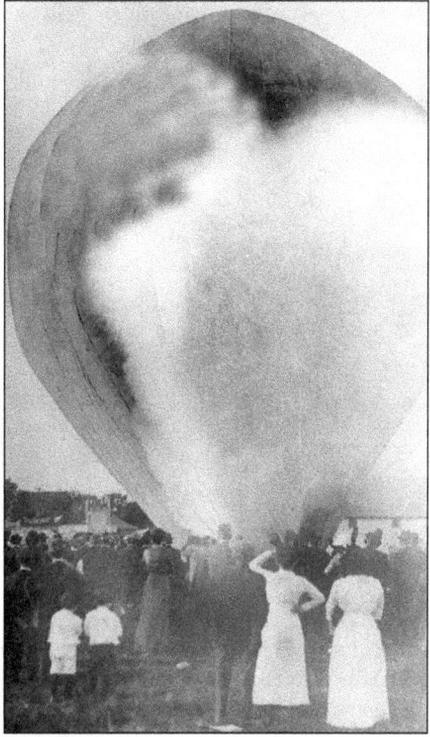

THE 1936 DODGE COUNTY FAIR BOARD OF
DIRECTORS. The fair's high standard has been
maintained throughout its 117-year run. The
1936 board of directors is but one of many
that has dedicated itself to the fair's continued
excellence. From left to right are Elmer Frederick,
George Hickey, Dr. Edwards, Henry Krueger, and
Attorney James Malone.

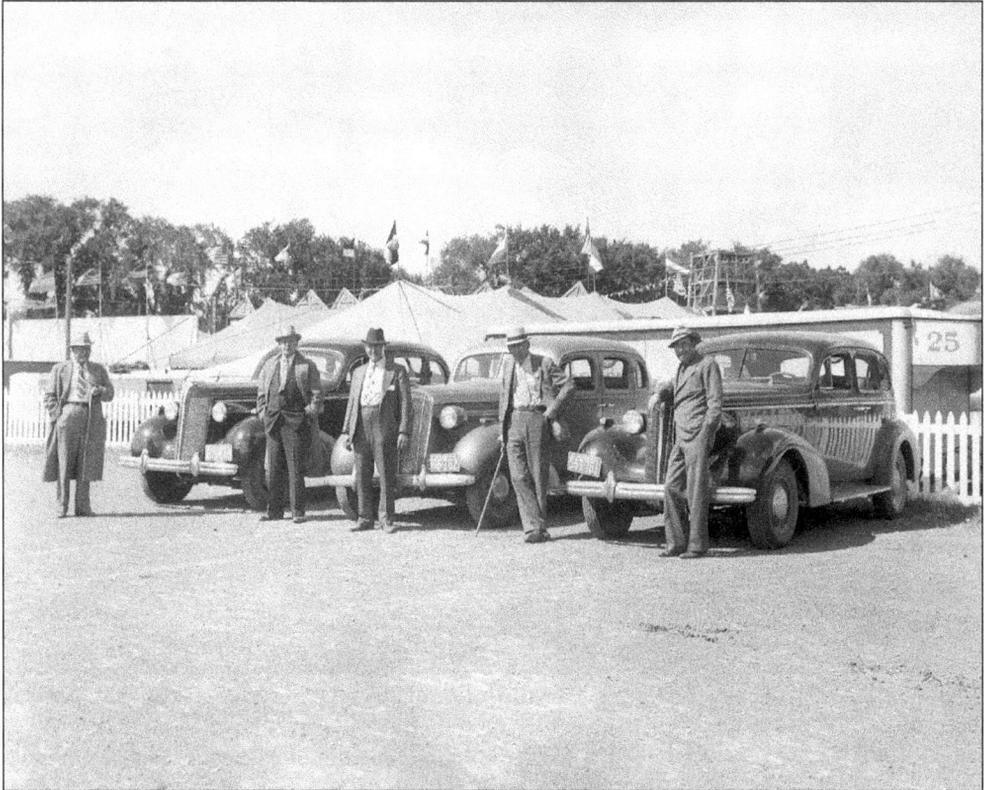

THE NATIONAL PASTIME. One of Beaver Dam's much-loved recreations was soon to become our nation's favorite pastime. Baseball teams with names like the Muldoons, Fats and Leans, and BD Bluesox dueled weekly against clubs from Columbus, Fox Lake, Burnett, Horicon, Juneau, and Milwaukee. In this picture, *c.* 1900, Beaver Dam player Hale scores the first run in a Sunday game versus a local opponent.

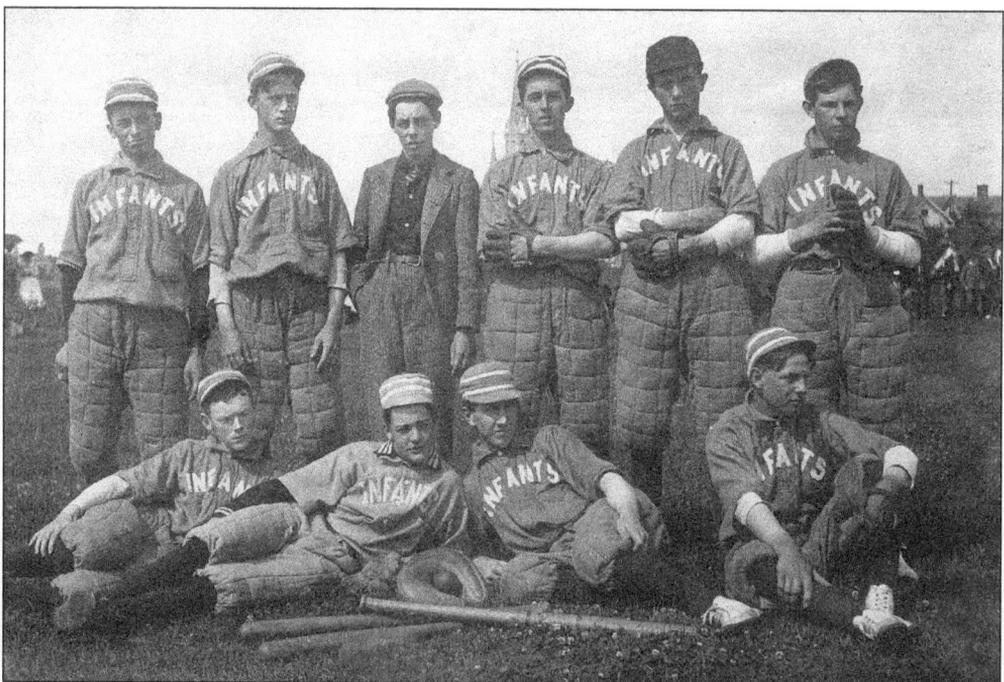

THE INFANTS. A local Beaver Dam team called the Infants prepares to do battle on a Sunday afternoon, *c.* 1900. Pictured here from left to right are the following players: (standing) Tinker Caspari, unknown, manager Humpty Malone, Bert Bates, unknown, and Lawrence Liebig; (seated) Red McCabe, Albert Koch, Ira Hillier, and unknown.

EMERSON "PINK" HAWLEY. One of the Kings of the Diamond hailed from Beaver Dam. Emerson "Pink" Hawley was born on December 5, 1872, and was twin brother to Elmer "Blue" Hawley. Their nicknames were derived from the color of clothing and ribbons used to identify the pair as infants. The Hawleys developed into one of the finest batteries in the state. Pink handled the pitching duties, Blue the catching. Many claimed Blue to be the better athlete, but Blue's fatal bout with pneumonia at the age of 19 left only Pink to carry the Hawley name into major league baseball.

His career spanned 10 seasons from 1892 to 1901 for such teams as the St. Louis Browns, NY Giants, and the Milwaukee Brewers. In 1895, his greatest year, he won 32 games and batted .308. Known for his sweet nature off the field, his on-field demeanor was fueled by his highly competitive nature. Never one to back down from a fight, Pink was famous for settling on-field disagreements with fisticuffs whether the argument was with opposing players or umpires. His penchants for fancy clothes, as well as his prowess on the mound, earned Pink the nickname the "Duke Of Pittsburgh." Upon retiring, he returned to Beaver Dam to coach in the semi-pro state league.

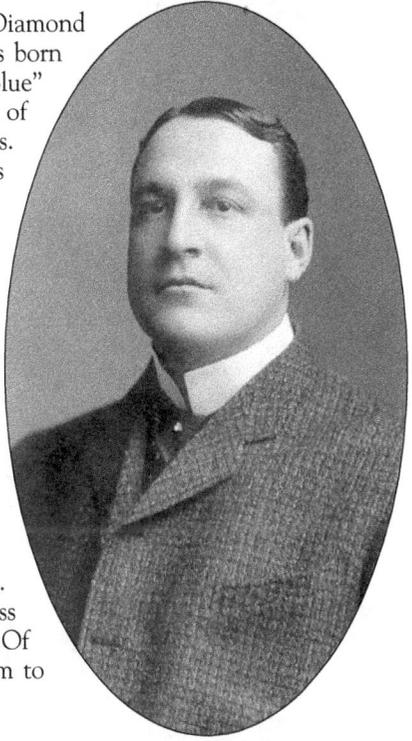

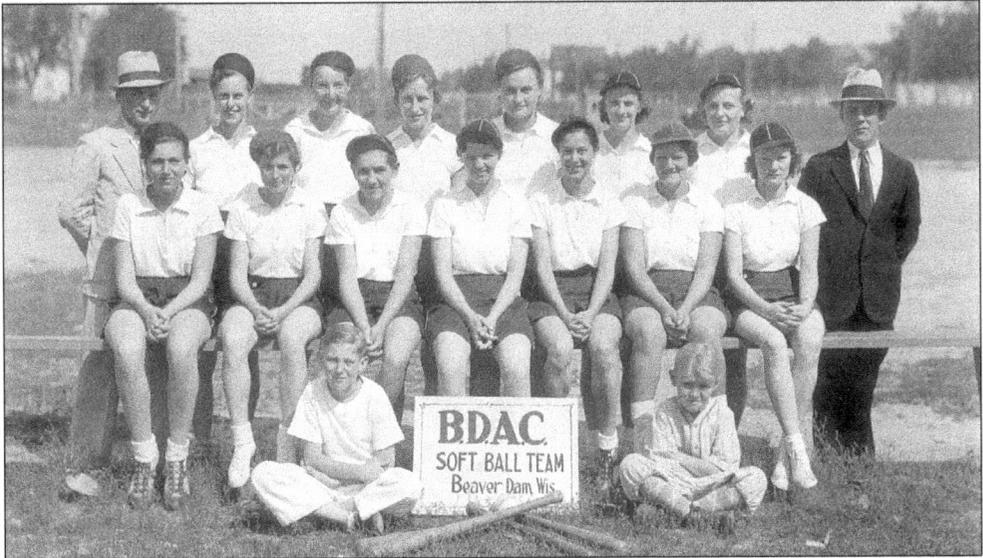

THE 1934 BEAVER DAM GIRLS SOFTBALL STATE CHAMPIONS. Prowess in the baseball arena was not left to the male of the species. Led by Maddy Horn and Vi Schneider, the 1934 Beaver Dam Girls Softball Team beat all comers as they won the state championship. The team included the following, as pictured here from left to right: (back row) Bill Messer (manager), Marian Lawrence Ellis, Mabel Oathout, Elizabeth Zamzow Becker, Maddy Horn, Ellie Wimmer, Angie Wimmer, and Earl Hendrick (coach); (front row) Dorothy Herr, Jeanette Kopff, Betty Edgerton, Bessie Berent, Blanche Schwartz, and Lorraine Rabehl; (sitting) Batboys Bill Schneider and Edward Pope.

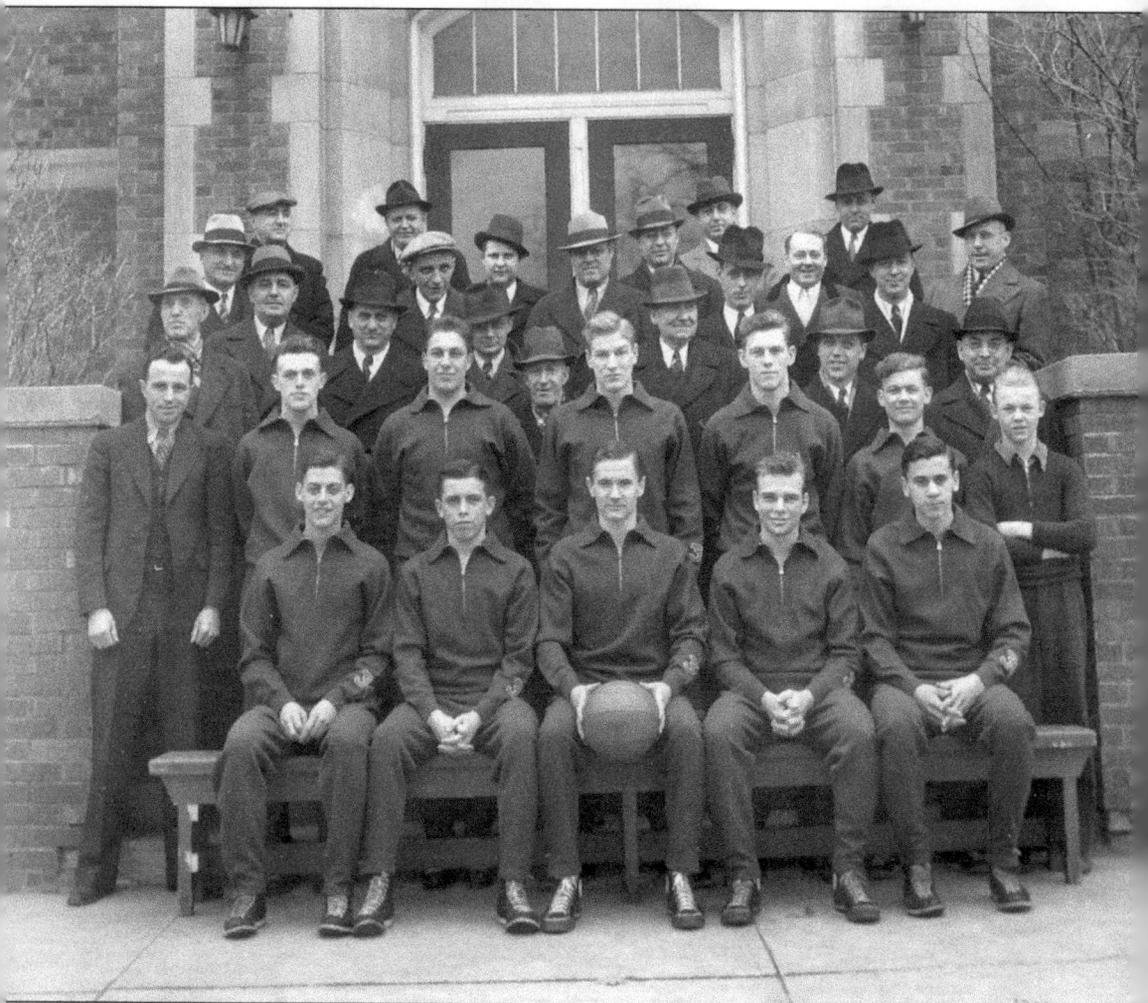

THE 1937 STATE CHAMPION BEAVER DAM HIGH SCHOOL BASKETBALL TEAM AND THE KIWANIS CLUB. Pictured from left to right are the following: (front row) Lyman Linde, Oliver Knoll, Don Halbman, Gib Lindloff, and Lawrence Kuehl; (second row) Coach Don Huddleston, Bob Ritsch, Mike Krobert, Harold Lutzke, Len Kronenberg, Ray Bennett, and A. "Eggs" Hammond; (third row) Charlie Starkweather, Wm. Hoefs, Warren Clark, Harold Grace, Clarence Keller, A. Wichman, Jim Huston, and Donald Kleinfelter; (fifth row) Lester Martin, Larry Hartzheim, Archie Luedke, and Jessie Canniff.

Six

MILITARY

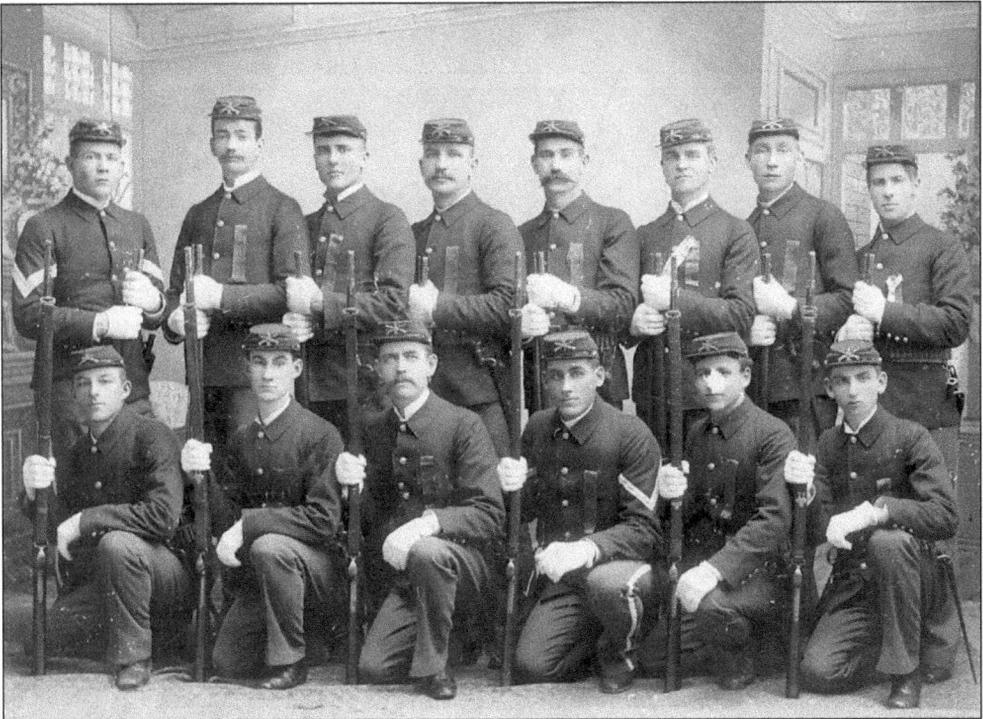

VETERANS OF THE SPANISH-AMERICAN WAR. The following men served in Puerto Rico during the Spanish-American War. Pictured from left to right are: (front row) Charles Hammer, Warren Porter, Willie Sculley, John Hankey, Louis Heninger, and Arthur Young; (back row) Charles Butler, Carl Ruedebusch, Jon Stancheski, Fred Kunklie, George Baner, Fred Edgerton, John Schiale, and Harvey Johnson.

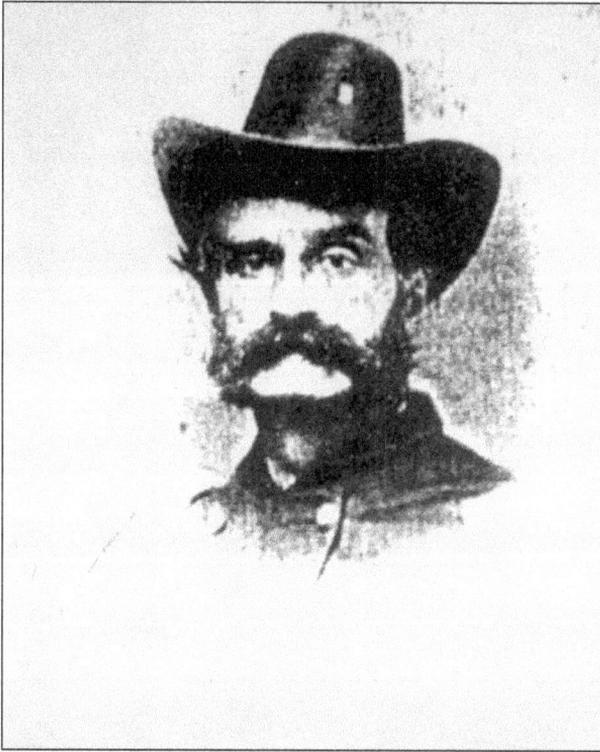

Capt. T.B. Catlin. The beginning of the 1860s would find a city divided. Though geographically one of the most northern states, many pro slavery sympathizers called Beaver Dam their home. But with the firing on Ft. Sumter on April 14, 1861, Beaver Dam was united behind President Lincoln. The unit known as the Beaver Dam Rifles, under Captain T.B. Catlin, was the first to answer the call. Its roster reflected a who's who of Beaver Dam citizenry. Ordway, Lewis, Patch, McFetridge, Drown, and Gould are just a few of those who served.

Remaining Members of the Grand Army of the Republic.

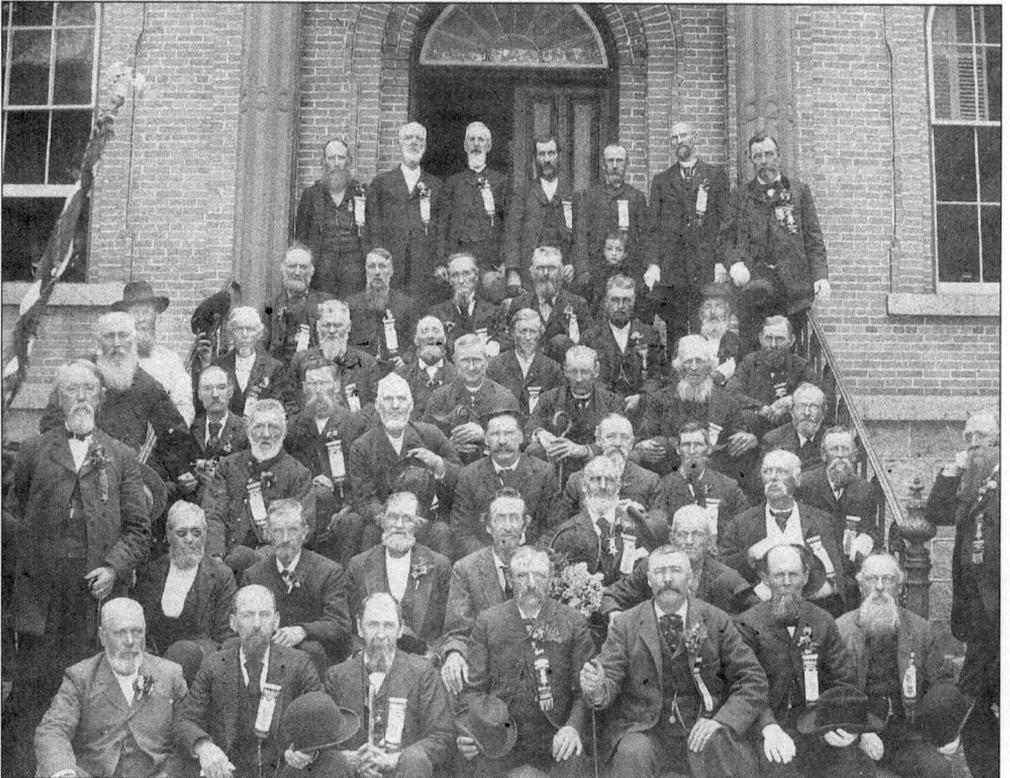

WILLIAM COXSHALL IN LATER YEARS.
Private William Coxshall played a
significant role in the Civil War's
final chapter. Coxshall, unaware of
the duty, volunteered to be one of the
hangmen of the Lincoln Conspirators.
One of the convicted conspirators was
a woman by the name of Mary Surrat.
After his tour of duty, Coxshall returned
to Beaver Dam and lived out his life
running a successful butcher shop. But
to his chagrin, he would be forced on
many occasions by pestering youth and
adults alike to relive the day he avenged
Abraham Lincoln's assassination.

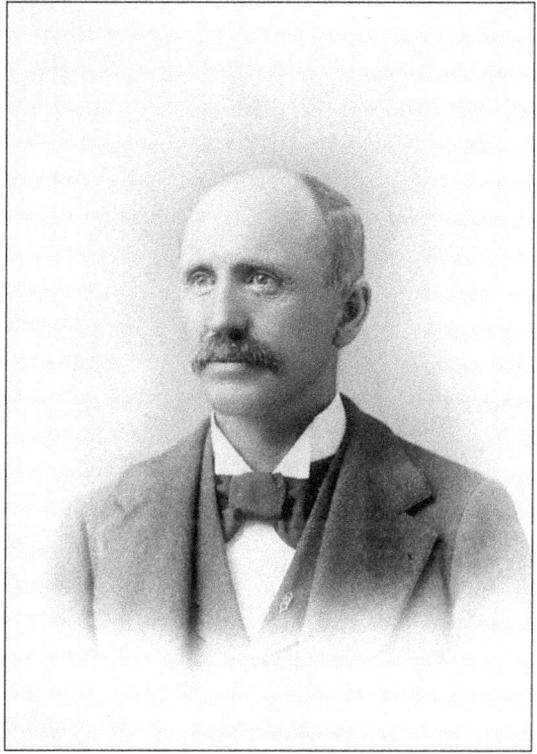

**THE HANGING OF THE LINCOLN
CONSPIRATORS.** Private Coxshall,
marked by an "x" in the photograph,
prepares to knock over the huge
timbers that will release the trap doors
allowing the noose to do its job.

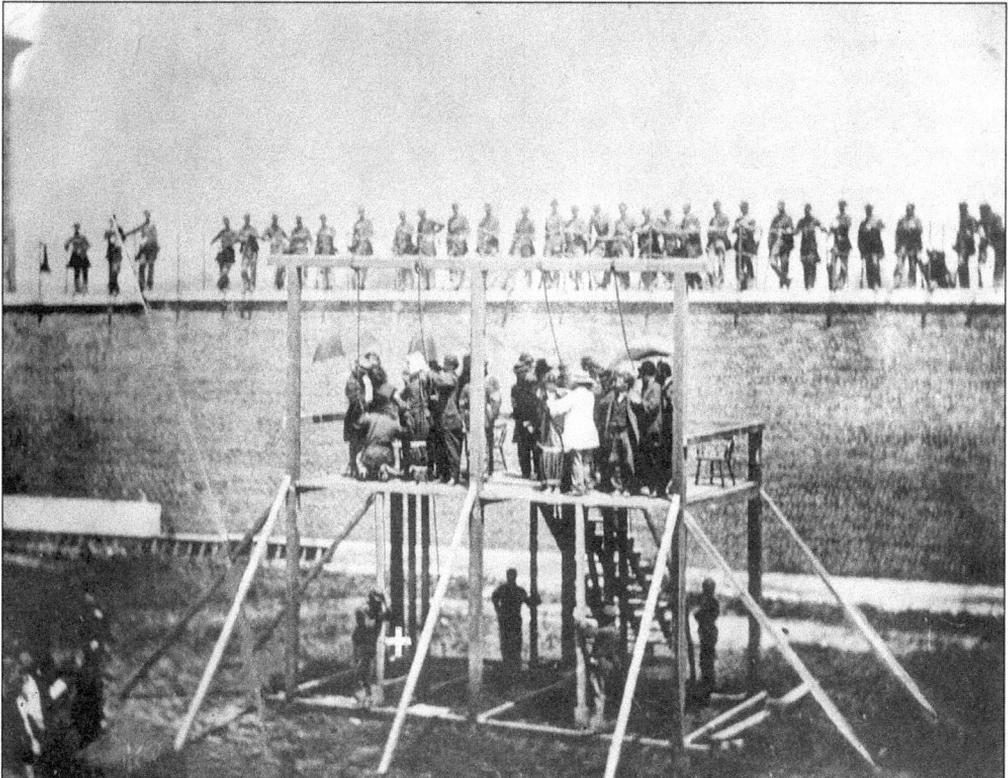

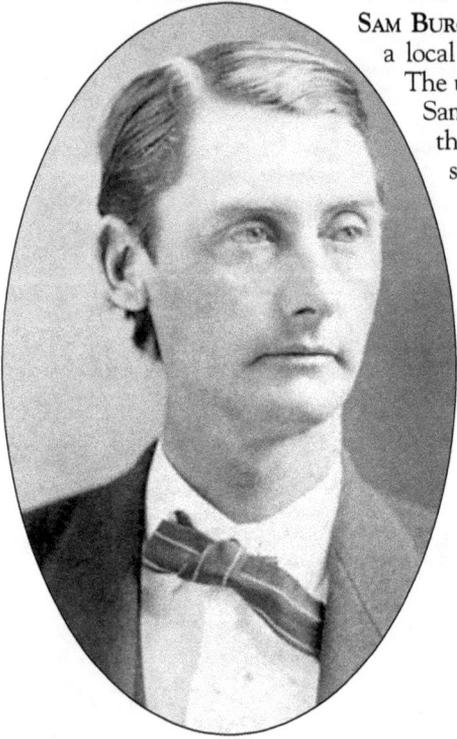

Sam Burchard. In 1880, the City of Beaver Dam organized a local militia. Seventy men signed on to form the unit. The unit elected to name itself the Burchard Guards after Samuel D. Burchard, a man who served loyally during the Civil War and held such honorable offices as mayor, state senator, and congressman.

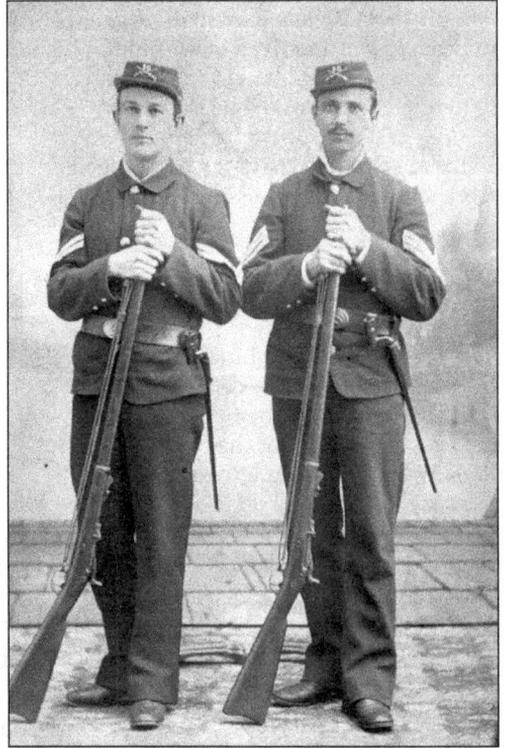

The Burchard Guards. The Burchard Guards were chartered by the governor in October of 1880. The company was assigned to the Fourth Battalion under the command of Lieutenant Colonel Chandler P. Chapman. The troop drilled in the concert hall for its first year-and-a-half. In 1882, the company relocated to the third floor of the unfinished new city hall. The soldiers installed the hardwood floors and plastered the walls. Pictured are two unidentified members of the guard. Note the "BG" on their military caps.

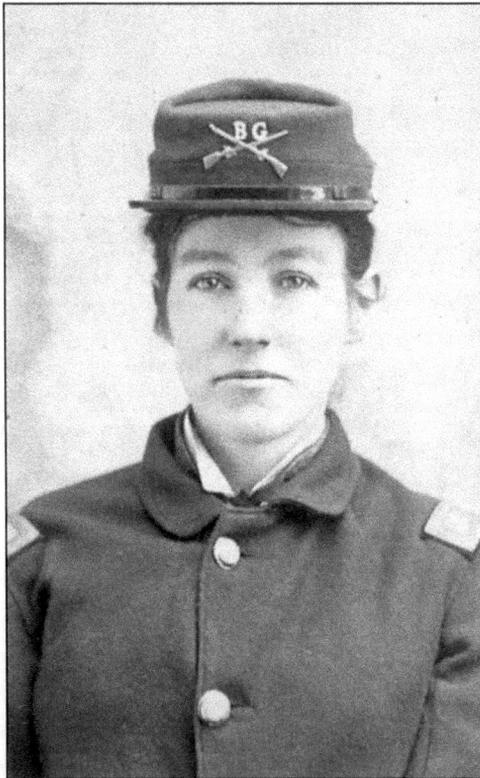

Annie Weaver. Annie Weaver tries on husband O.F. Weaver's Burchard Guards uniform. O.F. Weaver was one of the founding members of the guard.

COMPANY K AND THE SPANISH-AMERICAN WAR. In 1882, the governor issued an order requiring all guard units to discard private names and be assigned to regiments. The Burchard Guards became Company K and was assigned to the second regiment. The 19th century concluded with Beaver Dam joining the nation in a frenzy of patriotic fervor when the United Sates declared war against Spain. The city's Company K assembled for departure at the train station within hours of the president's call to arms. Company K's swift response was considered so remarkable that the unit received a special federal commendation. Eventually, Company K reached Puerto Rico where all fatalities to the company came from tropical disease, none from the battlefield. Although the war lasted a mere 8 months, the celebration for the returning troops will always be remembered as one of the most glorious ever experienced by the city. In this photo, Beaver Dam citizens await the company's return at the train station.

COMPANY K'S RETURN FROM PUERTO RICO. Company K returned from the Spanish-American War on September 9, 1898. Beaver Dam residents marked the return with a grand celebration.

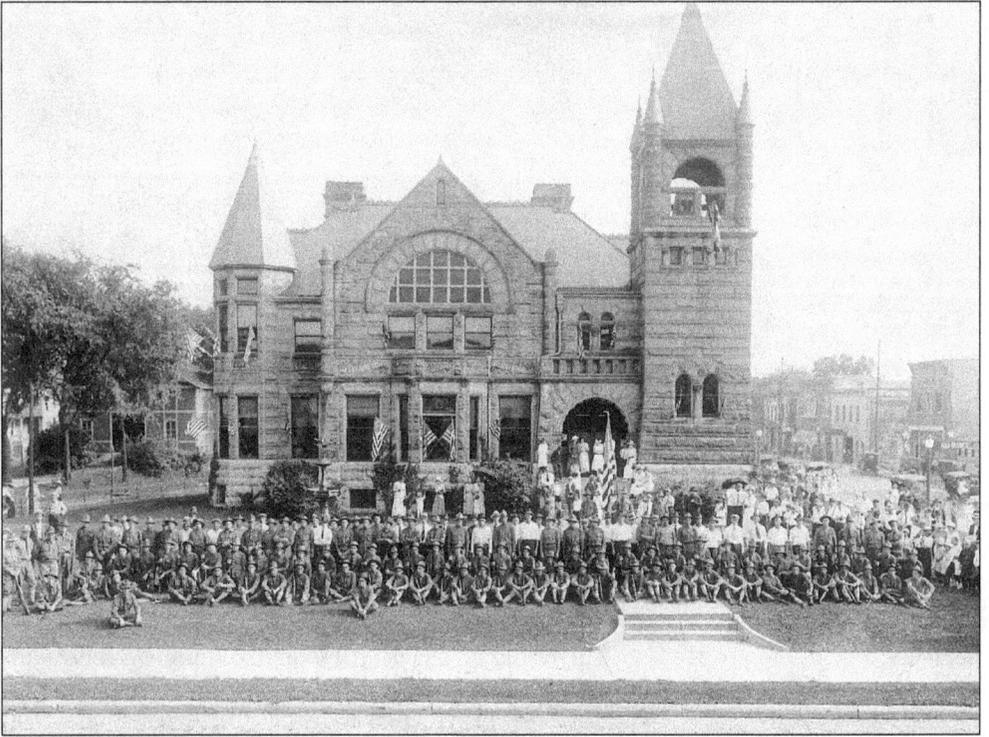

WWI AND COMPANY K. On the first day of military registration, 720 Beaver Dam men enlisted. By the end of the war to end all wars, the city had lost 26 men.

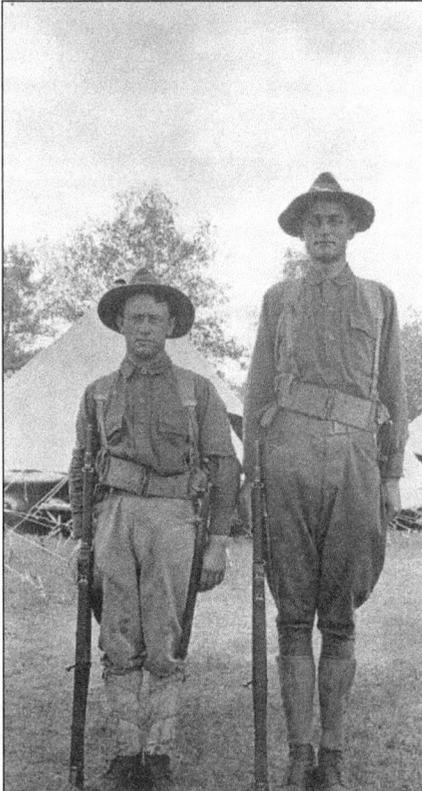

WWI SOLDIERS. Pictured are soldiers Charles Link (left) and John E. Miller. John E. Miller was the first Beaver Dam man to die in the war on the battlefields of France. The local American Legion Post 146 is named after serviceman Miller.

THE HOMEFRONT. The Red Cross took over the J.J. Williams House on Park Avenue. During WWI, local volunteers worked endless hours to help meet the needs of servicemen abroad.

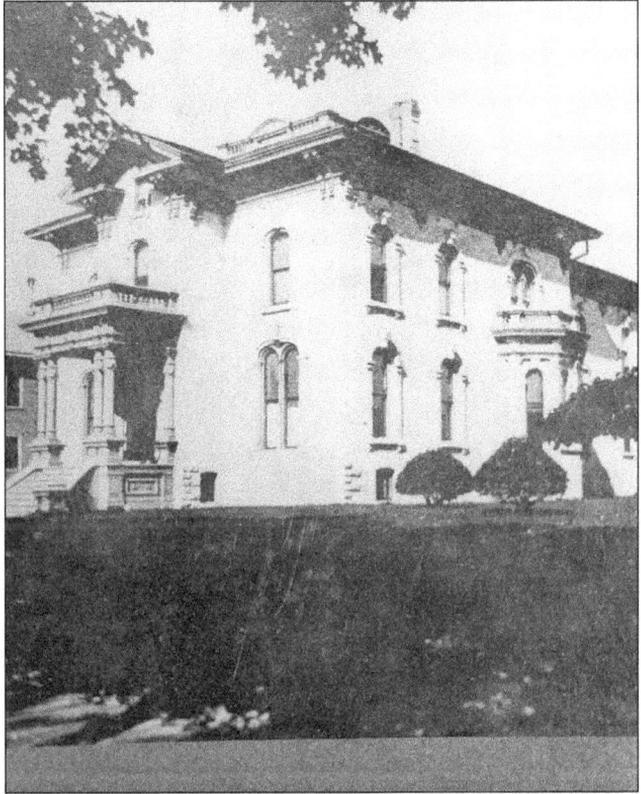

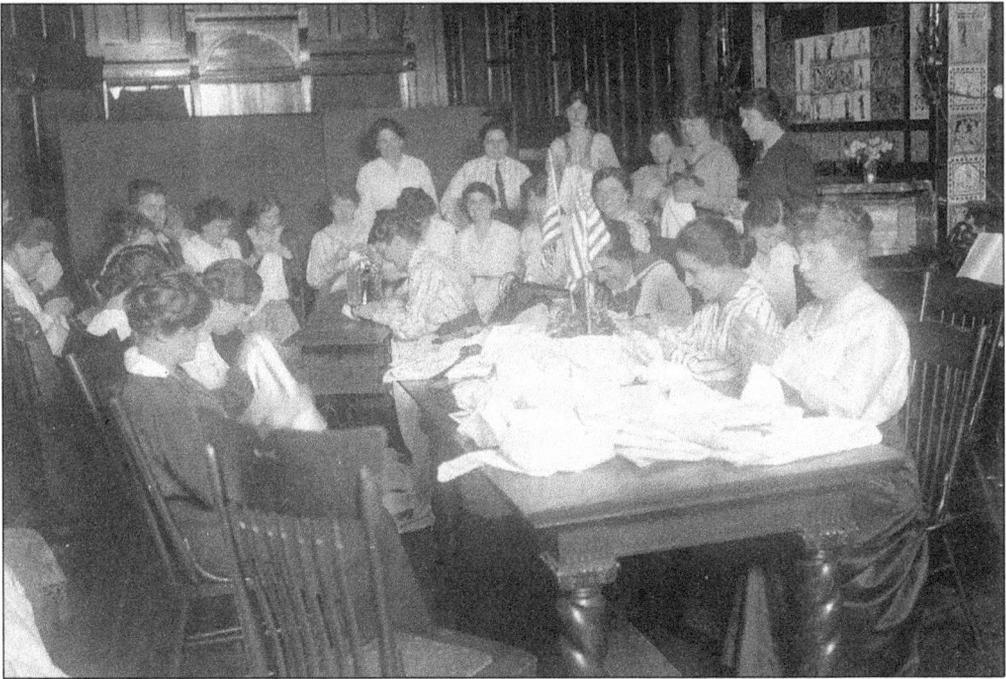

THE RED CROSS AT WORK. At its height, 200 women were sewing pajamas and hospital shirts, and folding gauze and muslin dressings for the war effort.

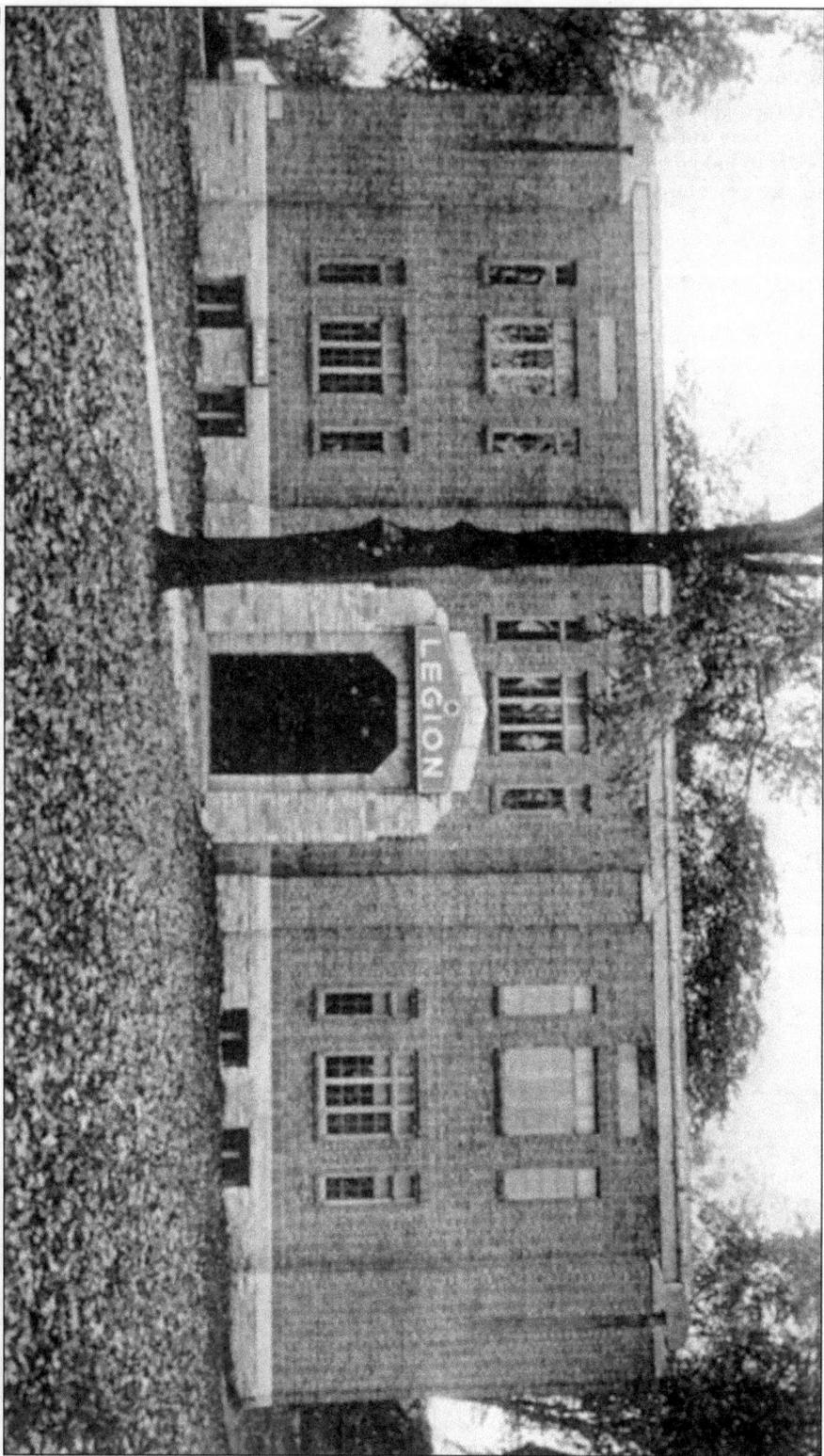

THE AMERICAN LEGION BUILDING. The American Legion Post 146 was chartered in 1919, adopting the name the John E. Miller Post 146. Albert A. Parker served as the post's first commander. The membership numbered 212. Post 146 moved to its current home at 200 West Street in 1935. Commander A.A. Volkman presided over the first meeting in the building on June 11, 1935.

Seven

FAME

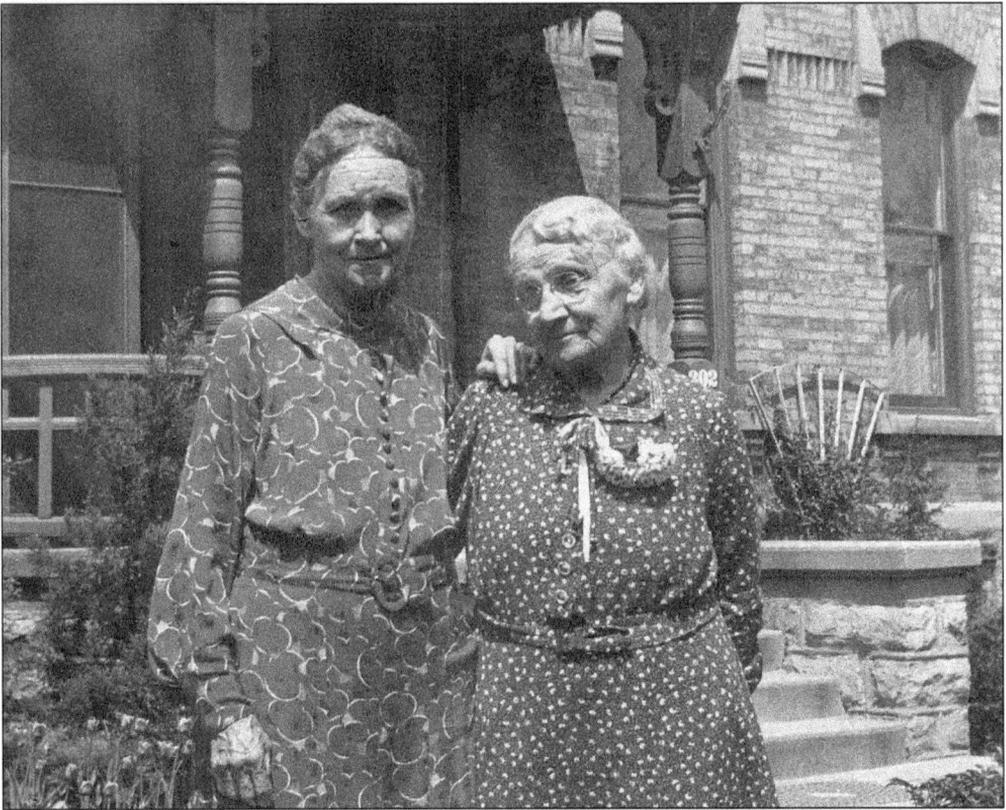

MARY SPELLMAN AND CAROLINE SHERMAN BEULE. Two of the most famous daughters of Beaver Dam are pictured here; Mayor Mary Spellman (left) and Mrs. Peter Beule. Mary Spellman was a beloved teacher who served the Beaver Dam School District for 51 years. After her retirement, she was elected mayor, holding the distinction as the first female mayor in Wisconsin and the first female mayor in the country in a city the size of Beaver Dam. Caroline Sherman Beule was one of the city's local historians and a founding member of the Dodge County Historical Society, Inc.

JUDGE A. SCOTT SLOAN. One of the greatest men to ever call Beaver Dam home, Judge A. Scott Sloan served his community on every level—local, state, and national. Sloan arrived in Beaver Dam in 1854 to practice law. Elected mayor in 1857, 1858, and 1879, Sloan also served as judge for the Third Circuit Court in 1858. A man of high principal, Sloan was an outspoken abolitionist and good friend of Abraham Lincoln. The two would travel together on the campaign trail, Sloan for congress and Lincoln for presidency. The two often shared accommodations, and Sloan would later complain that Lincoln's restless slumber often left Sloan napping on the hard floorboards. Both were elected to their respective federal offices, and Sloan was a trusted advisor to Lincoln during the Civil War. In 1864, he was appointed clerk of the United States District Court. From 1868 to 1874, he served as a judge for Dodge County. In 1873, he was elected attorney general for the State of Wisconsin. In 1881, he was elected judge of the Thirteenth Judicial District, a position he held until his death in 1895, when newspaper headlines across the state simply read, "Wisconsin's Giant Jurist, Dead."

LT. COMMANDER ALBERT MERTZ. In 1908, as a captain in the U.S. Navy, Albert Mertz navigated the smallest lightship squadron from New York around Cape Horn of South America to San Francisco. This accomplishment, as well as many others, were rewarded two years later when President Taft promoted him to the high position of rear admiral.

U.S. DESTROYER MERTZ. Admiral Mertz received one of the ultimate honors for a navy man when in September of 1943, a U.S. Naval Destroyer Leader was christened the *Mertz*.

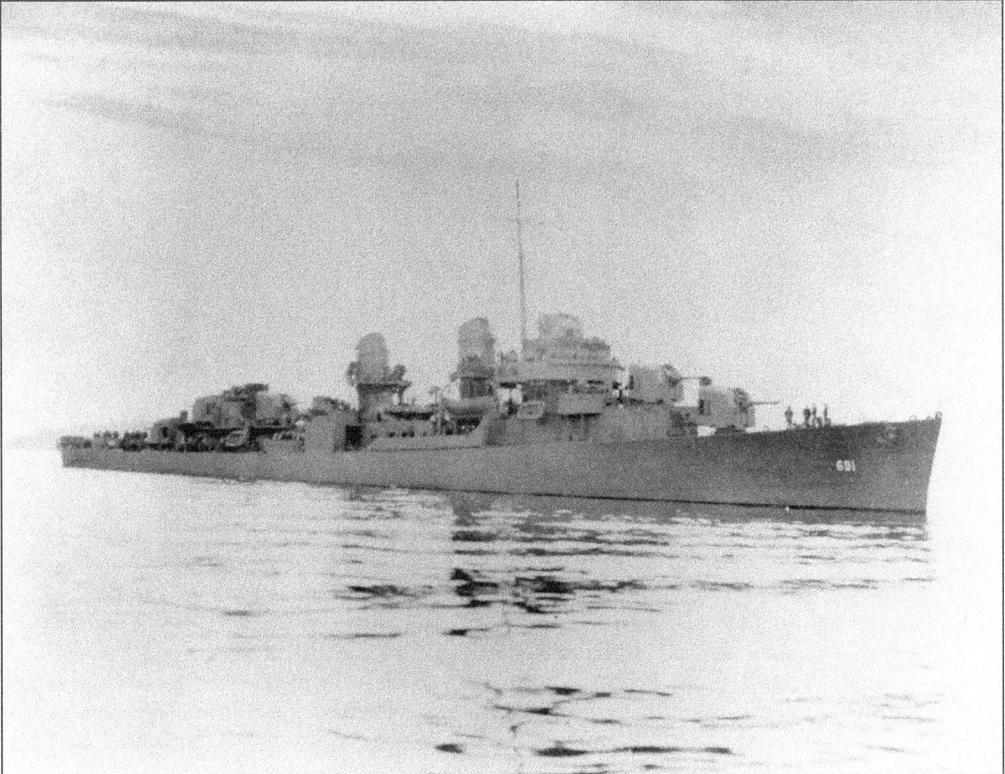

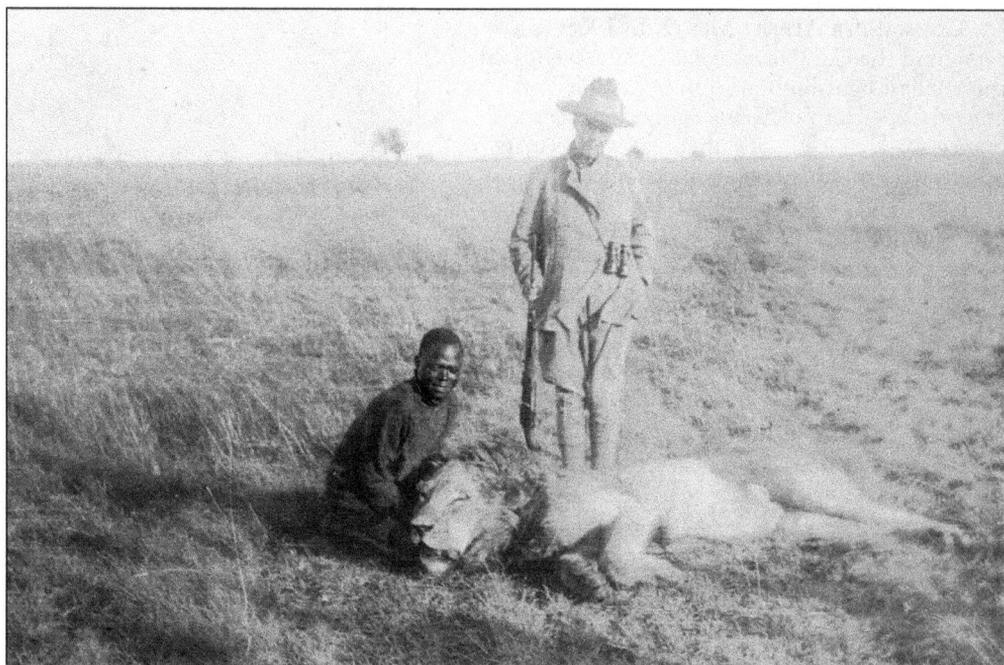

DELIA DENNING AKELEY. Delia Denning Akeley, along with husband Carl Akeley, mounted several safaris into deepest Africa. Delia's feats included the bagging of the largest elephant ever taken out of the continent. But her greatest contribution was her documentation of new species of plants, behavioral patterns of numerous animal species, and local native tribes. Her research was groundbreaking work for modern scientists such as Jane Goodall and Margaret Mead. (Courtesy of the Delia Denning Akeley Family.)

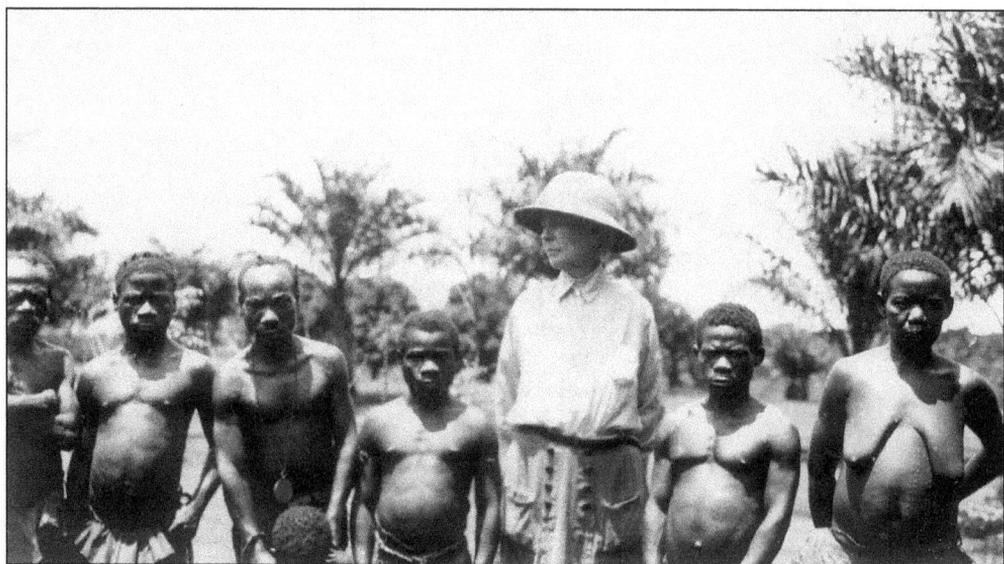

DELIA DENNING AKELEY WITH PYGMY TRIBE. In later years, at nearly the age of 60, Akeley headed the first solo expedition by a woman into Africa. She was the first white person to live and interact freely with the fierce Pygmy tribes in the British East Congo. (Courtesy of the Delia Denning Akeley Family.)

RAYMOND Z. GALLUN. Another Beaver Dam boy would make his mark in literature when, in 1935, Raymond Z. Gallun took his place as one of the 3 most influential science fiction writers of all time when he wrote the short story "Old Faithful." In his career spanning six decades, Raymond Gallun wrote over 100 short stories and 7 books.

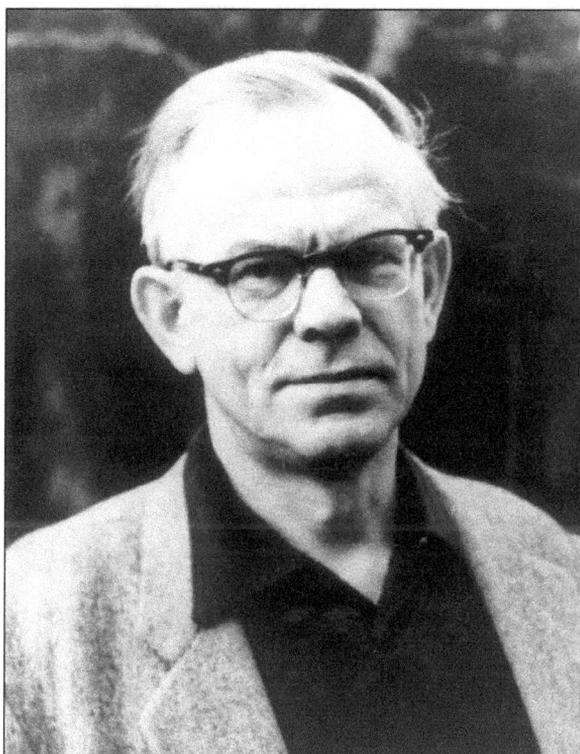

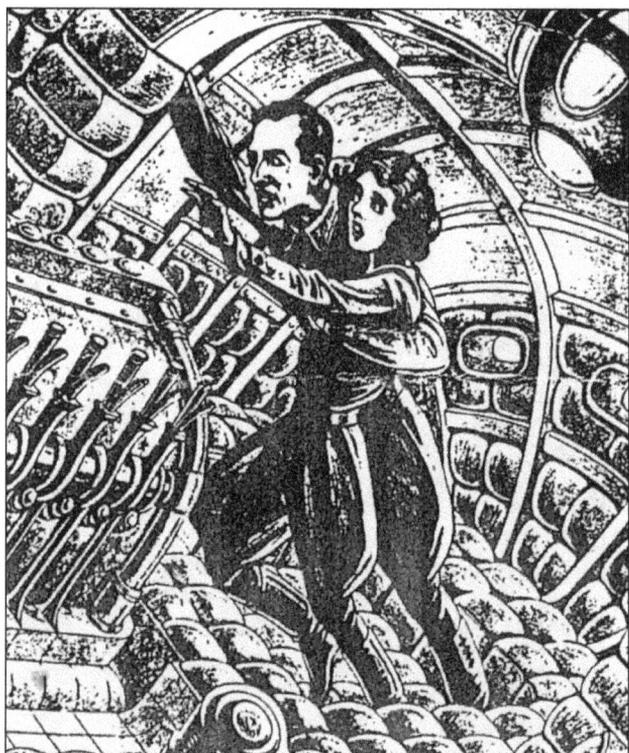

"OLD FAITHFUL" PULP FICTION STORY ART. The writing of "Old Faithful" by Raymond Gallun revolutionized the science fiction genre. It was the first depiction of an alien as friendly, rather than as a marauding, bloodthirsty extra-terrestrial. Instead of depicting only battles against spacemen, it was now possible for the science fiction writer to send man out to explore the heavens in concert with other species.

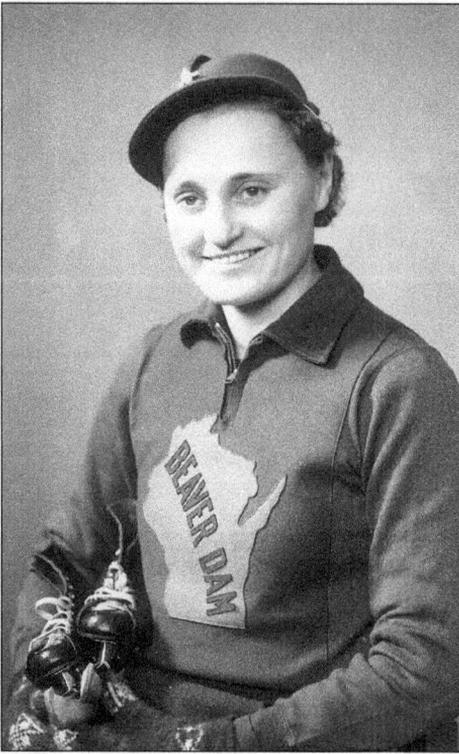

Speed Skater Maddy Horn. In 1937, Maddy Horn became the first Wisconsin woman to win a national championship in speed skating. In her illustrious career, she would win two more national championships, compete at the World Championships in 1938, set 10 world records (one of which stands to this day), and become the only female speed skater from the U.S. chosen to compete in the 1940 Olympics.

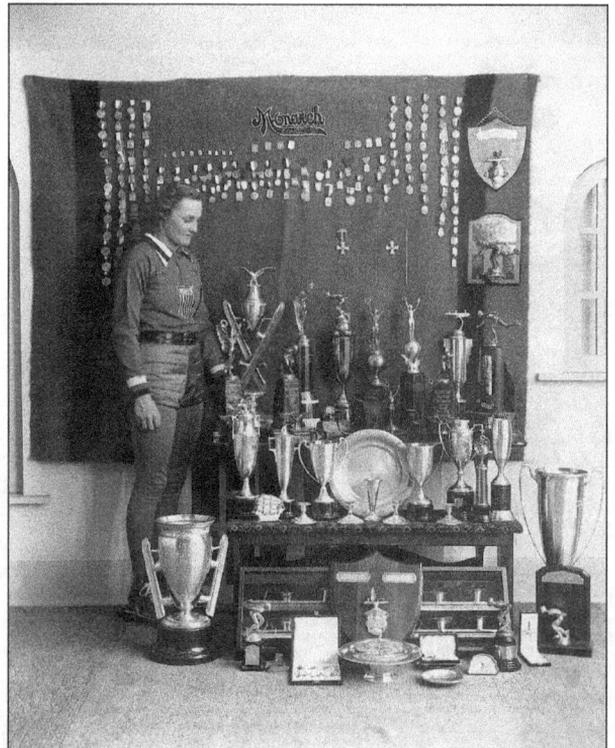

Maddy's Trophies and Medals. Maddy Horn won over 50 trophies and over 125 medals. However, Maddy was robbed of her opportunity at Olympic gold when at the very prime of her career, while boarding the ocean liner for Europe, she was informed that the games had been canceled due to the outbreak of WWII.

MADDY HORN IN HER OLYMPIC UNIFORM.
Denied her Olympic dream, Maddy
returned to the North American
competition circuit. She would proudly
wear her Olympic uniform at competitions.
Of her last 67 races, she won 63 and
retained her national crown.

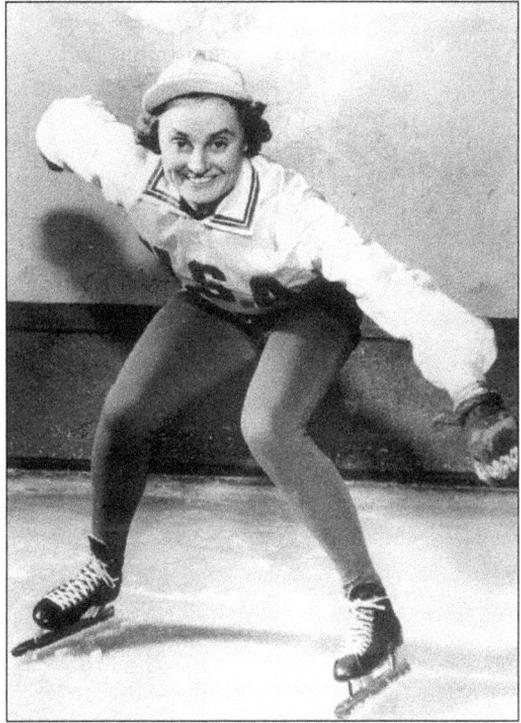

MADDY AND THE PRESIDENT. Maddy's
last race was scheduled for Washington
D.C. During her career, she had met the
crown heads of Europe as well as almost
every local and state official possible
from mayors to governors. However for
this competition, she was to present a
20-pound loaf of cheese to President
Franklin Delano Roosevelt. Unfortunately,
Roosevelt was in ill health and unable to
attend the presentation ceremony. Maddy
is shown presenting the loaf to Edwin
Watson, President Roosevelt's secretary.
Senator Robert M. LaFollette is to the left
of Maddy.

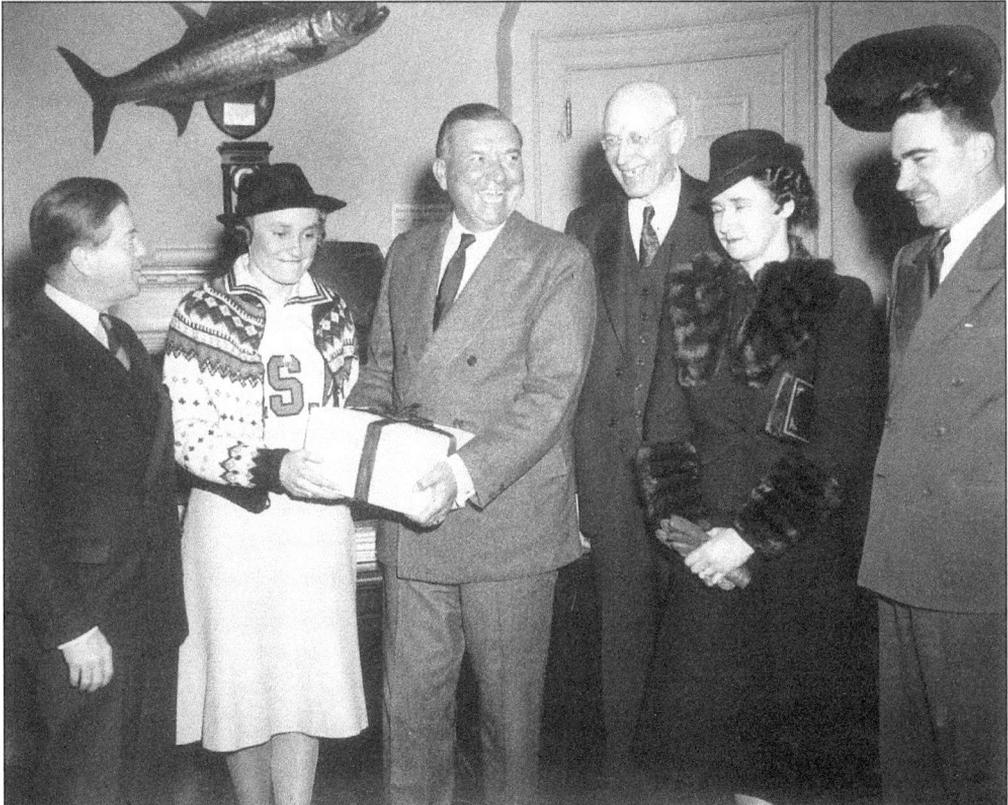

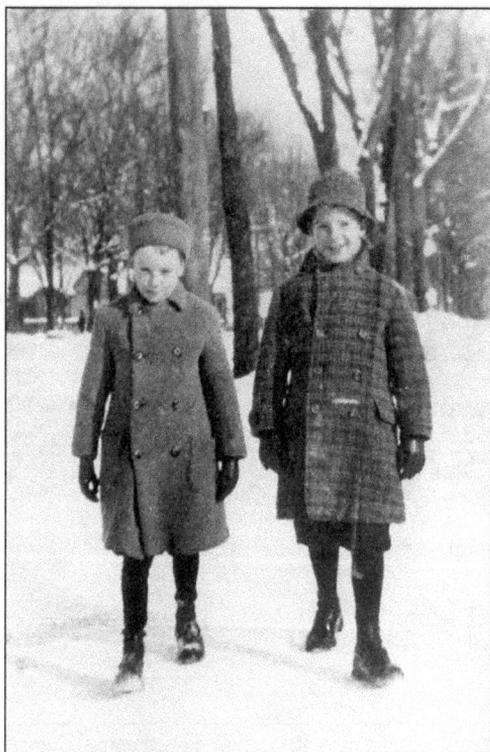

FRED MACMURRAY. Although born in Kankakee, Illinois, while his mother and violinist father were on a concert tour, movie star Fred MacMurray would always call Beaver Dam his home. He spent his formative years here and graduated from high school at the age of 16—the proud recipient of 10 varsity letters and the American Legion Award for excellence in academics and athletics. Here, the young Fred is pictured with childhood friend Randall McKinstry strolling down Park Avenue.

FRED MACMURRAY PUBLICITY SHOT. Fred MacMurray would go on to star in more movies than any other Golden Era star except John Wayne. He also found tremendous success on the small screen as "America's Favorite Dad" in the TV series *My Three Sons*. Here, he is pictured in 1935 on the set of his third movie, *CAR 99*, promoting his Beaver Dam boy-next-door image.

BRIAN DONLEVY. Former Company K mascot Brian Donlevy also went on to stardom in Hollywood. He was known as one of the greatest character actors of all time. His career spanned five decades. A young Brian is pictured here with his father, T.H. Donlevy, who was the superintendent of the local woolen mill.

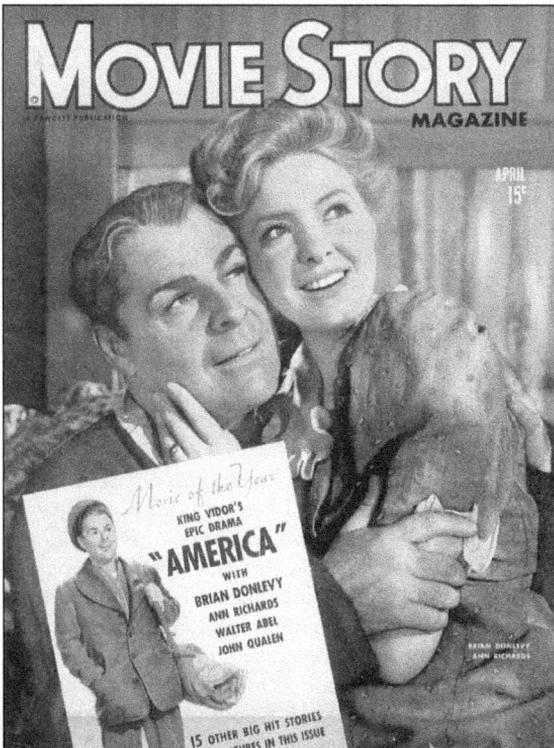

LEADING MAN BRIAN DONLEVY. Although best known as a character actor, Brian Donlevy would occasionally break away from the stereotype to star as the leading man, most notably in *The Great McGinty*. This *Movie Story* magazine cover from 1944 depicts another leading man opportunity for Donlevy in the epic movie *America*.

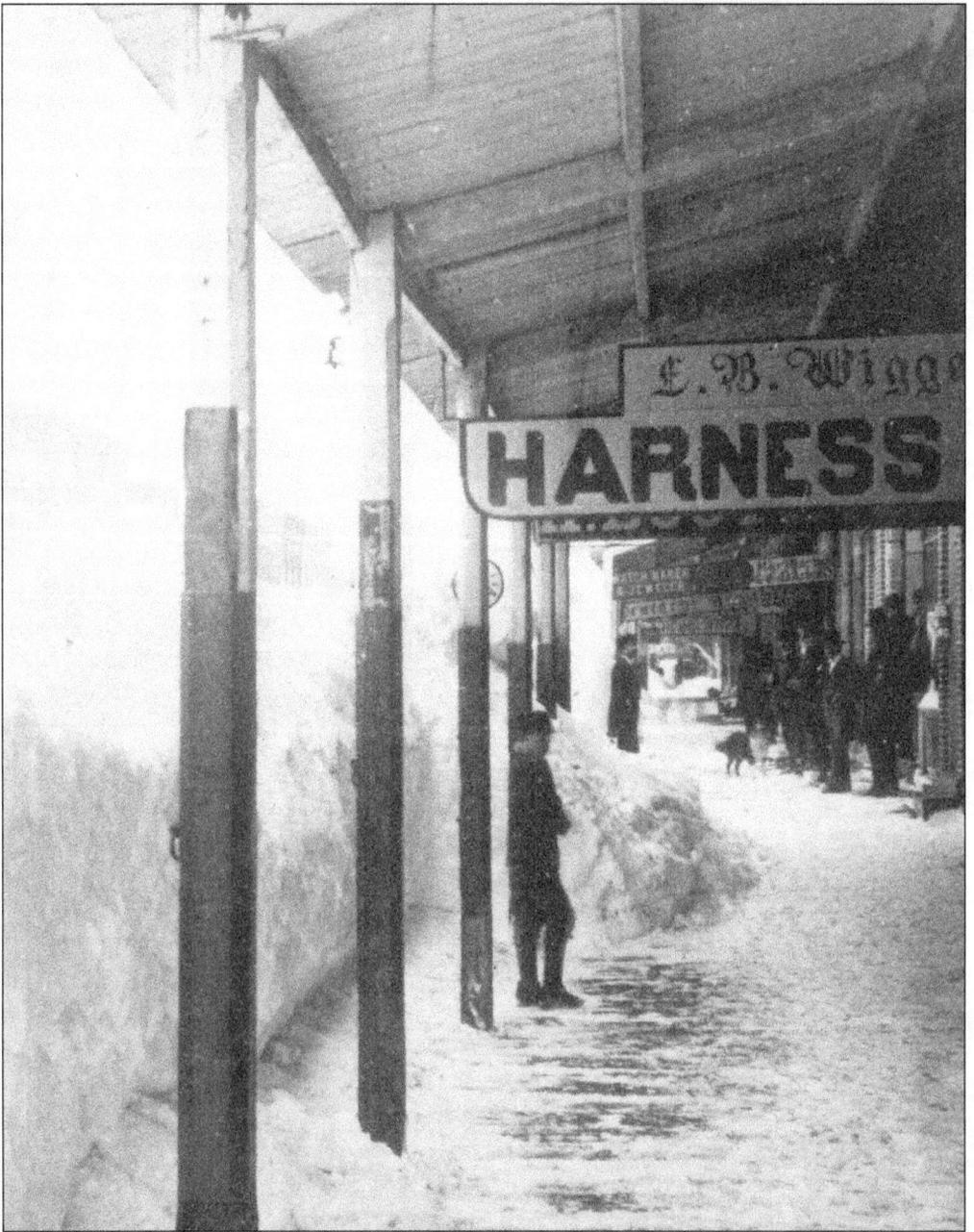

THE GREAT BLOCKADE. The most infamous snowfall in the history of Beaver Dam was delivered by Mother Nature on the last weekend of February 1881. The storm was known as the "Great Blockade," as within a few hours, 4 feet of snow fell on Beaver Dam streets. Accompanying the snow were blizzard winds that created drifts as high as 20 feet. Unable to move the snow, residents became prisoners in their own homes. Farmers were forced to dig tunnels from farmhouse to barn in order to care for their livestock. Just as it appeared the situation was almost under control, a second blizzard descended upon the city three days later, dumping another 4 feet. There was neither machinery nor manpower sufficient to move so much white powder. It would be weeks before the snow could be carted away in wagons to clear the downtown streets.

114

Eight

CENTENNIAL

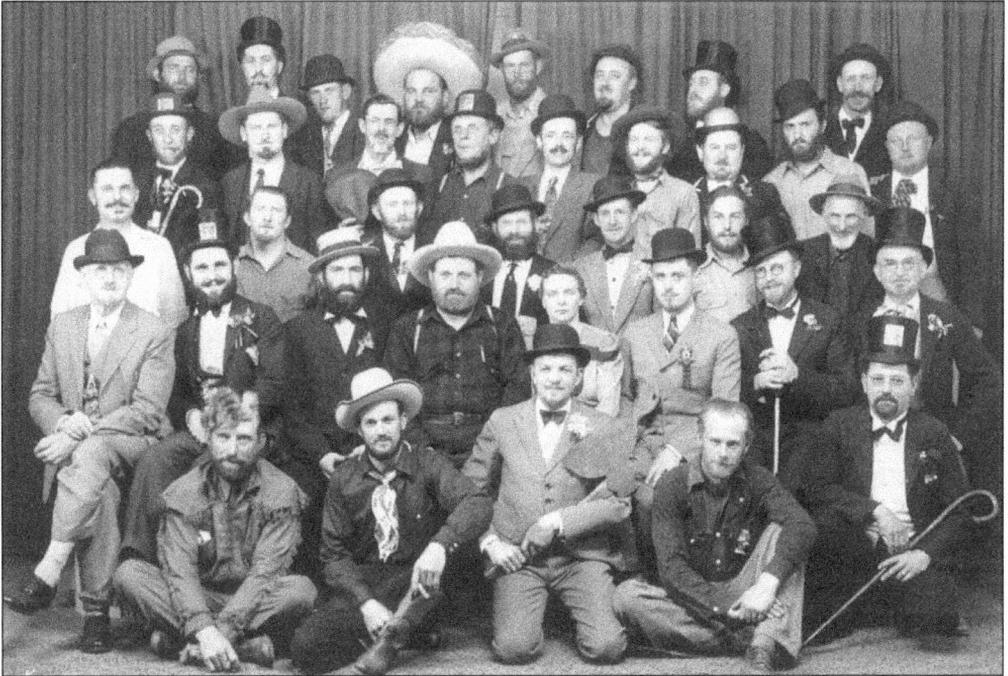

THE WHISKER CLUB. Beaver Dam celebrated its centennial in 1941. To promote the occasion, 54 men agreed to grow facial hair to imitate the beard and mustaches from previous eras. The club formed its own band and sponsored many of the events held during the celebration. Pictured above from left to right are: (front row) A.H. Derge, Ransom Castleberry, Ray Pederson, Martin Pederson, and Emroy Franz; (second row) August Erdmann, Karl Whitrock, Wilbur Smith (vice president), Griffin M. Jones (president), Beulah M. Clough (centennial secretary), Donald Sterlinske (secretary-treasurer), Milton Swenson, and Dr. J.N. Hoyer; (third row) Edmund Schulz, Herman Eyries, Arlo Pederson, Elmer Marthaler, Ben Miller, Clarence Hilgendorf, and John Gunn; (fourth row) Fred Kienow, Earl Dowd, Dudley Lathrop, Elmer Holt, Arthur Bedker, Herbert Fischer, LeRoy Ehlenfeldt, Byron Kostolni, and Edward Franz; (back row) Anton Tischler, Elmer Jesse, Harold Krause, Burton Shepard, W.H. Stump, Warren Hyde, Earl Geschel, and Reuben Kienow.

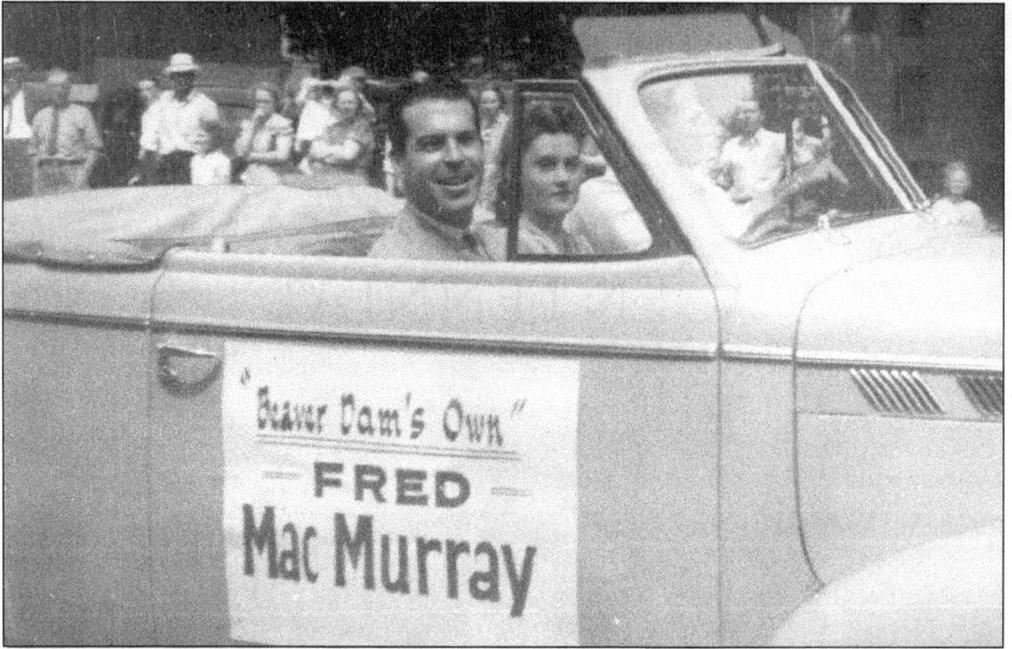

GRAND MARSHALL FRED MACMURRAY. The official centennial program cites 20 major events taking place during the 5-day celebration, among them an old fashioned Fourth of July picnic given by the Whisker Club, an air show, and a three-mile parade down Main Street. Fred MacMurray suspended a movie shoot to fly all night from Hollywood to Chicago in order to be parade co-grand marshall with Maddy Horn.

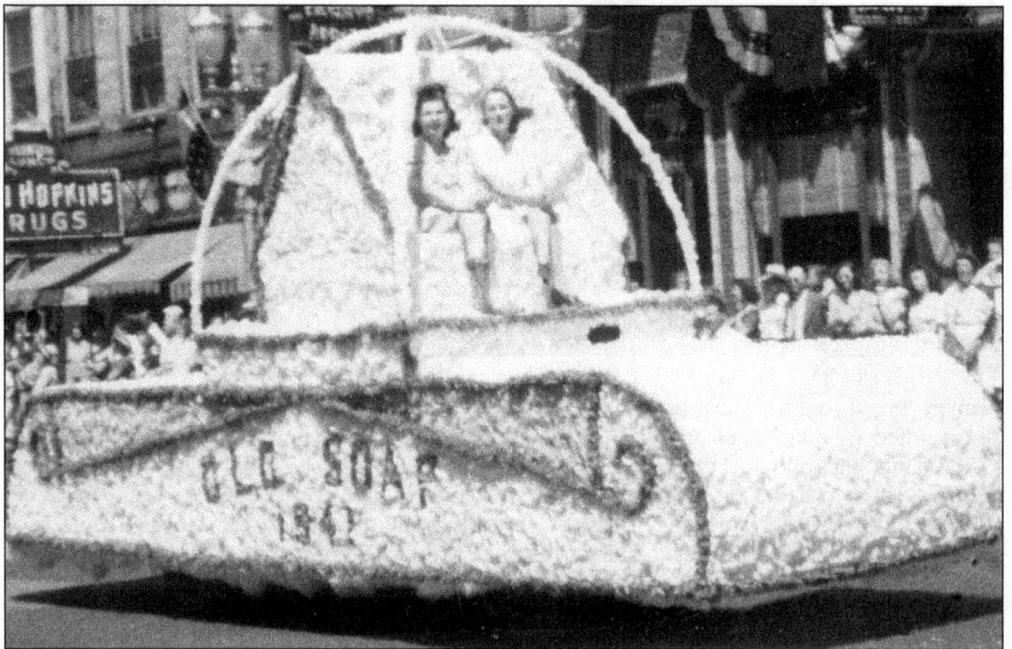

THE OLO SOAP FLOAT. Each major industry in the city sponsored a parade float. This one was created for the Klatt brothers, owners of the Olo Soap Company.

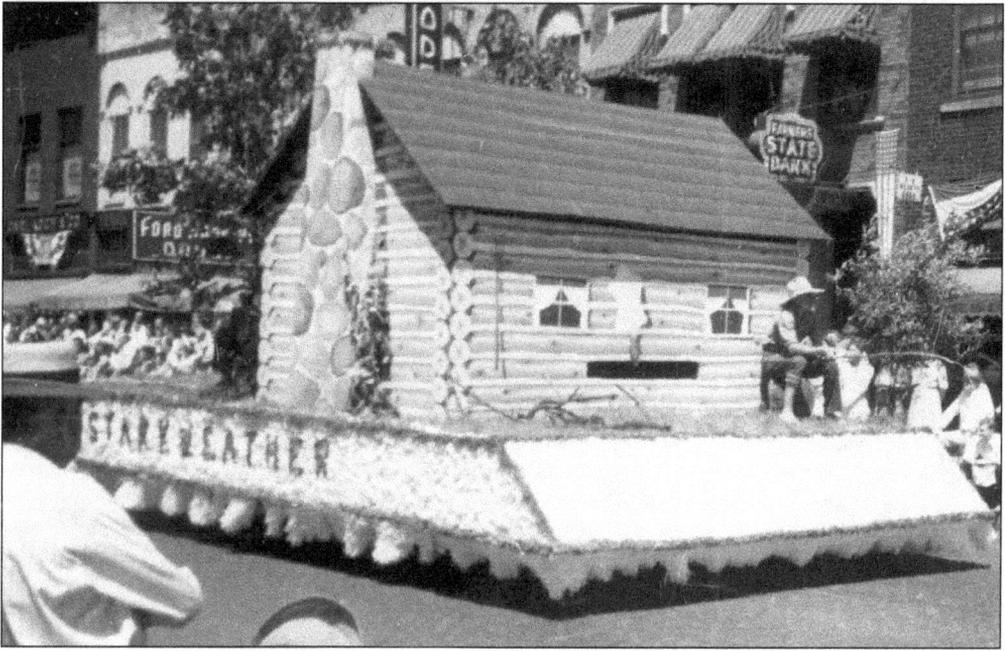

THE STARKWEATHER FLOAT.

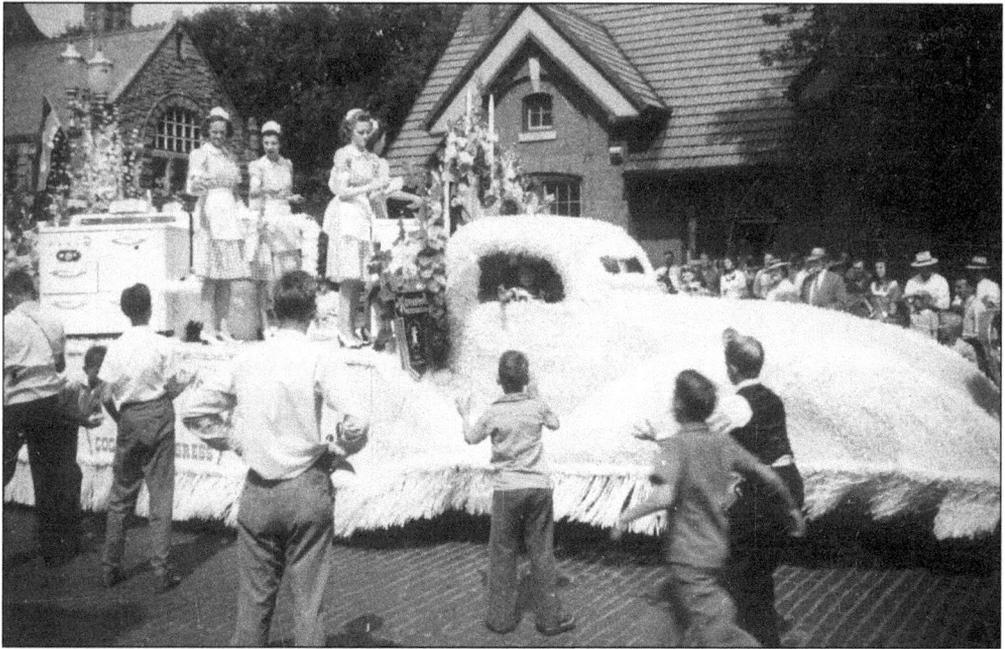

THE MONARCH STOVE FLOAT.

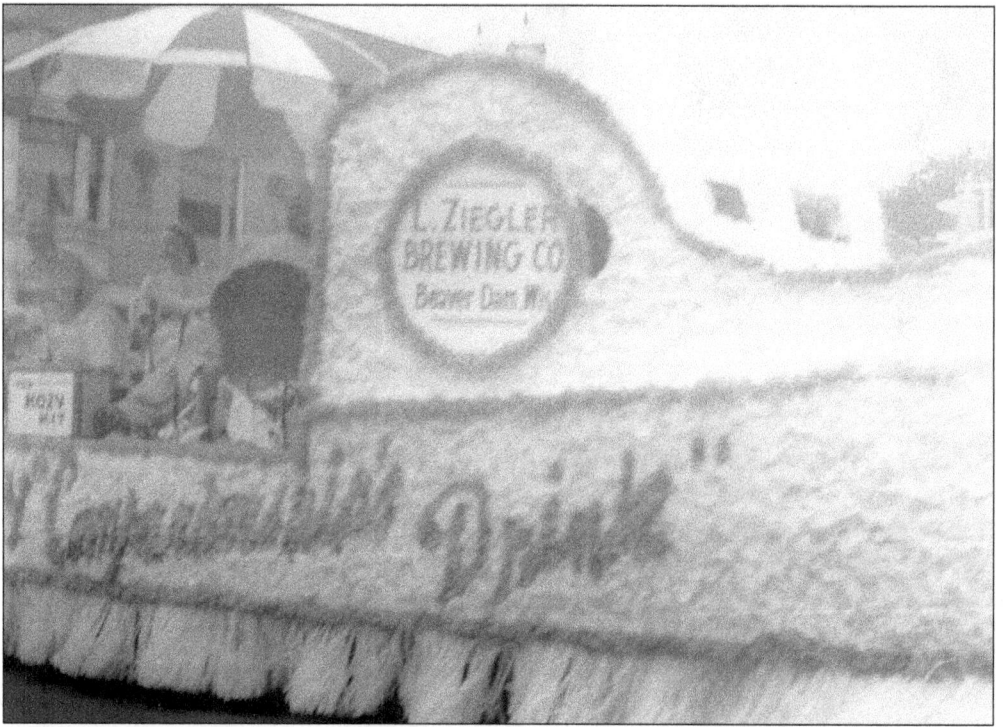

THE LOUIS ZIEGLER BREWING CO. FLOAT.

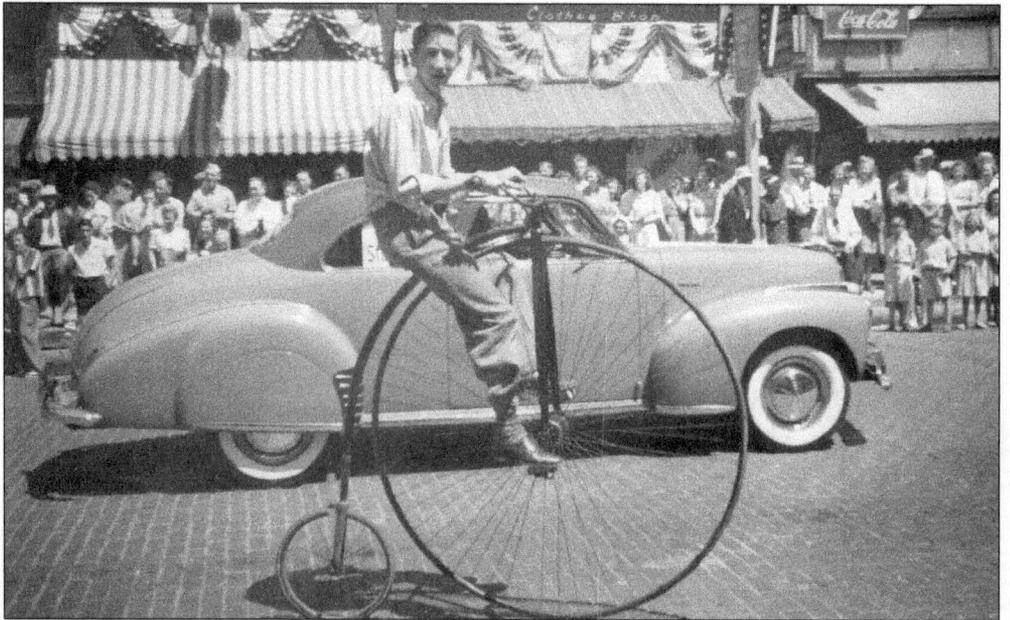

1890 HIGH BOY BICYCLE. One of the highlights of the parade was John McFetridge's high boy bike. The bike has not been ridden since and can currently be seen at the Dodge County Historical Society Museum at 105 Park Avenue.

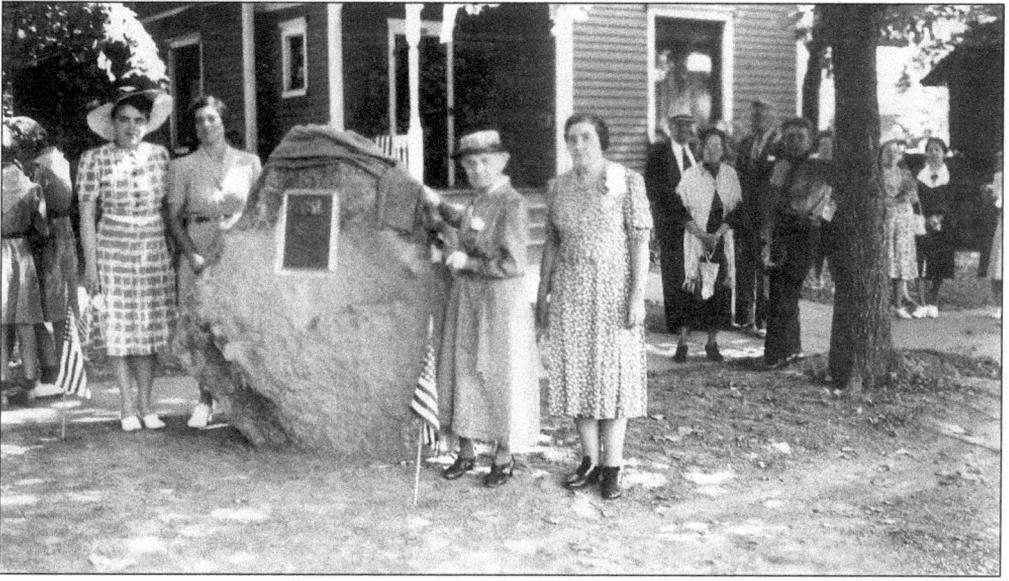

THOMAS MACKIE STONE MARKER. Another event of the centennial involved the placing of a stone marker at the original site of Thomas Mackie's log cabin, the first home in Beaver Dam.

PRACTICING FOR THE CENTENNIAL PAGEANT "THE WINGS OF TIME." "The Wings Of Time" pageant depicted the 100-year history of Beaver Dam. The drama comprised 16 acts and boasted a cast of over 750 Beaver Dam men, women, and children. Pictured above from left to right are Mr. and Mrs. Everett Hughes, Mr. and Mrs. Harold Grace, Mr. and Mrs. Ted Elser, and Mr. and Mrs. Elmore Elser. The group is practicing Act III, "The Ordinance of 1787."

119

Beaver Dam in the Gay 1890s. The city constructed a colossal proscenium at the fairgrounds to stage the elaborate pageant. Here is a scene recreating the days of the old horse and buggy in

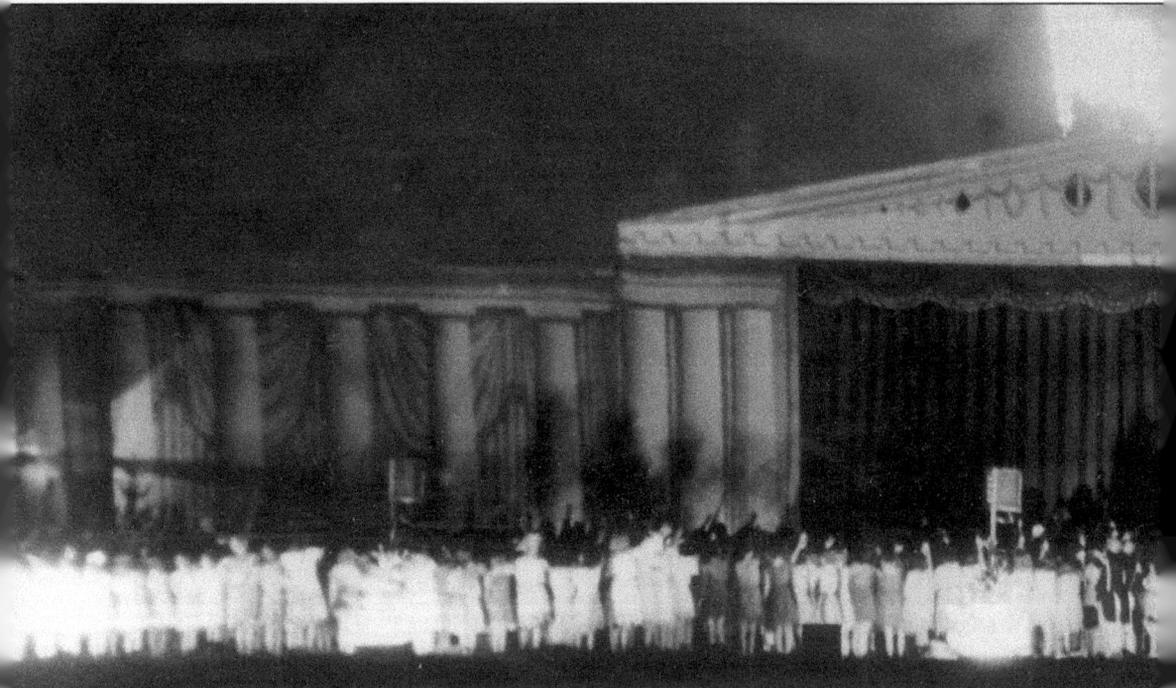

The Pageant Finale. The entire cast assembled on stage to end the play on a patriotic theme. The program for the pageant concluded with the following sentiment: "We have shown you the

the Gay 1890s.

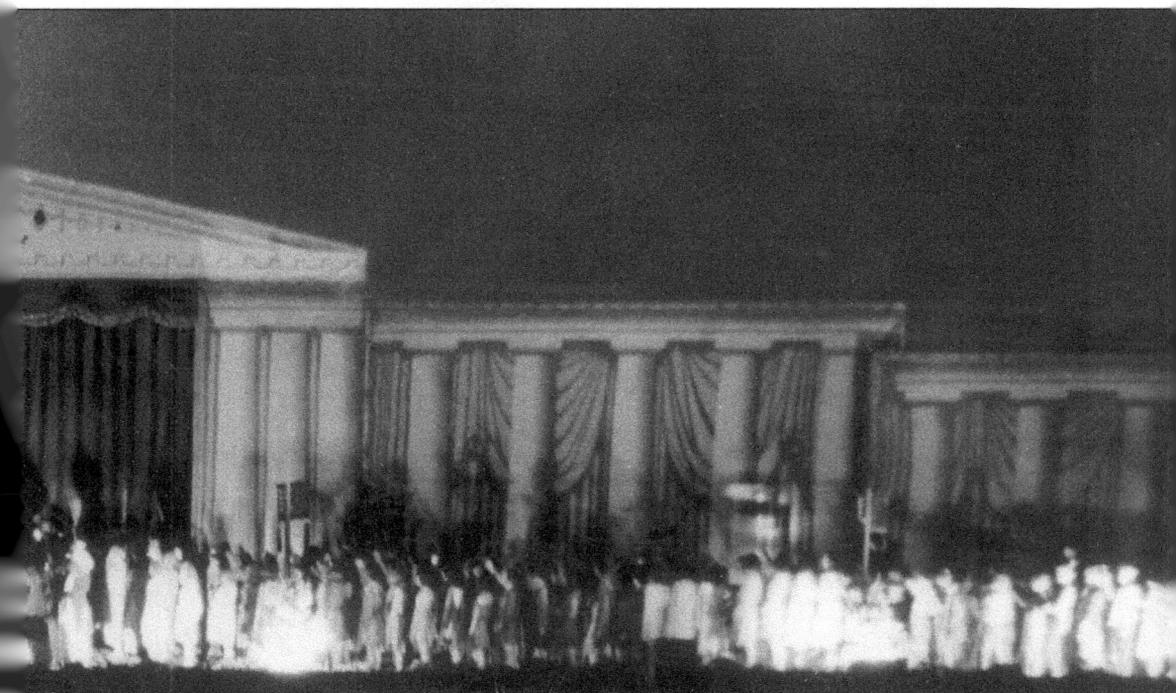

yesterdays of Beaver Dam: the tomorrows are your sacred trust."

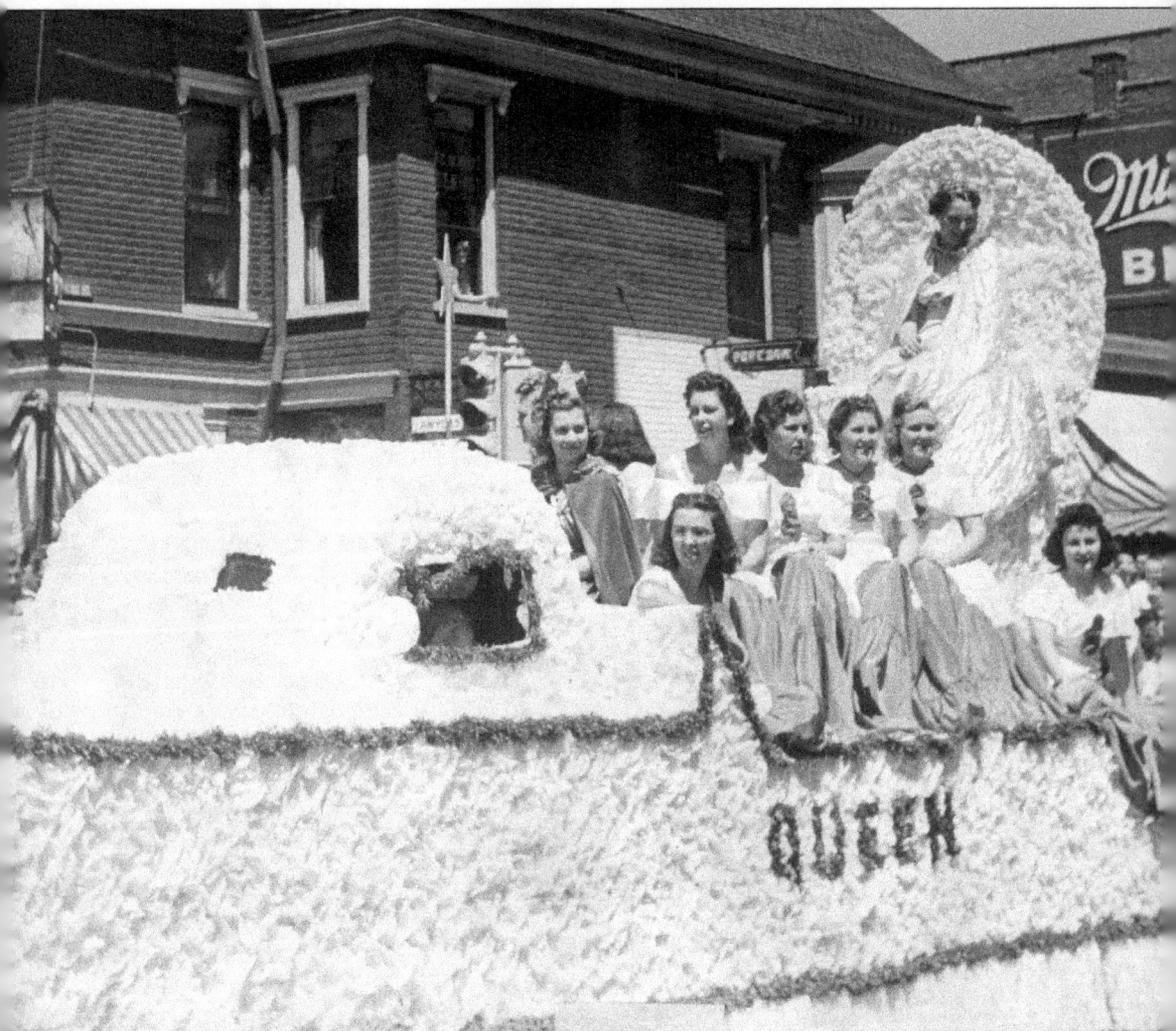

CENTENNIAL QUEEN DOROTHY HERR AND HER COURT. On July 4, 1941, Fred MacMurray crowned Dorothy Herr as Centennial Queen. Princesses in the Court of Honor included Charlotte Bender, Ruth Genrich, Carrie Dollar, Grace Hammer, Phoebe Kellom, Vera Marlefski, Jean Mahoney, Anita Volkmann, Shirley Frank, Lillian Michael, Ellen Bonner, and Louise Knaack.

BIBLIOGRAPHY

Beaver Dam: Historical Committee. *Centennial History Beaver Dam, Wisconsin*. Beaver Dam Centennial, Inc., 1941.

Beaver Dam: History Book Committee. *Sesquicentennial History Beaver Dam, Wisconsin 1841–1991*. Beaver Dam Sesquicentennial, 1991.

Gallun, Raymond Z. with Elliot, Jeffrey M., Starclimber: *The Literary Adventures and Autobiography of Raymond Z. Gallun*. San Bernardino, California: Borgo Press, 1991.

History of Dodge County. Chicago: Western Historical Company, 1880.

Hubbell, Homer Bishop. *Dodge County Wisconsin Past and Present*. Chicago, Illinois: The S.J. Clark Publishing Company, 1913.

Hoyt, Harlowe E.*Town Hall Tonight*. Englewood Cliffs, New Jersey: Prentice-Hall, Inc., 1955.

Olds, Elizabeth Fagg. Women of the Four Winds. Boston, Massachusetts: Houghton Mifflin Company, 1985.

Overfield, Joseph M. *Nineteenth Century Stars*. Kansas City, Missouri: Society For American Baseball Research, 1989.

People… Place… Things… Of Yesteryear in Beaver Dam. Beaver Dam, Wisconsin, 1961.

Printer, John Kelley. *Memorial Addresses on the Life and Character of Judge A. Scott Sloan*. Juneau, Wisconsin, 1895.

INDEX

Visit us at
arcadiapublishing.com

www.ingramcontent.com/pod-product-compliance
Lightning Source LLC
Chambersburg PA
CBHW080558110426
42813CB00006B/1337